The complete paintings of

# Giotto

Introduction by **Andrew Martindale**

Notes and catalogue by **Edi Baccheschi**

**Weidenfeld and Nicolson**

5 Winsley Street London W1

## Classics of World Art

**Editor**
Paolo Lecaldano

**International Advisory Board**
Gian Alberto dell 'Acqua
André Chastel
Douglas Cooper
Lorenz Eitner
Enrique Lafuente Ferrari
Bruno Molajoli
Carlo L. Ragghianti
Xavier de Salas
David Talbot Rice
Jacques Thuillier
Rudolf Wittkower

*The Classics of World Art are
published in Italy by Rizzoli
Editore, in France by
Flammarion, in the United
Kingdom by Weidenfeld and
Nicolson, in the United States
by Harry N. Abrams, Inc.,
in Spain by Editorial Noguer
and in Switzerland by
Kunstkreis*

Translation and introduction
© copyright by George
Weidenfeld and Nicolson Ltd,
1969
© Copyright by
Rizzoli Editore, 1966
Phototypeset in England by
BAS Printers Limited, Wallop,
Hampshire
Printed in Italy

ISBN: 0297761420

# Table of contents

*Photographic sources*     Colour plates : Emmer, Milan ; Scala, Florence.
Black and white illustrations : Alinari, Anderson, Florence ;
Photographic Archive of the Vatican Museum and Art
Gallery, Rome ; Archivio Rizzoli, Milan ; Bazzocchi,
Bencini and Sansoni, Brogi, Florence ; Oswald Böhm,
Venice ; Fine Arts Gallery of San Diego ; National Gallery of
Art, Washington D.C. ; Samuel H. Kress Collection, North
Carolina Museum of Art, Raleigh, North Carolina ;
Soprintendenza alle Gallerie, Florence ; Tacchini già Pais,
Città di Castello.

Drawings and sketches by Sergio Coradeschi.

# Introduction

The first striking feature about the career of Giotto is his fame. There can, of course, be no doubt about his importance as an artist, but the unexpected fact is that people were already commenting on this in the fourteenth century, and in the life-time of Giotto himself. In the context of the general paucity of information on medieval artists and their work, this is very surprising and deserves notice. Much of the comment derived from the mention of Giotto in Dante's *Purgatorio* (see p. 9). In this passage, a general lament on pride and the passing of fame was put into the mouth of a thirteenth-century manuscript illuminator, Oderiso of Gubbio. In this lament, two illuminators, two painters and two writers were compared in the sense that in each case the fame of the second had eclipsed that of the first – his immediate predecessor. This passage seems to have caused some surprise at the time that it was written (about 1313) on account of the type of person which it introduced into the poem. But commentators justified the idea that fame was possible in the mechanical arts (i.e. painting) with reference to antiquity; and the whole passage was explained as an indication that the sin of pride might be committed as easily by manual workers as by soldiers or nobles.

This passage from the *Purgatorio* undoubtedly put Giotto on the literary map. Whoever read Dante was told, in effect, 'Giotto is great and famous' and there exists a series of fourteenth-century references to Giotto all tending to extend and gloss this statement. In doing so, however, Dante's original purpose was almost certainly abused. The point of the passage was not Giotto's fame but his predecessor, Cimabue's pride; and, if one accepts the commentators' explanation for the passage mentioned above, these illustrative names were introduced merely to spice the passage with personalities with whom, Dante must have assumed, his (Florentine) public would be familiar. Had he happened to be Sienese, Roman or Venetian, the names would probably have been different. That Florentines were already aware of Giotto as a name is proved by one highly unusual occurrence. In 1312, Giotto was mentioned in a will (see no. 49) as the author of a crucifix before which a light burned. However, it was almost certainly Dante who inadvertently originated the fourteenth-century crescendo of Giotto eulogy – a 'press' which was so consistently good that the one remaining dissentient voice is worth recording. It occurs in a commentary on Dante made about 1376 by Benvenuto da Imola who wrote 'Giotto still holds the field, since no one more subtle than he has yet appeared, even though, nevertheless, he made great errors at times in his paintings, as I have heard from those most skilled in these things'.

In spite of the numerous literary allusions made to him, Giotto remains a very puzzling figure; and this for the simple reason that the writers, intent on underlining his greatness, seldom descended to details about his career. Moreover, when this happened, the results generally create as many problems as they solve. Much of the detail about his life is derived from administrative documents. Those in Florence suggest that he was a successful property owner and well enough off to lend money to others. Those in Naples suggest that he was sufficiently personable to be accepted at the Angevin court there. Literary sources from the first half of the century suggest activity also at Rome, Avignon, Padua, Rimini and Milan.

Of all this activity, only two major blocks of undisputed work survive. The first is the painting in the Arena Chapel at Padua (nos. 54–108). This is firmly authenticated and dated between 1303 and 1313 and forms the pivotal point for all Giotto studies. The

second is in Sta Croce, Florence (nos. 117–125 and 138–148), being a series of frescoes divided between the Peruzzi and Bardi chapels. The tradition of their authenticity dates only from the fifteenth century, but they are now unanimously accepted as the product of Giotto and his workshop at some period subsequent to the painting of the Paduan frescoes. The relative dates of the two chapels are, however, far from settled. Stylistic considerations suggest that it is unlikely that they were painted at the same time, but there are no external reasons to indicate which chapel is the earlier. One here reaches the first point of major disagreement between modern scholars.

It is difficult to summarize this particular problem but the general composition of the two sets of frescoes is not really similar. The almost uniform spatial treatment of the Bardi frescoes lends them an extraordinary clarity. In each, the architectural setting is focused on the central area, emphasizing the action which it contains and lending it dramatic point. By contrast, the settings of the Peruzzi Chapel are not focused on a central point; the architecture is turned obliquely towards the spectator and is, in a sense, more discursive, just as the narrative is more discursive. Even those scenes which contain but a single action differ very strikingly in their composition from those in the Bardi Chapel. This may be seen by comparing, for instance, the *Raising of Drusiana* (no. 121) with the *Funeral of St Francis* (no. 141). Few would question that the single-minded character of the Bardi frescoes represents an austere sort of perfection, from which it may be argued that they are more 'mature' and hence later. One cannot, however, ignore the controlling factor of the Arena Chapel. While making every possible allowance for a lapse in time, it is reasonable to expect those Sta Croce frescoes which look most like the Arena frescoes to be closest to them chronologically. Using this criterion, it is the Bardi Chapel which appears to be the earlier. The spatial descriptions of the Arena Chapel have a similar clarity; and the type of perspective which focuses towards a central area occurs a number of times (e.g. nos. 82, 83). On the other hand, there is little to hint at the composition of the *Raising of Drusiana*. It can therefore also be argued that the Bardi Chapel is earlier, representing a sort of 'Summa' of aims previously recognizable in the Arena Chapel; and with the Peruzzi Chapel, the artist moved on to a new and experimental stage in his career. The question is still open, and the reader must draw his own conclusions and judge for himself.

Turning back to the earliest phase of Giotto's life, the problems become more complex. Here the question to be asked is this: granted the achievement of the Arena Chapel, what would the artist have been likely to have painted ten years earlier? It is now generally agreed that Giotto must have been trained in some workshop based in the city of Rome, the most important centre of wall painting in the late thirteenth century. A chronicler mentioned round about 1313 that there was work by Giotto in S. Francesco at Assisi, and it so happens that a considerable body of thirteenth- and fourteenth-century fresco painting survives in this church; moreover, the thirteenth-century work certainly has close connections with Roman painting. Unfortunately, the same chronicler omitted to say precisely what Giotto painted, and in the upper church alone, at least five well-defined styles can be detected in the wall painting. However, leaving aside the possibility that the work referred to by the chronicler has been totally destroyed, the speculation concerning Giotto's intervention is generally focused on two areas. These are the frescoes attributed to the workshops of the so-called 'Isaac Master' (especially nos. 1, 2) and the so-called 'St Francis Master' (especially nos. 21–38). It has, at various times, been suggested that Giotto was either, that he was neither and also that he was both.

The later frescoes in the upper church at Assisi are certainly strongly reminiscent of Giotto and the most straightforward explanation has generally been that Giotto, trained probably under the 'Isaac Master', was, in fact, the 'St Francis Master' and painted the bulk of the St Francis cycle from 1295 to 1300. The Paduan frescoes therefore followed about ten years later and all differences are attributed to development during this period. This is plausible as a hypothesis explaining Giotto's origins. Doubts about it arise, however, from an examination of the frescoes themselves and are concerned chiefly with different aspects of quality. It is not that the St Francis frescoes are bad, but that the Paduan frescoes are so very much better. The paintings of the Arena Chapel are masterpieces of dramatic story-telling. But, in the St Francis cycle, the level of dramatic intensity never reaches the same heights; moreover, the faces, which are so expressive at Padua, appear wooden and uncommunicative at Assisi. There is an untidy profusion of different types of setting at Assisi and their relationship to the figures is more variable. If Giotto

was the St Francis Master, then in the last decade of the thirteenth century he was a competent, interesting and attractive artist, but qualitatively unremarkable; and it is arguable that this is not a normal pattern of development for artists of Giotto's calibre. The limitations to be found in early work should be those not of execution and quality but of scope and interests. It is at this point that the 'Isaac Master' may be considered.

The 'Isaac Master' takes his name from the two scenes portraying Jacob, Esau and the bestowal of the birthright. These two scenes are, in quality, probably the best surviving in the upper church; and this quality is to be seen particularly in their clarity and the dramatic intensity of their narrative. The difficulty in forming a broader assessment of the 'Isaac Master' lies in the fact that the subsequent Old and New Testament scenes associated with him and his workshop are in such bad condition. It is possible that he is identifiable with Giotto. Certainly if this were the case, the problems of quality, mentioned in connection with the St Francis legend, cease to exist. On the other hand, this merely pushes back one stage the problem of Giotto's origins; for the 'Isaac Master' has always been a somewhat shadowy figure whose art seems to derive in a not very precise way from Cavallini and the Antique.

Since it is undecided whether Giotto's work at Padua leads back to the St Francis cycle or to the Isaac scenes and, equally, whether he developed directly towards the style of the Bardi or Peruzzi chapels, it is not surprising that very considerable uncertainty surrounds almost all the lesser works. Only in the case of the Ognissanti Madonna (no. 109) is there unanimity in placing it in close association with the Arena frescoes. Even here, there is argument whether it ante- or post-dates them. The information provided by this book will give every reader a starting point for attempting a solution to these various problems, should he feel so inclined.

The questions raised by the details of Giotto's career can easily obscure a number of broader issues which are worth mentioning. For instance, whoever actually painted the upper church of S. Francesco at Assisi, it is an ideal place for seeing revealed, step by step, the remarkable development of central Italian fresco-painting probably between 1275 and 1300. One has only to walk the length of the church to see these changes taking place. The latest painters in the St Francis cycle had at their disposal a control of spatial effects which is not to be found in the frescoes round the High Altar. They were also more interested in the detailed appearance of the visible world, so that the *minutiae* of architecture, clothes and fabric, or animals and trees, all play an important part in the business of story-telling. Further, the necessity of making relevant figures appear to communicate was also treated as a serious problem. It may not be certain whether or not Giotto painted at Assisi, but at least the painting at Padua forms a perfectly intelligible sequel to what happened there.

On the fact of Giotto's importance, there has never been any argument. Indeed, at Assisi, the words used of Sir Christopher Wren at St Paul's come to mind *Si monumentum requiris, circumspice.* For in the lower church there is a wide variety of fresco-painting showing in some degree Giotto's influence. It is to be found in the straight Giottesque painting of the Magdalene Chapel (no. 115) and is also to be seen in the work attributed to Pietro Lorenzetti, Simone Martini and other Sienese painters. The interest of this spreading influence lies in the fact that it also involves Giotto's limitations. Few painters could escape imitating the solidity of his figures or his facial types. Most fresco painters imitated his architectural constructions. But almost all important painters consistently went beyond Giotto in the amount of narrative detail which they allowed into their work; and in this, conscious or unconscious criticism is implied. A comparison of many of the scenes at Padua with their counterparts in the lower south transept at Assisi (by Pietro Lorenzetti and his followers) will show how, round about 1330, it was possible to 'improve' Giotto. Nevertheless, Giotto's universal appeal must lie largely in the single-minded austerity of his painting. His story-telling tended to be stripped down to its bare dramatic essentials. Figures and action could thus be appreciated, uncluttered by unnecessary stage properties and stage 'extras'; and it was this directness and economy, as well as the firmness of his compositions and the physical presence of his figures which recommended his style to subsequent painters such as Masaccio and Michelangelo. Whatever the 'great errors' were which around 1376 'those skilled in these things' saw in his work, nothing more is heard of them. Giotto, his reputation supported by the writers on one side and the artists on the other, became in the fifteenth century not merely important but the most important painter of his period.

ANDREW MARTINDALE

# An outline of the artist's critical history

Giotto's own contemporaries regarded him as the inaugurator of a new type of painting, so much so that he was inundated with commissions from private citizens and public bodies all over Italy and enjoyed the kind of reputation which is reserved only for leading artists, indeed for *the* leading artist. It was not long before the details of his life and physical appearance had faded into the mists of the past. However, his art continued to exercise a very real influence and to evoke imitation long after he himself was dead. Even in Ghiberti's day, Giotto had already become a legendary figure. The opening lines of Ghiberti's biography suffice to convince us of the truth of this statement: 'In a village near Florence ... was born a child endowed with great genius who drew sheep from life'. Masaccio, too, owes much to him and even Michelangelo was to borrow some of his own designs from the Sta Croce frescoes.

In propounding his theory of the development of art, Vasari attaches vital importance to the comparison between Cimabue and Giotto for the purposes of artistic appreciation. Although he concludes that Giotto is the better, the more 'modern' of the two, he nevertheless sees that his art has to be viewed against the background of the artist's own era, which was both 'gross and foolish'. Admittedly, Vasari was more interested in the man than in the artist and, after his day, Giotto's influence gradually declined. He somehow came to be regarded as a kind of sacred monster and so little interest was evinced in his works that by the seventeenth century many of them had been lost or come to be attributed to other artists. The honourable exception is Baldinucci, whose writings display personal knowledge of Giotto's art. His period of oblivion continued into the eighteenth century, when the frescoes in the Peruzzi and Bardi chapels were actually whitewashed over. It was not until towards the end of the nineteenth century, when there was a fairly widespread revival of interest in the criticism and appreciation of art, that there was a move to extend the investigation of sources and search for documents which had, in fact, begun on a very small scale a century earlier. Most important, however, was the rediscovery of the works themselves. In some ways, German Romanticism was equipped with new means for a more vital encounter with Giotto and his era. It was, therefore, unfortunate that all art criticism in the age of the Romantics was seriously hampered by the 'primitive' label, which barred the way to any true appreciation since the general tendency was to allege that Giotto's art lacked 'technique'. There were even those who were further blinkered by the irrational belief that the parade of piety in his works was the main purpose of his art. A more all-embracing assessment of Giotto's work, based on authentic historical and aesthetic criteria, came after the turn of the present century. Even so, it was not until the advent of Cubism that certain characteristic features of his art were appreciated to the full. In a sense, it is only now, in the light of Marangoni's perceptive study of the lyrical quality of the workaday world depicted in Giotto's paintings, that we are witnessing a revival of interest in the naturalness and equilibrium of his constructions.

---

Once, Cimabue thought to hold the field
In painting; Giotto's all the rage today;
The other's fame lies in the dust concealed.
DANTE ALIGHIERI, *Divina Commedia* (*Purgatorio*), 1310ca
(English translation by D. L. Sayers)

... the greatest master of painting in his time and one who, more than any other, depicted both people and actions from life.... G. VILLANI, *Cronica*, 1340ca

... he was so brilliant that there is nothing in nature, mother and mistress of all things in all seasons, that he with his stylus and pen or paintbrush did not depict so true to life that it seemed to be, not a likeness, but a product of nature; so much so that very often men's eyes have been deceived in the things he painted and the painted image taken for reality. Since he was thus responsible for reviving that art which had for many centuries lain hidden on account of the erroneous opinion that the purpose of painting was to provide pleasure for the eyes of the ignorant rather than for the intellect of the knowledgeable, he well deserves to be regarded as one of the glories of Florence. ... G. BOCCACCIO, *Decameron*, 1350ca

... a panel or image of the Blessed Virgin Mary, the work of the great painter Giotto ... the beauty of which is not appreciated by the ignorant, but is a cause of wonder to those who are masters of art. F. PETRARCA, *Epistolae de rebus familiaribus*, 1361ca

Giotto still holds the field because no one subtler than he has yet appeared, even though at times he made great errors in his paintings, as I have heard from men of outstanding talent in such matters. BENVENUTO DA IMOLA, 1376ca, quoted by MILLARD MEISS, *Painting in Florence and Siena after the Black Death*

From this excellent man ... there gushed glistening streams of painting, resulting in a completely new style in which nature was both cleverly and pleasantly portrayed. F. VILLANI, *De origine civitatis Florentiae et eiusdem famosis civibus*, 1381ca

... he transposed the art of painting from Greek to Latin and adapted it to 'modern' taste. Hence his art was more complete than that of any previous artist. C. CENNINI, *Libro dell'arte*, 1390ca

9

Before Giotto's day, we see that painting was dead. But he rescued it from a state in which it was capable only of depicting laughable caricatures. His followers carried on his work and transmitted the gift to others so that there are now many exponents of the highest forms of art.    M. PALMIERI, *Della vita civile*, 1440ca.

Giotto became a master in the art of painting. He introduced a new kind of art and abandoned the unpolished style of the Greeks . . . Giotto saw in art something that others were unable to put into it. He initiated a natural art which was pleasing to the eye, though he was careful to observe the rules of perspective and proportions. He excelled in all forms of art and both expounded and rediscovered theories which had lain buried for 600 years.    L. GHIBERTI, *Commentarii*, 1450ca

I am the man who brought painting to life when it was dead,
whose hand combined sure accuracy with masterly ease.
Whatever is to be found in nature, may be found in my art.
To no-one was it given to paint more, or to paint better. . . .
I am Giotto – what need was there to say it?
This name of itself will for many years suffice as an epitaph.
A. POLIZIANO, Giotto's epitaph, 1490

A painter's work will not be of any great worth if he takes that of another artist for his model. However, if he learns from nature, his work will indeed bear fruit. The truth of this contention is borne out by those painters after the Romans, who all imitated one another with the result that art, as a whole, deteriorated from one age to the next. Then came the Florentine painter, Giotto, who was not content merely to imitate the work of his master, Cimabue, but, having been born in a wild mountain area, he began to draw . . . and after long years of study and endeavour he surpassed not only the artists of his own day, but those of past centuries as well.    LEONARDO, *Codice Atlantico*, 1500ca

. . . It is very true that just as poets describe the outside, so painters portray as far as possible what is inside, in other words the thoughts and feelings. In ancient times, the first to do this was . . . Aristides of Thebes, whose 'modern' counterpart is Giotto.    B. VARCHI, *Lezione nella quale si disputa della maggioranza dell'arti*, 1546

. . . he became so very adept at imitating nature that he dispensed entirely with that clumsy Greek style and revived the modern and excellent art of painting, inaugurating the custom of painting people from life, a practice which had fallen into abeyance for more than two hundred years. . .    G. VASARI, *Le Vite*, 1568

. . . (there are in Assisi) a great many frescoes done by Cimabue the Florentine and by Giotto . . . (painters) in an age when painting may be said to have still been a babe-in-arms which, however, in the course of 400 years, has grown to giant stature in our own day.    L. SCARAMUCCIA, *Le finezze de' pennelli italiani*, 1674

. . . He discovered a great deal; indeed, he became so practised in this excellent art that he caused a great stir in his own day . . . since to some extent he succeeded in making the figures he depicted live by imbuing them with an expression of affection, love, anger, fear, hope and so on while at the same time he endeavoured to convey an appearance of naturalness in the folds of their garments. In addition, he introduced an element of perspective in the handling of his figures, coupled with a certain gentleness of line. All these features represented complete innovations in art as it had been practised up to his day.
F. BALDINUCCI, *Apologia a pro delle glorie della Toscana*, 1677

Today, the paintings of Giotto are, indeed, looked at. However, they are not admired except in so far as one is led to wonder at the great progress made by art since his day.    F. L. DEL MIGLIORE, *Reflessioni e aggiunte alle* Vite . . . *del Vasari*, post 1681

. . . nor can it be denied that Giotto caused a far greater stir than any other artist in his own day. It is quite clear, however, that the reason why he alone has remained famous, and even the names of many other contemporary artists are now unknown, is that written records were kept of him and of the other Tuscan artists whereas nothing at all was written about painters from other cities.    S. MAFFEI, *Verona illustrata*, 1732

. . . The works of Giotto, successor to Cimabue, are a great deal better, though in themselves they are pretty poor. . . . This great master, whose work is lauded to the skies in every history of art, would today hardly be considered fit to paint a signboard. Yet one must admit that there is a trace of genius and of talent in his scribbles.    C. DE BROSSES, *Lettres familières écrites d'Italie*, 1739–40

Giotto painted pictures which still give pleasure.    VOLTAIRE, *Essai sur les moeurs*, 1746

Cimabue is not much of an artist as compared with Dante (in his own field) and Giotto does not fare much better from a similar comparison with Petrarch. Nevertheless, both Dante and Petrarch were men versed in the literature of Greece and Rome whereas all Giotto and Cimabue had to guide them were crude examples of painting and sculpture. They had not the discovery of Greek and Roman statues to guide them, as had Raphael and Michelangelo in a later age.    S. BETTINELLI, *Del Risorgimento d'Italia*, 1775

And I much prefer those twisted necks that Giotto and Simone (Martini) gave to their figures . . . than the affected ones Parmigianino gave to his. . . . When painting on a small scale, (Giotto) excels Simone . . . but Giotto in his turn is not the equal of Simone when painting on a large scale with complexity of composition. . . . (Simone's figures) have all the appearance of people who are awake and are about to spring into action. The Florentine painter's figures, on the other hand, are really only half awake, or in the state of a man who sits down to rest or is kept on his feet by sheer willpower.    G. DELLA VALLE, *Lettere senesi sopra le belle arti*, 1785

If Cimabue was the Michelangelo of that period, then Giotto was its Raphael. Painting in his hands became so delicate that none of his pupils nor indeed any other artist until Masaccio managed to surpass or even to equal him, at least where grace is

concerned. He took a more balanced view of symmetry; his designs were gentle and his use of colour soft. All those pointing hands and pointed feet, those terrified eyes, so indisputably derived from Greek painting, in Giotto were toned down, rounded off and smoothed into greater unity. L. LANZI, *Storia pittorica della Italia*, 1789

His work affords examples of his own imaginative and creative ability which can profitably be studied even today by any artist who aims at greatness. . . . W. Y. OTTLEY, *The Italian School of Design*, 1808–23

The very earliest examples of modern painting, as for instance the work of Giotto . . . are characterized by that complexity, that variety and that element of symbolism which were developed in greater depth in the more powerful works of Michelangelo and Raphael. S. T. COLERIDGE, *General Character of the Gothic Mind in the Middle Ages*, 1818

He has never been surpassed in the greatness and truth of his conceptions, nor in the close-knit and sustained unity he achieved whether in a single picture or a series of pictures. J. D. PASSAVANT, *Ansichten über die bildenden Künste . . . in Toscana*, 1820

While paying due credit to Dante for his great qualities of mind and heart, we shall find it much easier to appreciate his works if we remember that in his day, which was also that of Giotto, there was a revival of interest in the portrayal of nature and life in figurative art. Dante, too, was preoccupied with this new concern for the physico-imaginative element. He therefore saw things so clearly with the eye of his imagination that he was able to give them a distinct and definite outline in his poetry. . . . W. GOETHE, *Dante (Italienische Litteratur)*, 1826

. . . Though it may not be true to say that he abandoned it completely, he at least moved away from the tendency of his predecessors to portray sacred and divine subjects in an elevated style. Instead, he turned Italian painting towards the expression of actions and feelings in which, as in the essence of monachism, the humorous is given a place alongside the pathetic. . . . In view of all this, I do not know quite what certain people are aiming at when they do all in their power to boost Giotto's influence and work as representing the culminating point of the new art. C. F. RUMOHR, *Italienische Forschungen*, 1827

Giotto introduced innovations into the methods of mixing colours hitherto used and he also altered both the concept of and the whole approach to pictorial representation. He was interested in the present moment and in reality; and the figures and emotions which he portrayed were, in a sense, a commentary on the life which was going on around him. By a happy coincidence, these tendencies in Giotto came to the fore at a time when customs became more liberal and life, on the whole, rather more gay than of old, and when devotion first blossomed to a number of new saints who had lived and died not very long before the artist's own day. Prompted as he was by his interest in the immediate present, it was these very saints who exercised a particular attraction for Giotto. The content of his painting thus implied the depicting of real people and the portrayal of actual personages, actions, passions, situations, attitudes and gestures. This emphasis thus tended rather to obscure the element of grandiose and sacred austerity which had constituted the essence of all the best examples of art up to his own day. The worldly was given a place in painting and, once admitted, it tended more and more to gain ground; moreover, in accordance with the spirit of his age, even Giotto was prepared to portray the humorous alongside the pathetic. G. G. F. HEGEL, *Vorlesung über die Aesthetik*, 1829

Giotto's works seem to me to be full of life and perhaps even grandiose, but I do not find them graceful. J. G. QUANDT, *Geschichte der Malerei in Italien . . . von L. Lanzi*, 1830

The earliest age in the history of art was rendered luminous by a number of great men, chief among whom was Giotto, who surpassed all the others, and his school. What kind of light shone in that age? The light which is the wellspring of all art, one might even say the soul of art: namely the true and accurate portrayal of human passions and emotions. Not only is the essence of this expression conveyed both vividly and fittingly; what is more, it is reduced to a unity and a peak of simplicity which has never been surpassed either in earlier ages by the Greeks or in later times by Leonardo and Raphael. Let anyone who questions the validity of this contention go to Assisi or Florence, where the works of Giotto and others of his time are to be found, and see for himself. T. MINARDI, *Delle qualità essenziali della pittura italiana*, 1834

Greek simplicity in composition; economy of means, which makes for the grandiose and for immediate impact; clear expression of the strongest and most varied emotions, with no exaggeration; and so the artist never stretched the legs of his figures into impossible strides, made them raise their arms too high or strike heroic and theatrical attitudes with indecent gesticulations. His drawing is far behind that of the fifteenth-century artists; but in his draped figures there is a symmetry and a rightness of proportion which can stand almost any comparison. In the outline of his figures, he keeps the greatest possible simplicity, making judicious use of right-angles. To avoid harshness, he ingeniously alternates straight lines with curves, though he always avoids the kind of wavy lines which make for triviality or mannerism. He aims principally at capturing the movement of each figure in as few lines as possible. He combines a keen observation of reality with geometrical elegance of sines and angles, in attitudes which are always majestic, natural, suited to the character of the figure, his movement and the surrounding space. . . . He knows how to concentrate masses of light to the best effect, skilfully off-setting the dark areas by a carefully placed change of tone; he never fails to retain a quality of grandeur in the grouping of the individual figures and is careful never to break them up or complicate them with a fussy use of half tones. . . . He often adds to the elegance of his compositions by introducing the most charming pieces of architecture, in the mixture of Arabic, Byzantine and Gothic styles so common in Italy in his day. Although he did not know in detail the rules of perspective, he had a working knowledge of, or rather an instinctive feeling for them. . . . He was at his best in treating religious themes rather than historical or domestic subjects. P. E. SELVATICO, *Scritti d'arte*, 1836

... beauty only occurs at a certain moment, namely between the thirteenth and fifteenth centuries; Giotto and, I think, Perugino, represent its peak.   E. DELACROIX, *Journal*, 1853

It was not on account of his greater learning, nor was it thanks to the discovery of new theories of art, nor because of his superior taste, nor yet by means of 'ideal' principles of selection that (Giotto) became the leader of the progressive schools in Italy. It was simply because he took an interest in what went on around him, because he discarded conventional attitudes and portrayed instead the movements and gestures of living men: because he substituted for the stylised circumstances of artistic convention the events of everyday life that he achieved greatness and became the master of other great artists.   J. RUSKIN, *Giotto and his Works in Padua*, 1854

Personally. I would be inclined to describe this work (the 'Cappellone degli Spagnuoli' in Florence, containing frescoes by Andrea di Buonaiuto) as the finest monument of medieval Christian painting. In spite of Giotto's astonishing aptitude for portrayals of this type, neither he nor any of his many followers has left us anything comparable to this chapel. It is indeed the masterpiece of Christian symbolism.... This felicitous combination of grace and majesty (originated by Duccio) with all the elements of the traditional style gives us something far superior to the semi-Byzantine efforts of the thirteenth century and the prosaic Madonnas which the naturalist, Giotto, was then beginning to model on the burghers of Florence.   A. F. RIO, *L'art chrétien*, 1861

Viewed from afar, Giotto gives the impression of being a barbarian devoid of skill; in fact he proves to be a fully accomplished painter. Nevertheless, this great-hearted genius did not, indeed could not, possess the kind of scientific knowledge which can only be acquired over the centuries. For this reason, his execution is coarse, his drawing too hasty and lacking in precision. Had Giotto had any forerunners, the world would have gained a second Raphael....   H. TAINE, *Voyage en Italie*, 1866

In place of the rigid, stilted grandeur of earlier paintings (which may have been impressive but which remained as obscure and incomprehensible as a speech in a foreign language), Giotto gives us figures which clearly betray their own emotions. Men of flesh and blood with whom the onlooker can feel an affinity and in whom the artist expresses his own ethnic sentiments. For the first time, art is seen to speak the language of the country....   C. SCHNAASE, *Geschichte der bildenden Künste im Mittelalter*, 1876

The first Italian, the first Christian, to arrive at some kind of understanding of the virtues of domestic and monastic life and to portray them for the benefit of all and sundry – from the prince to the shepherd, from the wisest philosopher to an untaught child.   J. RUSKIN, *Mornings in Florence*, 1877

... it fell to Giotto and, after him, to Giovanni Pisano, to express in art the new concrete religious conception of the poets and of the Franciscan preachers.   H. THODE, *Franz von Assisi*, 1885

As far as technique is concerned, there are very few modern painters who are inferior to Giotto; but I know of none whose works affect me as deeply as do Giotto's. How is it that the moderns, who are so very superior to him, are nonetheless so very far behind him? There can be no doubt that the mood of the times has a great deal to do with it; because, although Giotto was a great painter, there are painters alive today who could be equally great if they would only dare to express themselves with Giotto's clarity and naturalness.   S. BUTLER, *Note Books*, 1890ca

The fact is that Giotto and Cimabue, like Holbein, lived in a civilization which was very much like a pyramid, with an architecturally designed inner framework in which each individual was a stone and all together formed a monumental society. We, on the contrary, live in anarchical chaos; we artists who love order and symmetry are completely isolated.   V. VAN GOGH, *Lettres à Emile Bernard*, 1890

This, then, is Giotto's claim to everlasting appreciation as an artist: that this thorough-going sense for the significant in the visible world enabled him so to represent things that we realize his representations more quickly and more completely than we should realize the things themselves, thus giving us that confirmation of our sense of capacity which is so great a source of pleasure.   B. BERENSON, *The Florentine Painters of the Renaissance*, 1896

He was not an impetuous dreamer, but a man with his feet on the ground; he was not given to lyrical flights of fancy, but was an observer of all things; an artist who was never carried away by the mood of the moment, but whose art always spoke clearly and expressively.   H. WOELFFLIN, *Die klassische Kunst*, 1899

Giotto did not possess Cimabue's emotional temperament nor his penchant for dramatic effect. In Giotto, everything is calmer, clearer. Though he possessed the ability to convey the maximum dramatic effect in some scenes, his talent was very much more of the 'epic' variety. In this sense, Cimabue is to Giotto what Michelangelo is to Raphael.   U. G. G. ZIMMERMANN, *Giotto*, 1899

Giotto is the greatest minstrel in the language of lines, the world's supreme epic painter.... (He gained much) from having lived in an age when the magnifying and mythical/poetical effect which for us only comes with the passage of time, made itself felt at once, so that his own contemporaries are magnified to gigantic and heroic proportions.   R. FRY, *The Monthly Review*, 1901

His poetry is no longer a liturgical hymn; it is the poetry of Dante. Like Dante, Giotto retains all the vitality of ideal inherited from the past while, at the same time, he opens the door to the new reality. His aim is to create a harmony between idealism and realism. His idealism enables him to capture reality with an immediacy which has never been repeated. His realism brings the divine down to earth, in the midst of men, instead of leaving it in solitary splendour in shrines and temples, so to speak, as had been the case in the past. Not only is his form

plastic, but it serves to emphasize the structures of his composition. His colour schemes are novel, intense and daring, even though their primary purpose is to throw the form into relief.
A. VENTURI, *Storia dell'arte italiana*, 1907

Beauty in Giotto is full of that fascinating and vigorous ingenuity which makes us sense with a new freshness the far-reaching and vital relationship between art and nature. . . . Giotto's narratives are like an architectural structure. Each element has been carefully assessed and each has been incorporated into the overall design in such a way as to ensure that its objective significance determines both the mode and the measure of its rhythmic function. . . . Giotto does not see the separate sections merely as the various stages of a single event, but rather as factors which all work together to bring out the specific significance of symbolism and thought in the event illustrated. Throughout the centuries, this principle has tended to introduce a number of false values into art, though it is on this very principle that the strength of Italian painting as a whole and of Giotto's own painting in particular in fact rests. It is this principle which is the source of the absolute assurance, vigorous energy and supreme epic inspiration with which all his works are imbued.
F. RINTELEN, *Giotto und die Giotto-Apokryphen*, 1912

Cimabue's art possessed the kind of rhythm St Francis displayed in his verse. But Giotto's art is set to the kind of metre of which Dante was such a consummate master. MOELLER VAN DEN BRUCK, *Die Italienische Schönheit*, 1913

Later I realized that the special quality that strikes one about these frescoes (Allegories of the Virtues and Vices in the Scrovegni Chapel), their extraordinary beauty, was due to the great part played in them by the symbol: the thought symbolized is not expressed; rather its reality as actually experienced or materially felt renders the meaning of the work more literal and more precise, conveying its admonition in terms which are peculiarly concrete and impressive. M. PROUST, *Du côté de chez Swann*, 1913

The style of his figures is essentially sculptural. In most cases, they stand out in sharp relief against the background; the outlines are unbroken; the forms are solid, never cluttered up with unnecessary detail. The clearly defined graduated planes give a sense of the third dimension rather as in bas-reliefs. As a painter-cum-sculptor, Giotto is the first of a long line of typically Florentine artists who, throughout the Renaissance, formed the backbone of the Florentine tradition. O. SIREN, *Giotto and some of his Followers*, 1917

Any closer harmony between the figure and the background would have been a source of distraction. Any greater precision of plastic effect would have made the human image somewhat material. Any further accentuation of line would have robbed the human image of its reality. Any richer use of colour would have impaired the precision of each figure. Less architectural stiffness of composition would probably have resulted in magnificent details, but would at the same time have depreciated the overall warmth of the creation. The harmony of all these

elements, which is knitted into the fusion of line and plastic plane, enables Giotto to convey with iron logic in a very small space the ideal of which he first dreamed and the reality which he then studied. L. VENTURI, *L'arte*, 1919

Structural unity is the characteristic feature of Giotto's genius as, indeed, of all creative genius. Like the pupil in a human eye, reality sparkles in the particular form given to it by Giotto. The Christian idea passes from the abstract to the concrete in the form given to it by Giotto, namely an idea of form. Form and idea illuminate each other. This explains the indestructible unity of these paintings (in Padua). C. CARRÀ, *Giotto*, 1924

In you, Cimabue, there are faith, doctrine and will power. In me, all these fine things suddenly give in without a struggle and Memory sweeps the field. Memory uses me in order to portray everything which comes to her, the only freedom left to me being that of deciding how best to arrange the details. . . . I need to plumb my subject to its depths. So I forget the rules and it does not even matter if the thing which has taken my fancy is no longer visible, because I go on seeing it and I can almost feel it coming at me even in the dark! . . . I cannot prevent my eyes from looking – with an earnestness for which you castigate me – at all the lovely things of this world for which they yearn and long all the time, so much so that when one of these things is taken away from me, every other desire and every other resolution falls to the ground. A. BALDINI, *Dialogo di Giotto e Cimabue*, La Ronda, 1919

In Giotto and his school, the individual forms are placed as it were in plastic isolation within the compositional tension. The depicting of the episode is divided into primary and secondary action. The primary action is enclosed between the converging diagonals of the central pyramid; the secondary seems to take place at a moment dramatically distinct from the more acute emotive climax in the centre of the composition and is confined to upright figures on either side, which strengthen the composition itself by means of their bulk and verticality. R. OFFNER, *Studies in Florentine Painting*, 1927

The difference between the richness of Giotto's inspiration and that of other artists lies in the fact that he was able to repeat the same theme in a number of works without appearing to handle it in an ephemeral or facile fashion. Every one of his works is a solid construction and perfect as an example of the stage of development attained by the artist at the time of its execution. The *raison d'être* and secret wellspring of Giotto's fecundity lie in his ability to confine each expression within itself, so that the artist was always able to renew his creation with a new approach and with complete detachment. The tranquillity with which each conclusion is reached, the very energy with which Giotto completes each picture, leave the way open for renewal and therefore also for a new creation. G. L. LUZZATTO, *L'arte di Giotto*, 1928

Cézanne clearly owes much not only to the Venetians, but to the whole volumetric tradition in Italy, ranging from its supreme source, Giotto, that titanic builder of polyhedric masses, to Masaccio who carved his figures against a background of

massive blocks of chiaroscuro.   M. TINTI, Pinacotheca, 1929

The more one looks at these frescoes (in Padua), the more one is overwhelmed by the greatness of the artist whose innate genius enabled him – at a time when idealism reigned almost supreme in thirteenth-century art – to bring art into the reality of every-day life and human emotions, and to express himself in forms and by means of a technique which, even at that early date, came very close to classic perfection.   C. GAMBA, *Giotto*, 1930

Reality! With intrepid step, Giotto advanced as far as the walls of this citadel. Indeed, he pushed open the door and looked inside to see what was there, got a general impression of what lay beyond, but did not cross the threshold. . . . Giotto is acquainted with reality; but acquaintanceship is not love. Indeed, his art reigns supreme between the old love and the new knowledge precisely because he unites them both and excels both in an adamantine synthesis in which the aspiration to the divine thrills with a human pulse, the trend of medieval art is married to the trend of humanistic art, which may be said to have been sensed prophetically by Giotto. Precursor, prophet, torch-bearer: he is all these, while remaining a man of the old dispensation, lighting the way for those who come after him.
L. COLETTI, *L'arte di Tomaso da Modena*, 1933

Giotto, like Cimabue, has certain affinities with the Roman school of mosaic artists. However, his personal contribution, which in itself is enough to justify the esteem in which he is held, lay in the fact that, while taking over some of the conventions current in his day, he introduced a grandiose simplicity of conception, a hitherto unknown depth of pathos in expression and a balance between the spiritual and the sensuous, between nature and thought, which were inherited by those who came after him. For this reason, this first painter of genius in the order of time was a true precursor of modern art.   P. JAMOT, *Exposition de l'Art Italien*, Petit Palais, Paris, 1935

The profound and poetic humanity of St Francis, whose feeling that the brotherhood of all things sprang from the universal responsibility for human frailty found expression in a form which was more lyrical than mystical, was viewed by Giotto with a clarity which was in no way clouded or obscured by mystical or apocalyptic overtones. Giotto gazed at the saint and saw the man. This sense of human dignity, which is such a prominent feature of Giotto's work, may be seen (in Assisi) as much in the Master's disregard of the established pattern of anecdote and iconography which had already been built up around the saint, as in his refusal to include certain details. His St Francis is not the emaciated and ascetic hero of Bonaventura Berlinghieri or Cimabue. . . . It follows that we are treated to no rapture, no sudden display of emotion, even in the *Miracle* scenes, in the *Stigmata* or in the Crucifix of S. Damiano. Instead, we find a consistent and inflexible reaching for a human and not merely naturalistic concreteness, which is transmuted into figurative concreteness once it has been endowed with a moral consciousness. Thus sanctity, seen as the peak of human dignity, is not presented as necessarily the fruit of hallucinations and fasting. Rather is sanctity humanity itself, in the Christian

social redemption of man who is a saint in so far as he is a man and not vice versa.   C. BRANDI, Le arti, 1938

Apart from considerations imposed by the need for clarity of narrative, Giotto's entire effort was directed to affirming the dignity of human destiny by means of the material significance of the human figure. This is emphasized by the unifying effect of an organic composition in which all the figures, being predominantly vertical and simplified in outline, are in immediate relation (either singly or in groups) with the side margins of the picture. On the same principle, the figures are arranged across the picture in a continuous row which also harmonizes with the horizontal margins. In this way, the composition approximates to a regular geometrical pattern which makes it fit naturally into the rectangular framework.   R. OFFNER, The Burlington Magazine, 1939

Giotto's powerfully dramatic compositions capture the action at the culminating point, which is very often the precise moment at which the representation may also hint at what has gone before and suggest the probable outcome. These compositions include only such details and protagonists as are absolutely essential while at the same time these very details are ideally subordinated to the figures, to the *action* portrayed.   P. TOESCA, *Giotto*, 1941

If you go and stand in the middle of the floor of the Chapel (Scrovegni), at the spot which affords the best vantage point for taking in at a single glance the wall which frames the archway leading to the apse, you will see at once with all the clarity and force of an illusion that the two painted areas (on the end wall) 'perforate' the wall and are designed as an integral part of the architecture of the edifice. This perfect illusion is conveyed by the converging of the two Gothic vaults on a single centre point which coincides with the axis of the church so that they seem to form part of the 'real' existential depth of the apse. This illusion is enhanced by the careful use of light in each of the two architectural structures in question in such a way that, in each case, the light is cast from a central point and falls in exactly opposite directions, even to the extent to which the pillars and piers of the mullioned lights are thrown into relief. A final ingredient in the illusion is the colour of the sky which is seen through the window to be not an 'abstract' ultramarine but a pale blue, in perfect harmony with the (real) colour of the sky seen through the windows of the apse. The cumulative effect is such that one almost expects to glimpse one or two of the swallows gliding past as they take off from the gutter of the Augustinian monastery nearby. . . .   R. LONGHI, Paragone, 1952

The old tradition . . . was on the right lines when it saw in Giotto's art a combination of great intellectuality and unsurpassed mastery of style with the almost ingenuous freshness and candour of one who is discovering and revealing the simplest truths. The task of the modern critic is to investigate and clarify the interdependence in truth and the mutual relationship of all these elements. It will then become apparent that this simplicity, born of elimination and a fully conscious choice, constitutes

ideally the culmination of a long and far-reaching spiritual evolution. It will be seen that the liberating force of his poetry could never have been so illuminating and powerful had it not been for that very wellspring and background of thought and reflection which, in Giotto, were deeper and wider than in any other artist of his time. We will realize that the essence of his rhythm of form lies as much in the innate rush of feeling as in the power which is exercised in imposing balance and limits on this very feeling.   C. GNUDI, *Giotto*, 1959

In Padua, ... there was no longer any need for the artist to insist on the sharpness of outline to which he had to have recourse in Assisi in order to contain the movement of the mass and at the same time emphasize the principal dramatic movements of the figures. The continuous modelling of the masses in close harmony with the plane in itself resolves all tension. The form is either gently curved or unmistakably clear cut on level planes; however, the device of making the figure stand out from the background by means of violent shading, which was used in Assisi, has here no place. The sense of drama is conveyed with greater force, though the overall atmosphere is one of greater peace and serenity. The masses are more massive, though nonetheless effective; the compositions tend to be more complex, but at the same time more compact and more closely knit together.... R. SALVINI, *Tutta la pittura di Giotto*, 1962

Only in Giotto does the spatial quality of the figure finally cease to be subordinated to the surface of the wall without any recourse to visual illusion or to psychological suggestion. His figures are coloured masses, and their handling is coordinated with the available space as defined by the architectural structures. The spatial treatment nevertheless retains its own autonomy of pictorial space, even when the scenes painted include structures which are not merely either fictitional or illusory but are in themselves pictorial facts or objects, such as figures, trees, rocks. G. C. ARGAN, Enciclopedia universale dell'arte, 1963

... Once again, there is a clarity of connection, a logical structure of composition, a conscious subordination of each and every secondary feature to the dramatic point of the narrative, which has wrongly been defined as classical. In fact, the narrative quality is peculiar to Giotto and springs from his complete identification with the predominantly lay and rationalistic mentality of the new bourgeois which came to the fore in his day. Though it is true that this love for clarity of discourse and logical structures never led him to a somewhat abstract form, this was only because he remained open to the ideas (available to him at every cultural encounter) suggested by the current popular 'romance' literature which was still very much in vogue particularly in the Po Valley, but also in Umbria. These ideas were themselves the fruit of a vast harvest reaped from a kind of probing of the reality of everyday life which was quite unknown to the classicist tradition of central and southern Italy. This was an experience which was anything but unwelcome to the Florentine who, though he described himself as an 'ancient', probably only did so in so far as he, like Dante, recognized the ancients as being the fathers of knowledge, and possessing the finest key to the interpretation of reality. But our Florentine cannot have been in any doubt that the reality in question was that of the contemporary world. His classicism, unlike that of Cimabue and his pupils, ... has no underlying current of nostalgia. G. PREVITALI, *Giotto*, 1964

The particular element which renders every sentiment absolute is his ability to convey a sense of profound awareness which is expressed in an ordered composition, clarity of theme and a 'monumentality' of touch. Gothic art in Giotto's day also displayed equally intense sentiments, the same kind of torment, dream and ecstasy. Nevertheless, it is this sense of awareness and of balance which, in Giotto, renders them more universal and, if possible, more eloquent. This is because, in Giotto, the whole is caught in a superior vision which sounds the supreme laws of the universe and so reveals the values of dignity and human liberty. C. SEMENZATO, *Giotto: la Cappella degli Scrovegni*, 1966

# The paintings in colour

## List of plates

*In the captions to the Plates, the actual width of the original or of the section of the work illustrated is given in centimetres.*

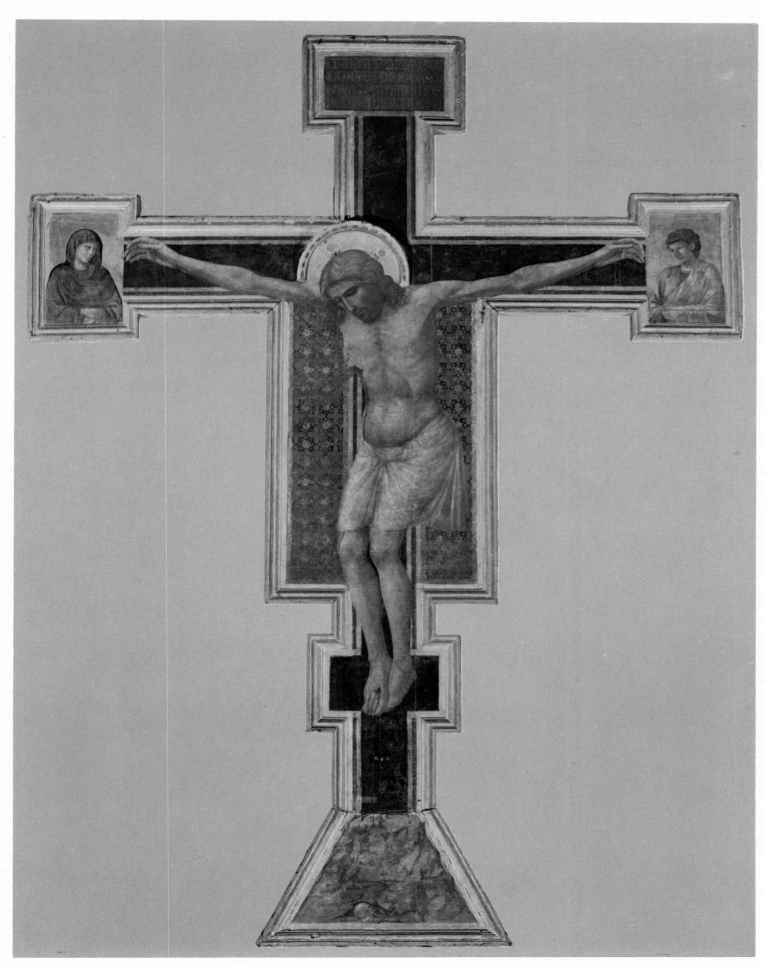

**PLATE I**     CRUCIFIX  Florence, Sta Maria Novella
Whole (406 cm.)

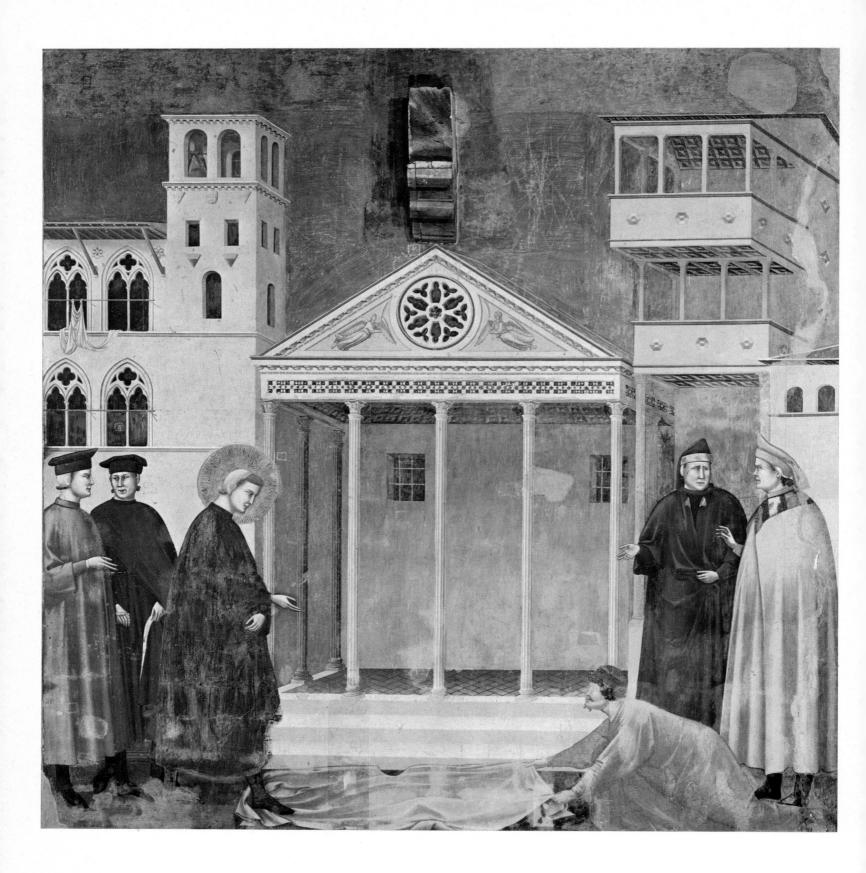

**PLATE II**     MAN IN THE STREET PAYS HOMAGE TO ST FRANCIS  Assisi, Upper Basilica
Whole (230 cm.)

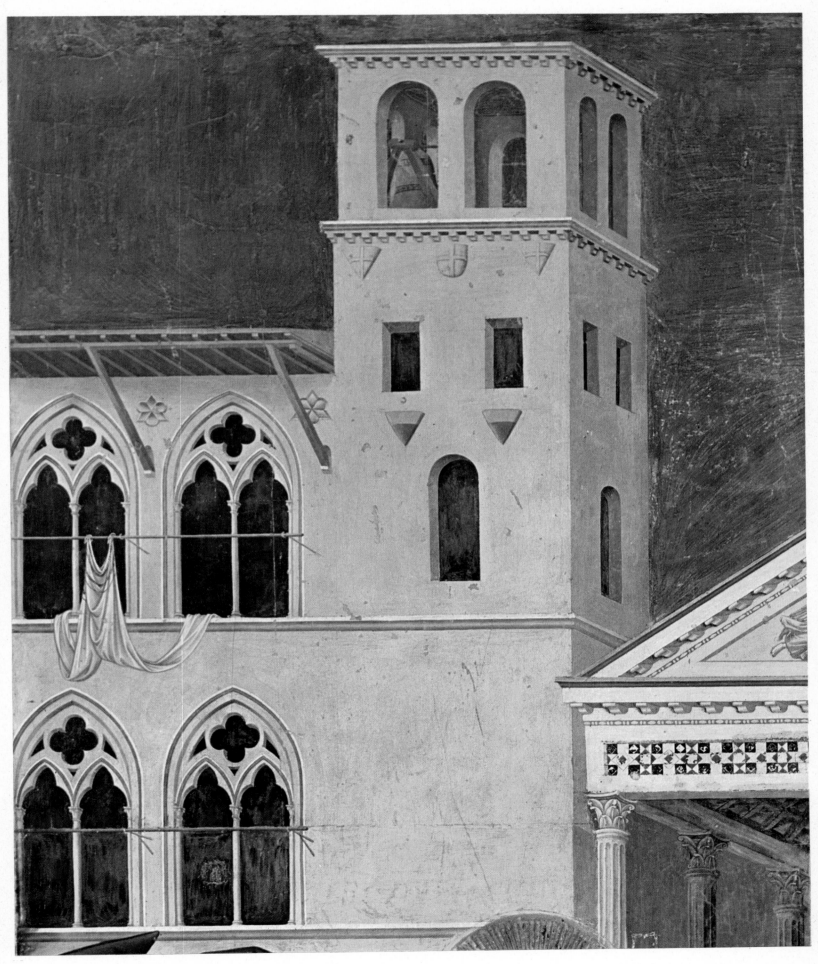

**PLATE III**    MAN IN THE STREET PAYS HOMAGE TO ST FRANCIS  Assisi, Upper Basilica
Detail (86.5 cm.)

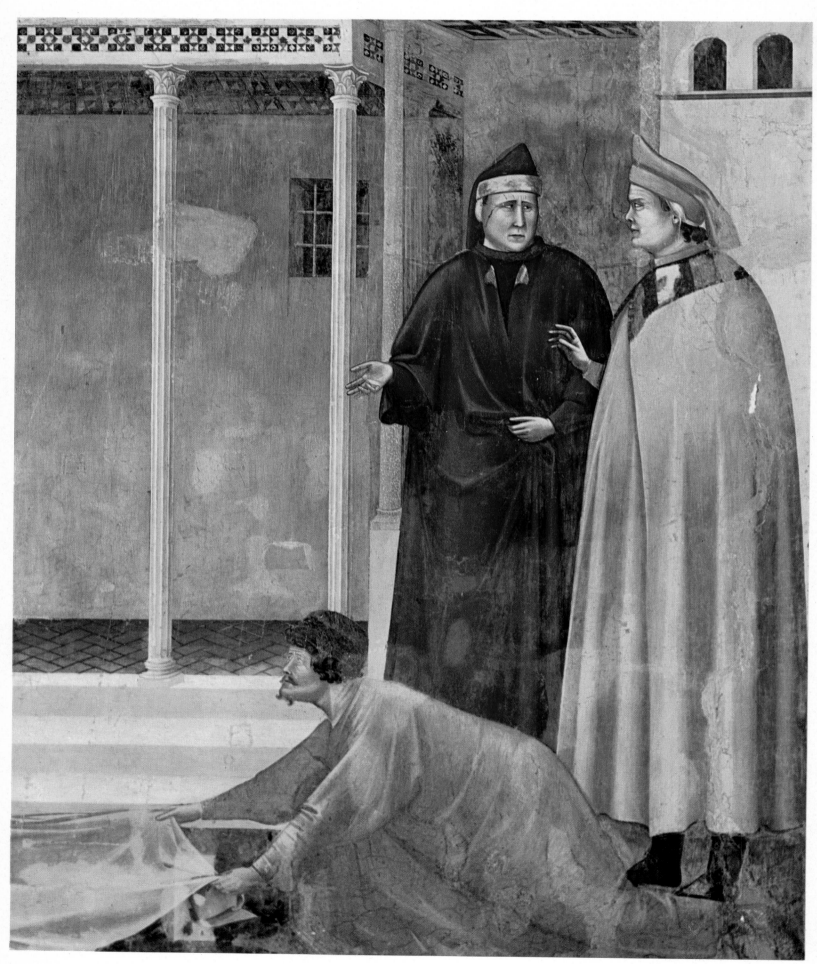

**PLATE IV**  MAN IN THE STREET PAYS HOMAGE TO ST FRANCIS  Assisi, Upper Basilica
Detail (110 cm.)

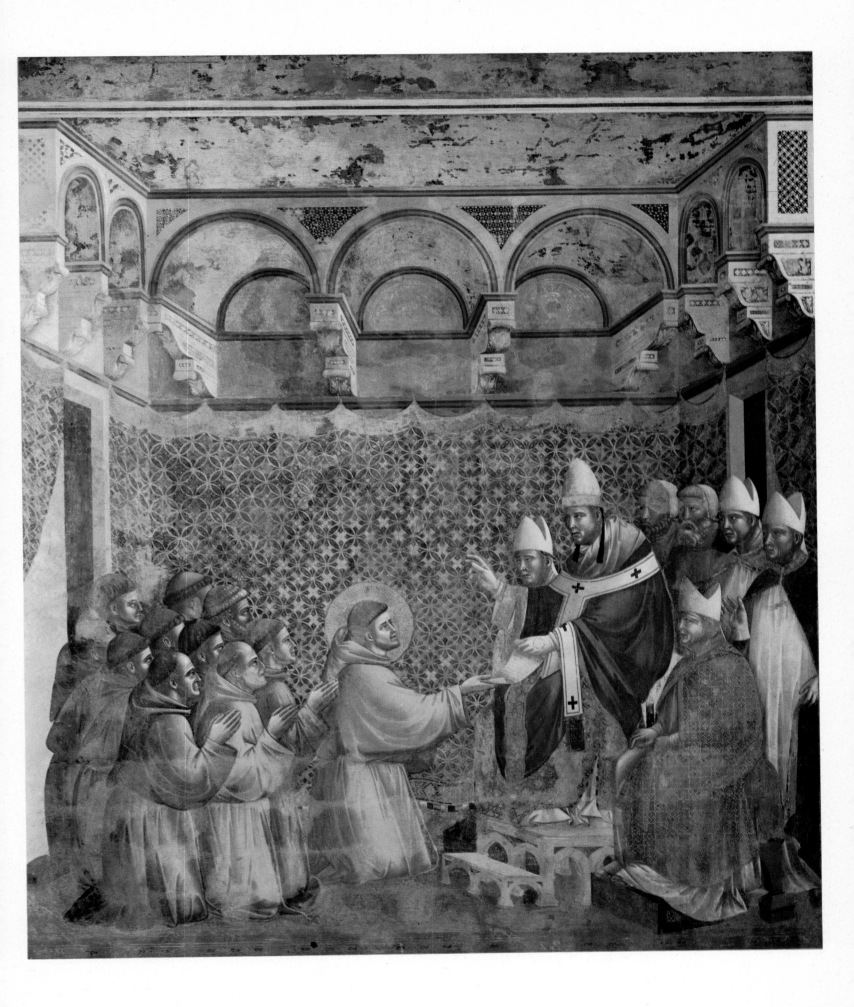

**PLATE V**  FRANCISCAN RULE APPROVED  Assisi, Upper Basilica
Whole (230 cm.)

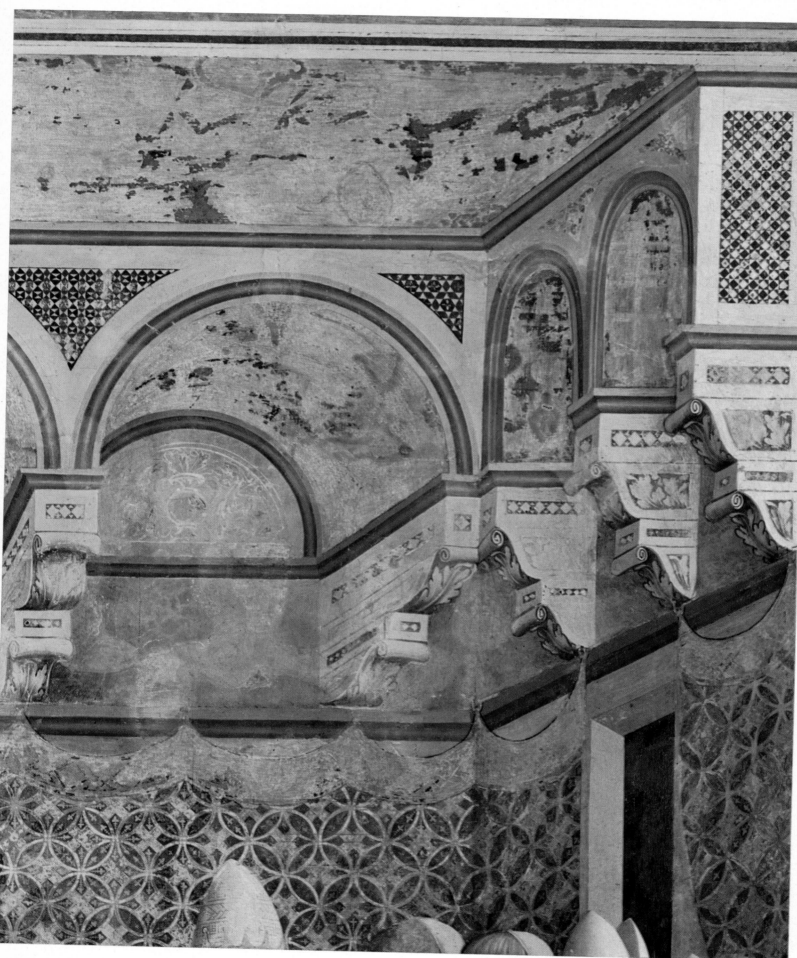

**PLATE VI**    FRANCISCAN RULE APPROVED  Assisi, Upper Basilica
Detail (99 cm.)

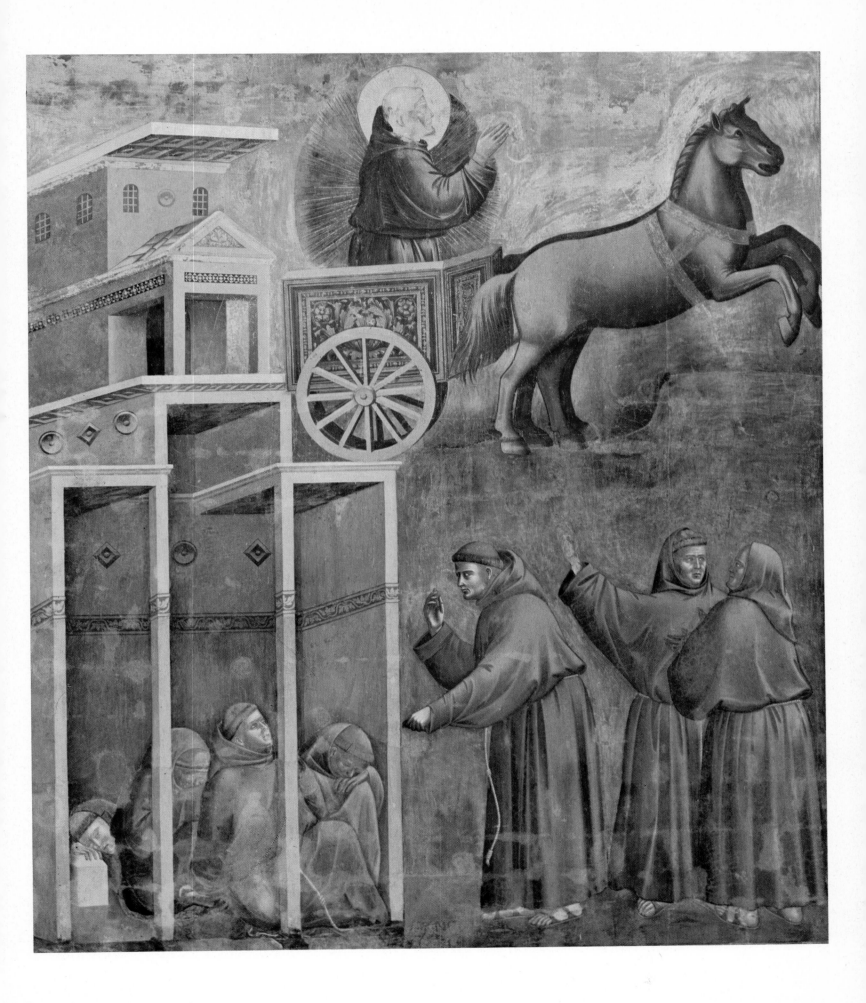

**PLATE VII**   VISION OF FIERY CHARIOT   Assisi, Upper Basilica
Whole (230 cm.)

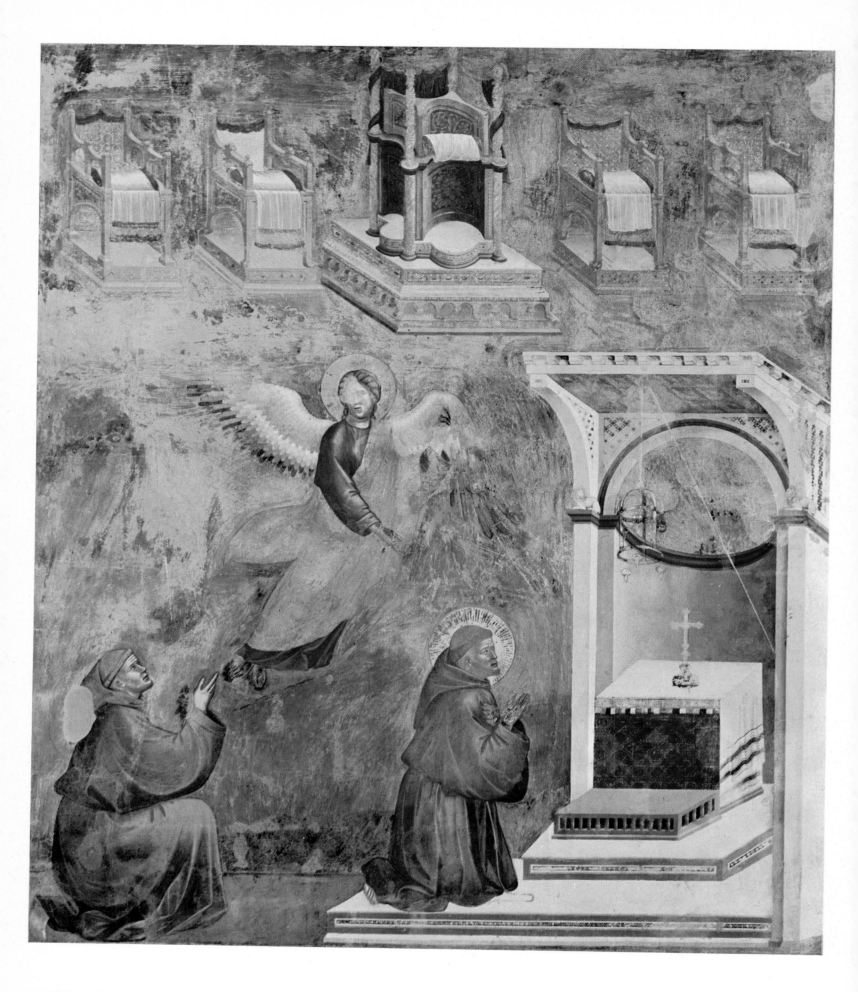

**PLATE VIII**   VISION OF THE THRONES  Assisi, Upper Basilica
Whole (230 cm.)

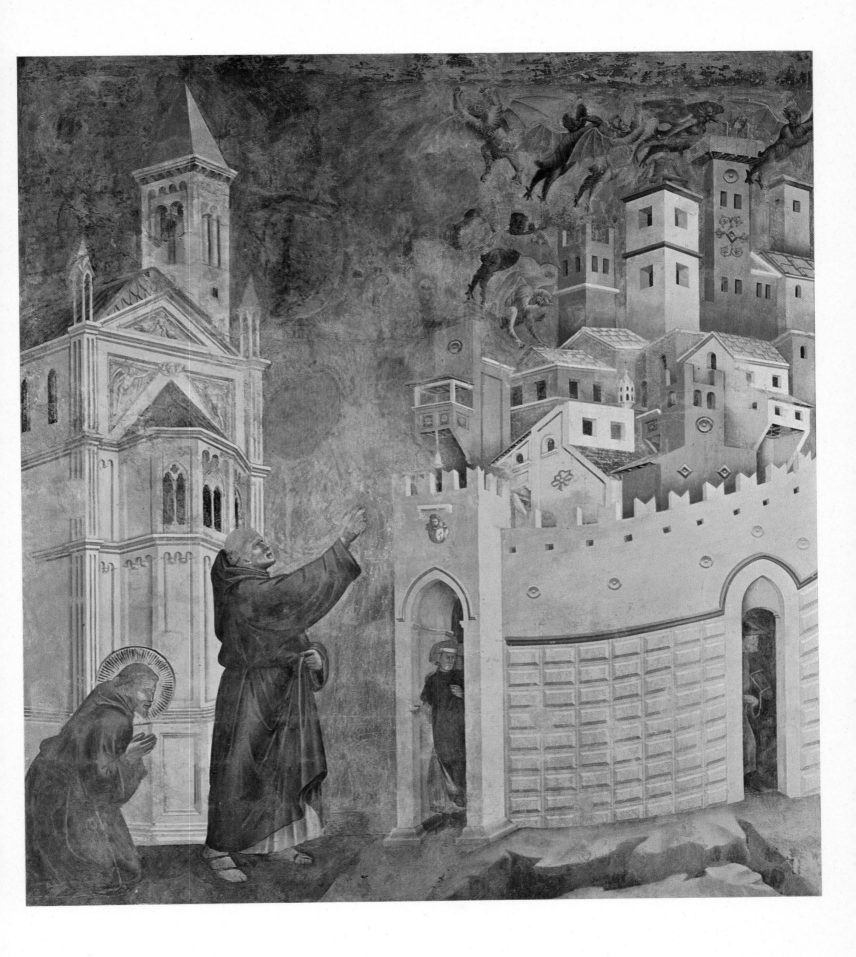

**PLATE IX**    DEVILS ARE DRIVEN OUT OF AREZZO  Assisi, Upper Basilica
Whole (230 cm.)

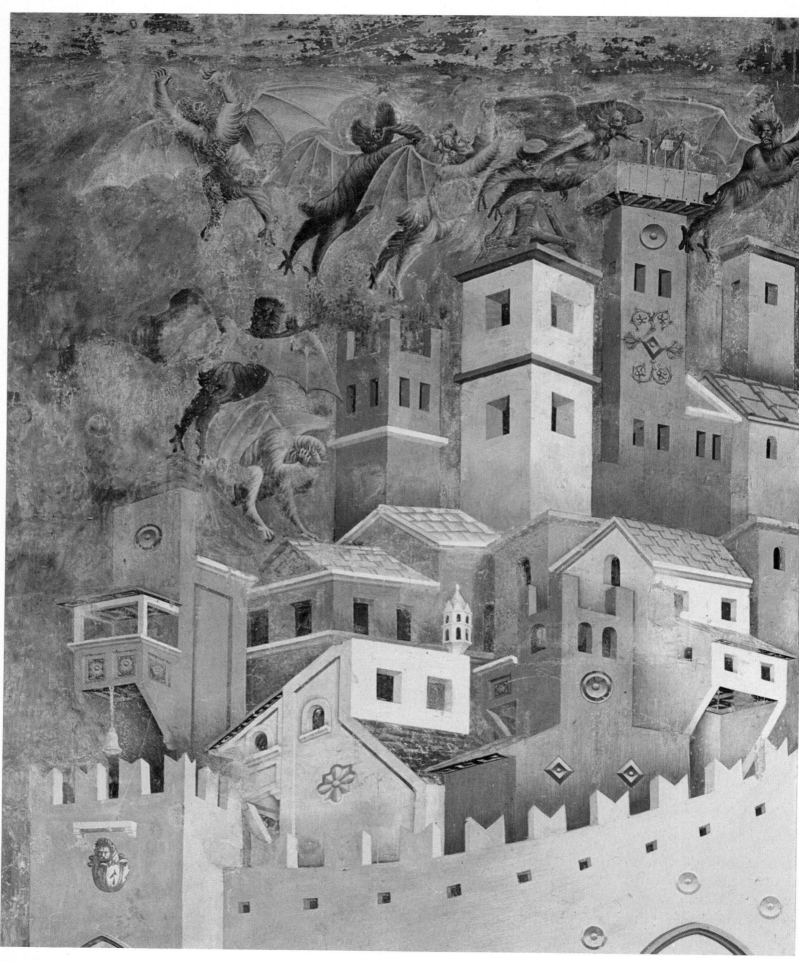

**PLATE X**     DEVILS ARE DRIVEN OUT OF AREZZO  Assisi, Upper Basilica
Detail (129 cm.)

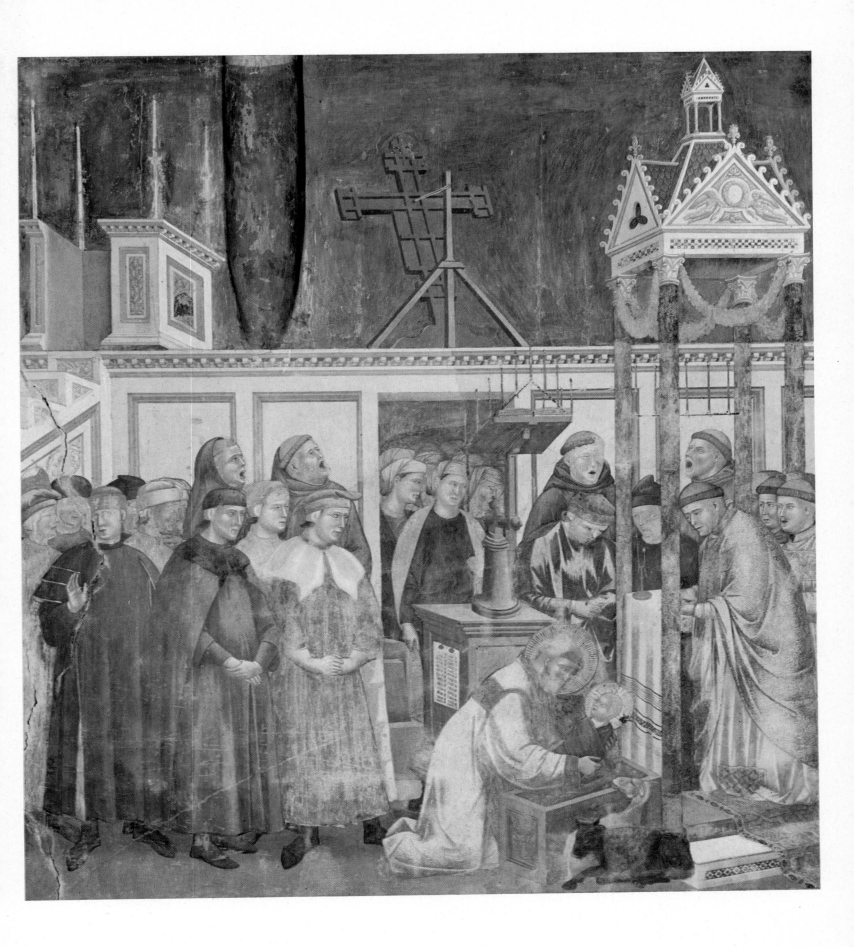

**PLATE XI**    CRIB AT GRECCIO  Assisi, Upper Basilica
Whole (230 cm.)

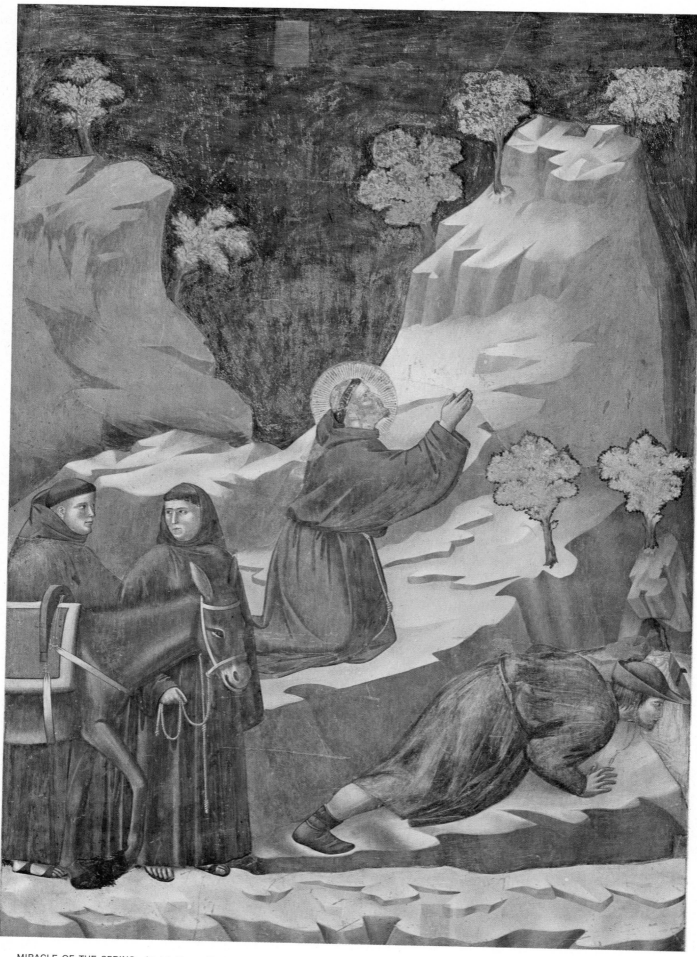

**PLATE XII**    MIRACLE OF THE SPRING  Assisi, Upper Basilica
Whole (200 cm.)

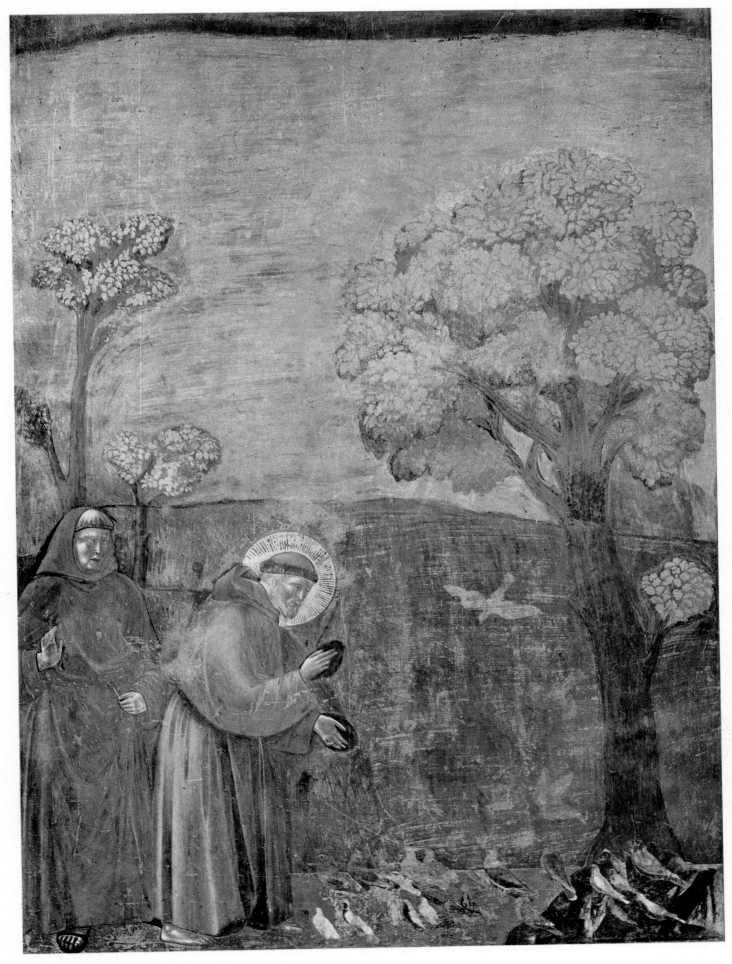

**PLATE XIII**    ST FRANCIS PREACHES TO THE BIRDS  Assisi, Upper Basilica
Whole (200 cm.)

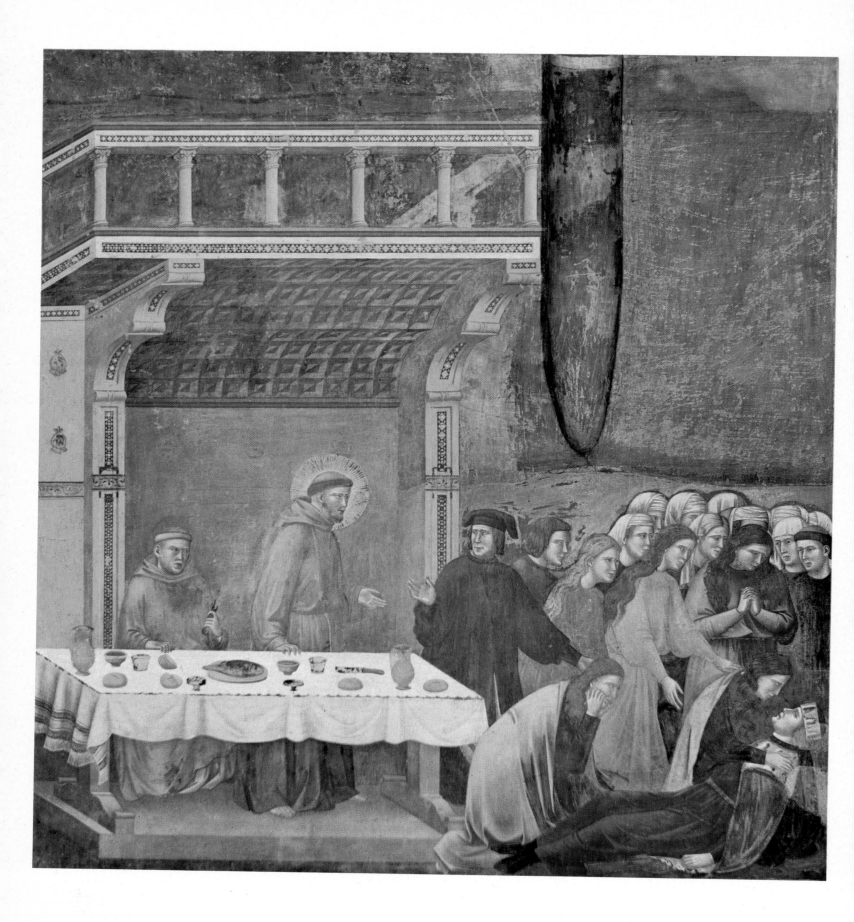

**PLATE XIV**    DEATH OF CAVALIERE DI CELANO  Assisi, Upper Basilica
Whole (230 cm.)

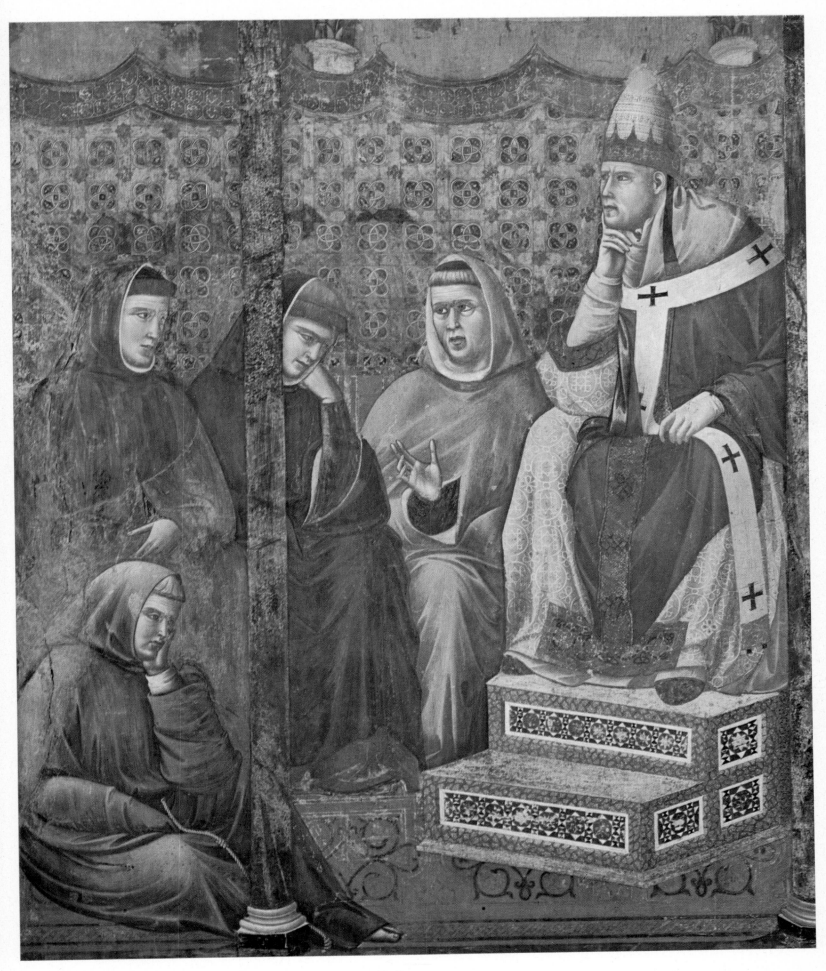

**PLATE XV**   ST FRANCIS PREACHES BEFORE HONORIUS III   Assisi, Upper Basilica
Detail (117.5 cm.)

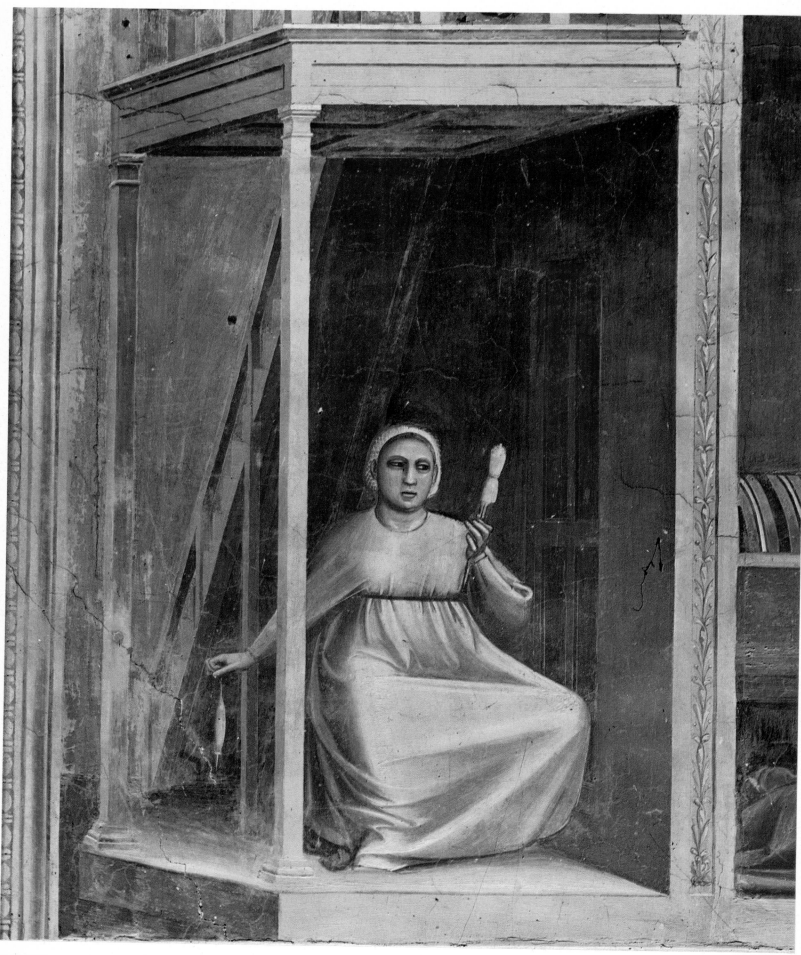

**PLATE XVI**    ANNUNCIATION TO ST ANNE   Padua, Scrovegni Chapel
Detail (89.5 cm.)

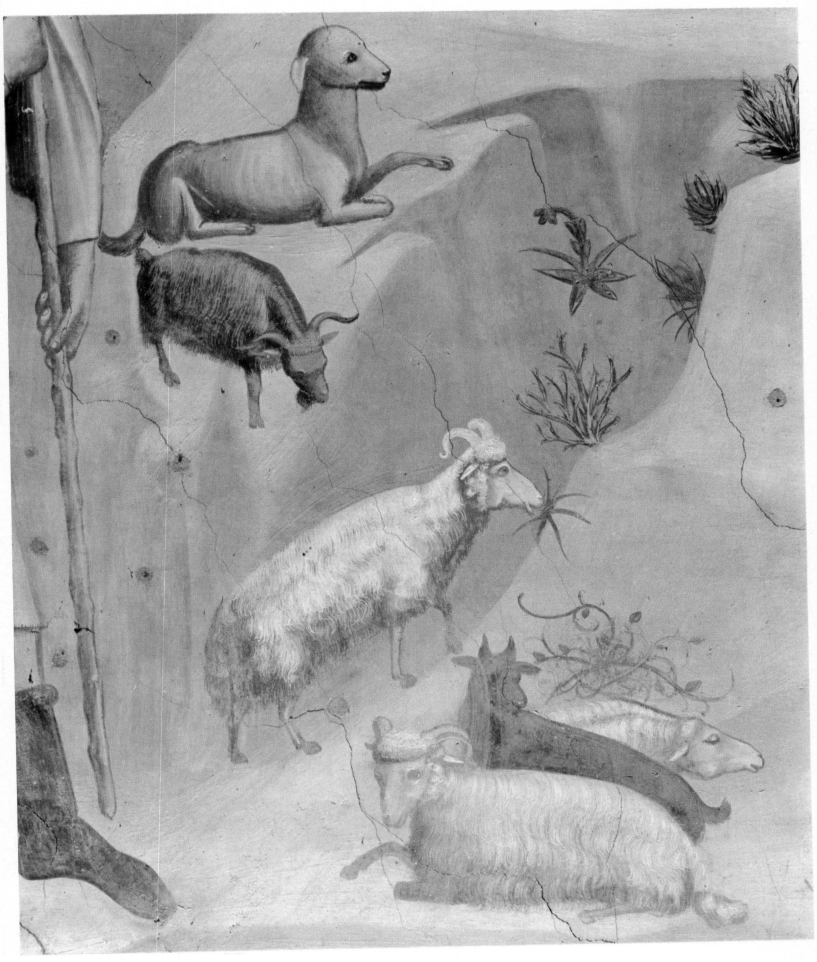

**PLATE XVII**   JOACHIM'S DREAM   Padua, Scrovegni Chapel
Detail (55 cm.)

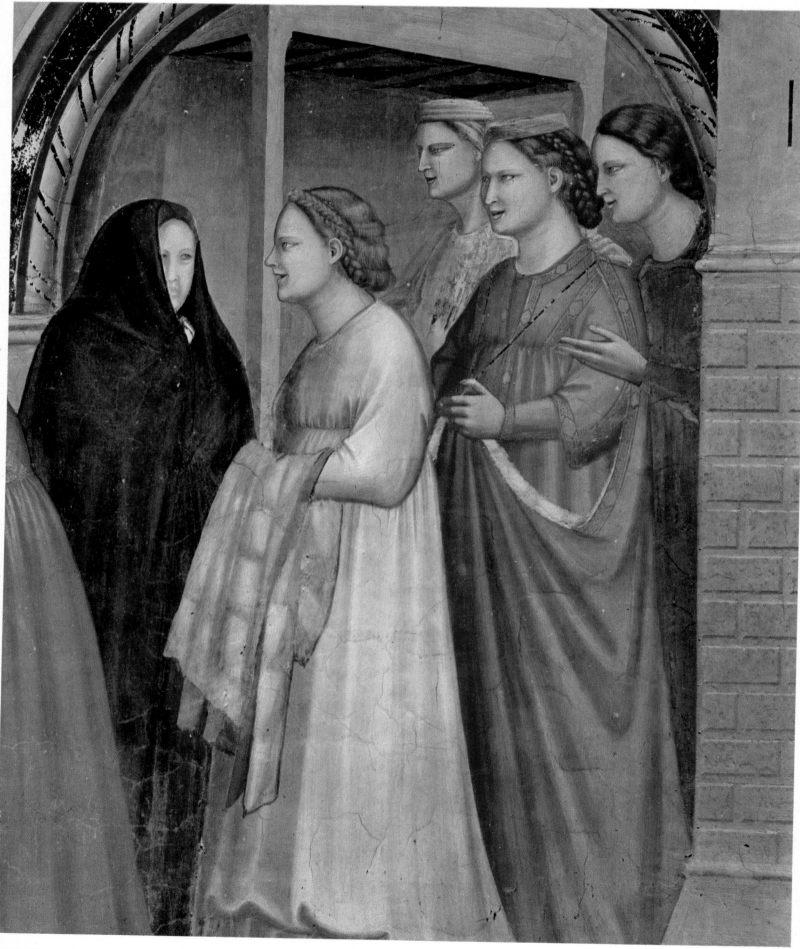

**PLATE XVIII**    MEETING AT THE GOLDEN GATE  Padua, Scrovegni Chapel
Detail (76.5 cm.)

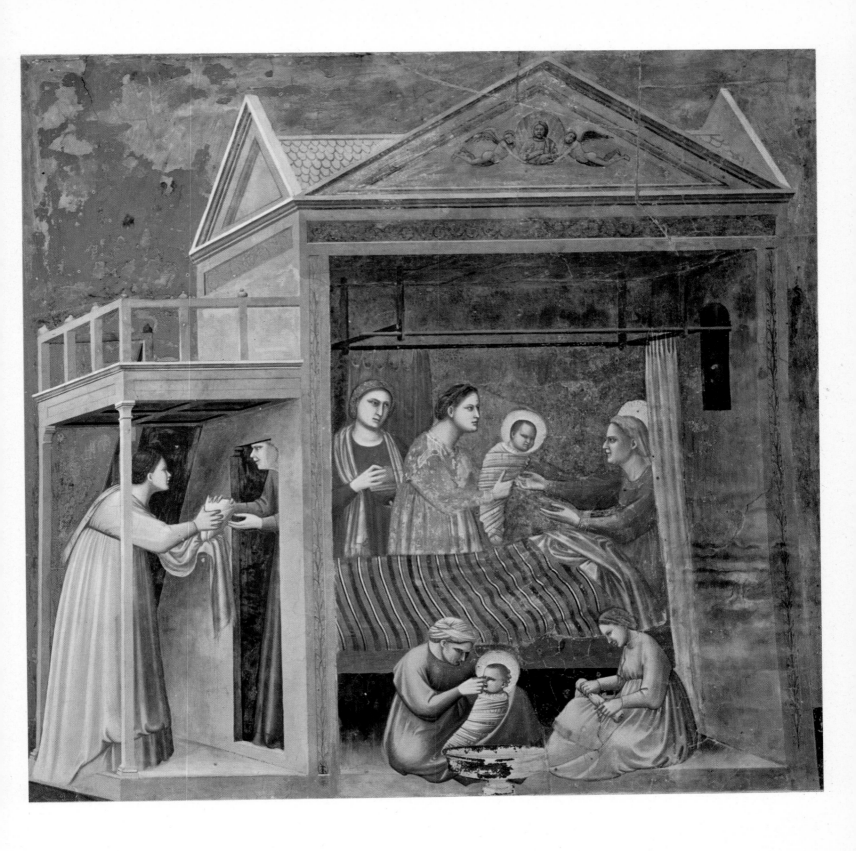

**PLATE XIX**    BIRTH OF THE MADONNA   Padua, Scrovegni Chapel
Whole (185 cm.)

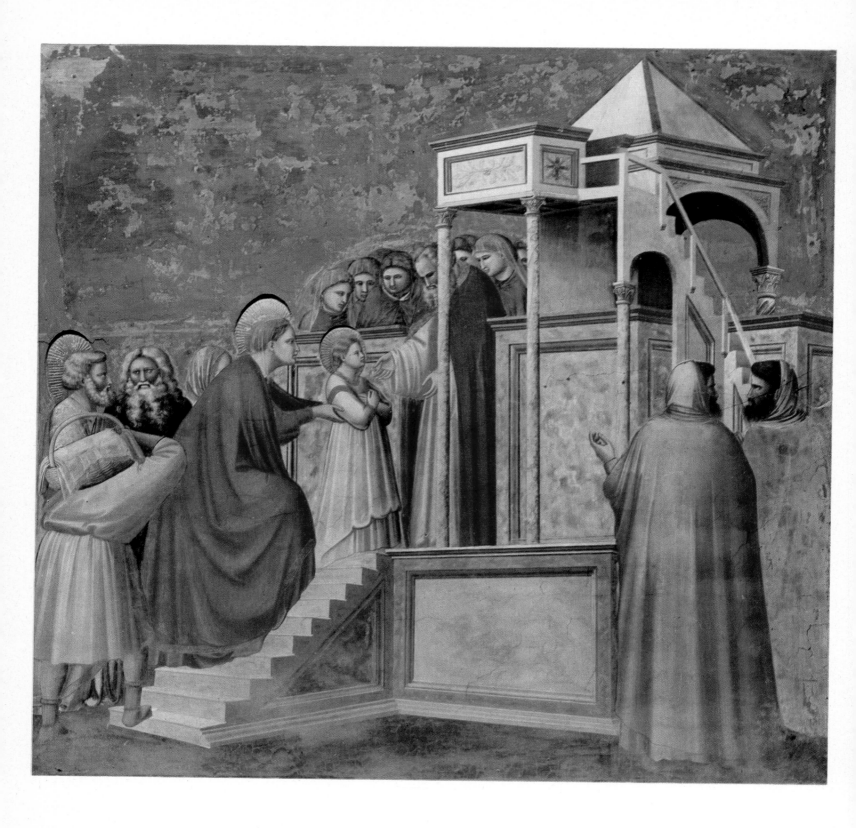

**PLATE XX**     PRESENTATION OF THE VIRGIN IN THE TEMPLE  Padua, Scrovegni Chapel
Whole (185 cm.)

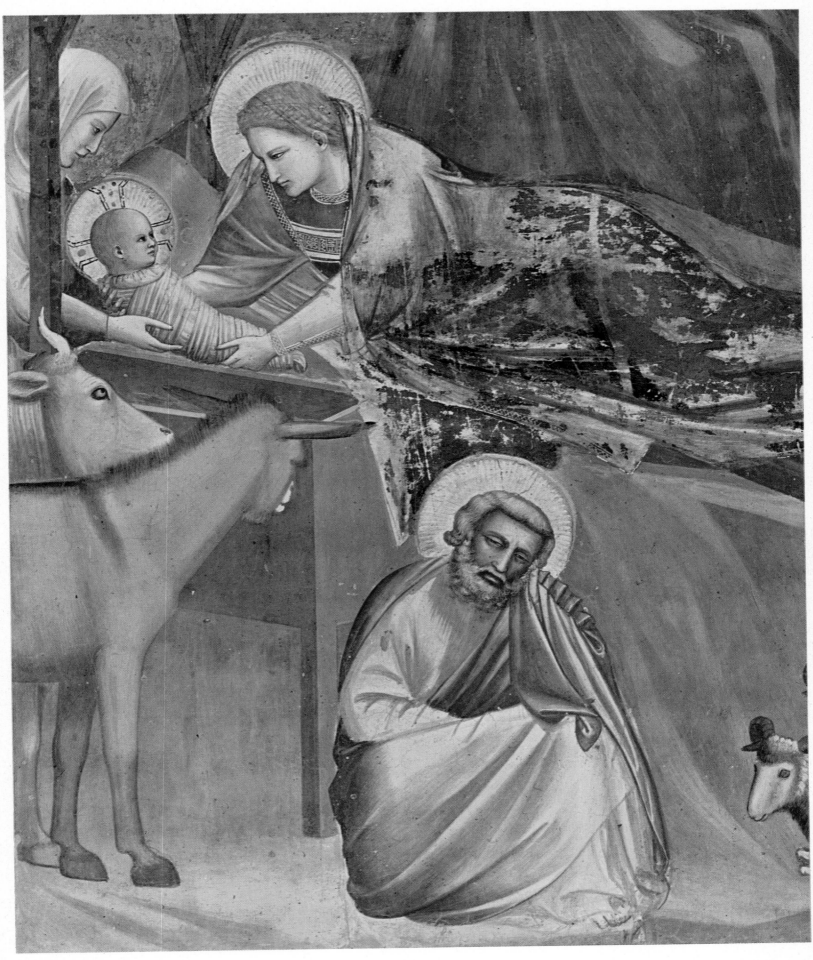

**PLATE XXI**   NATIVITY AND APPARITION TO THE SHEPHERDS   Padua, Scrovegni Chapel
Detail (100 cm.)

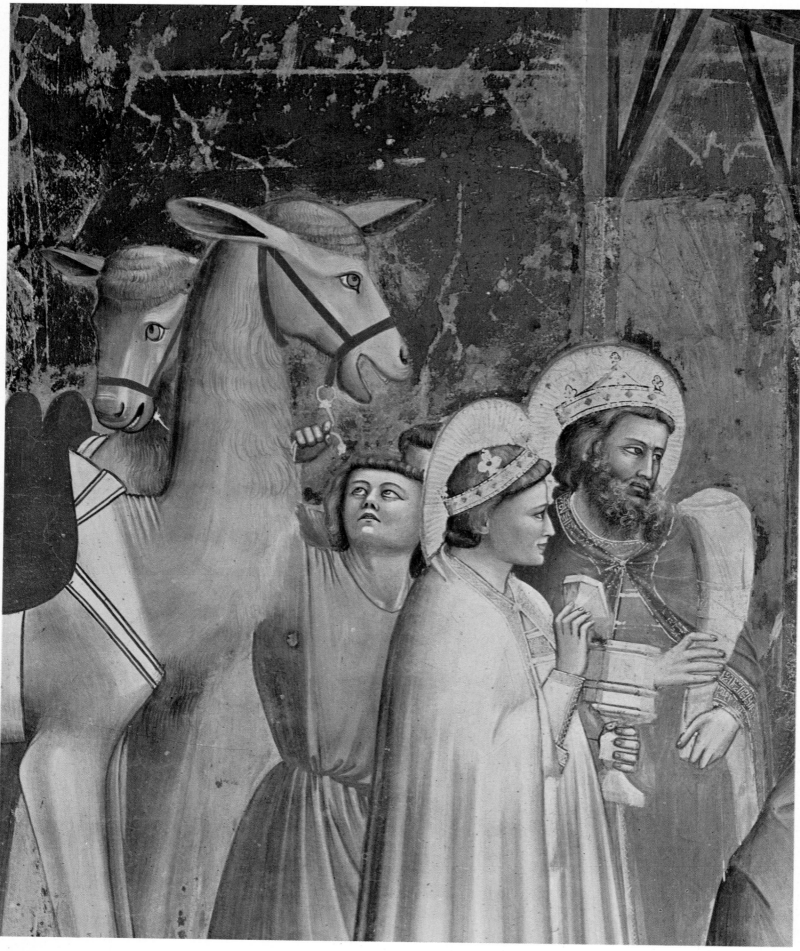

**PLATE XXII**    EPIPHANY  Padua, Scrovegni Chapel
Detail (89 cm.)

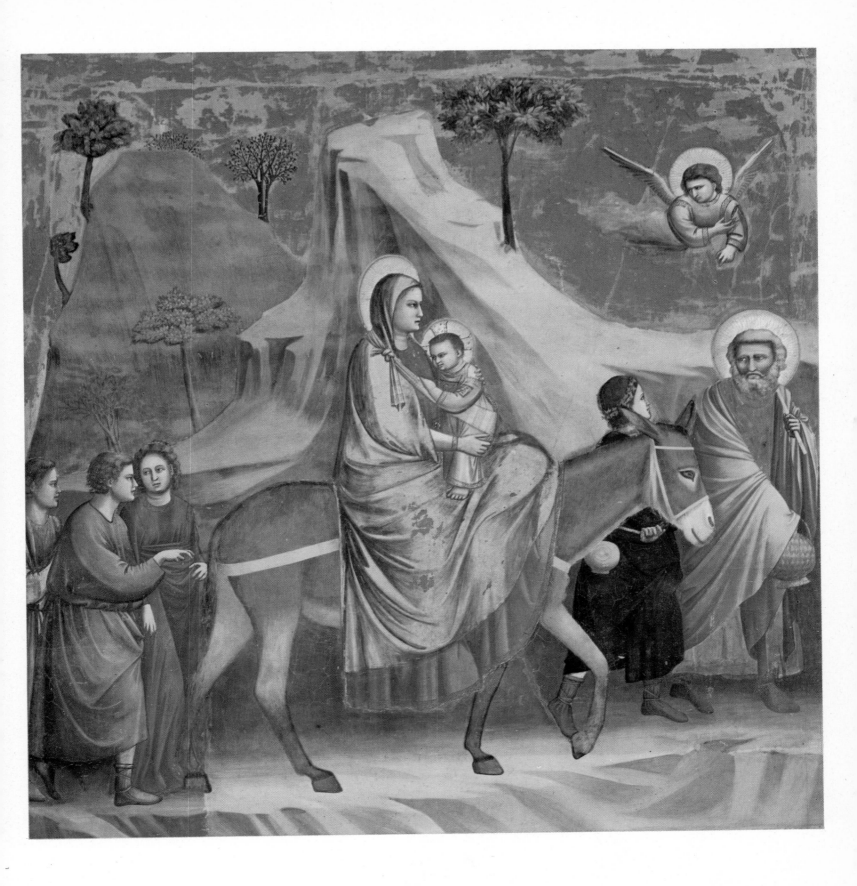

**PLATE XXIII**    FLIGHT INTO EGYPT  Padua, Scrovegni Chapel
Whole (185 cm.)

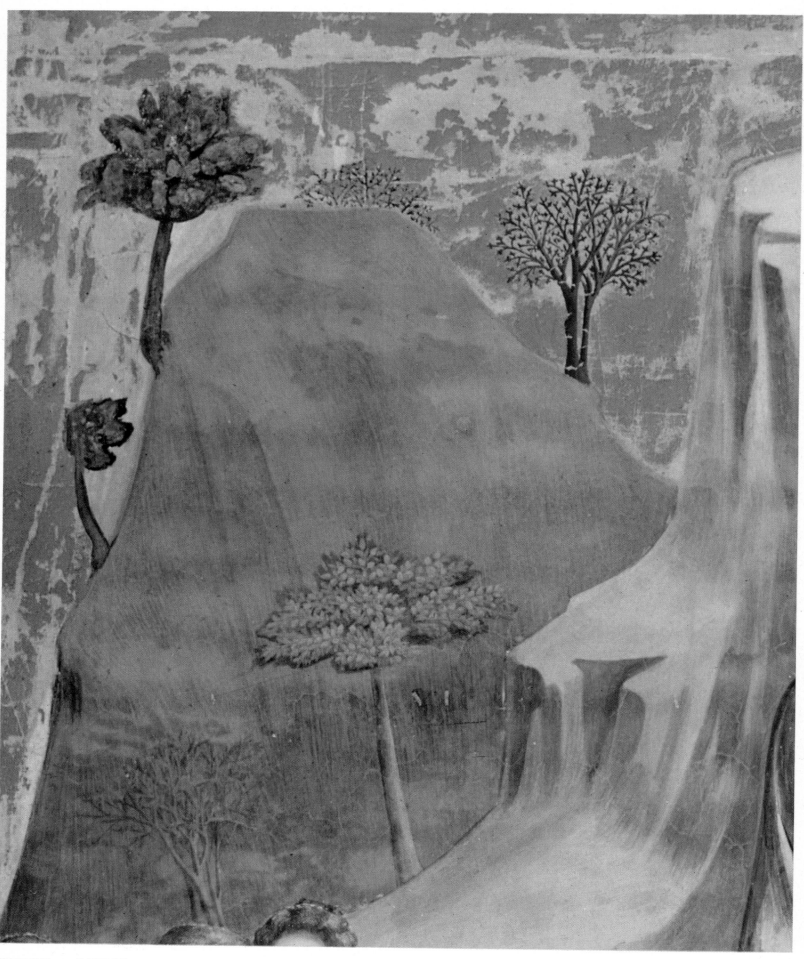

**PLATE XXIV**    FLIGHT INTO EGYPT  Padua, Scrovegni Chapel
Detail (78 cm.)

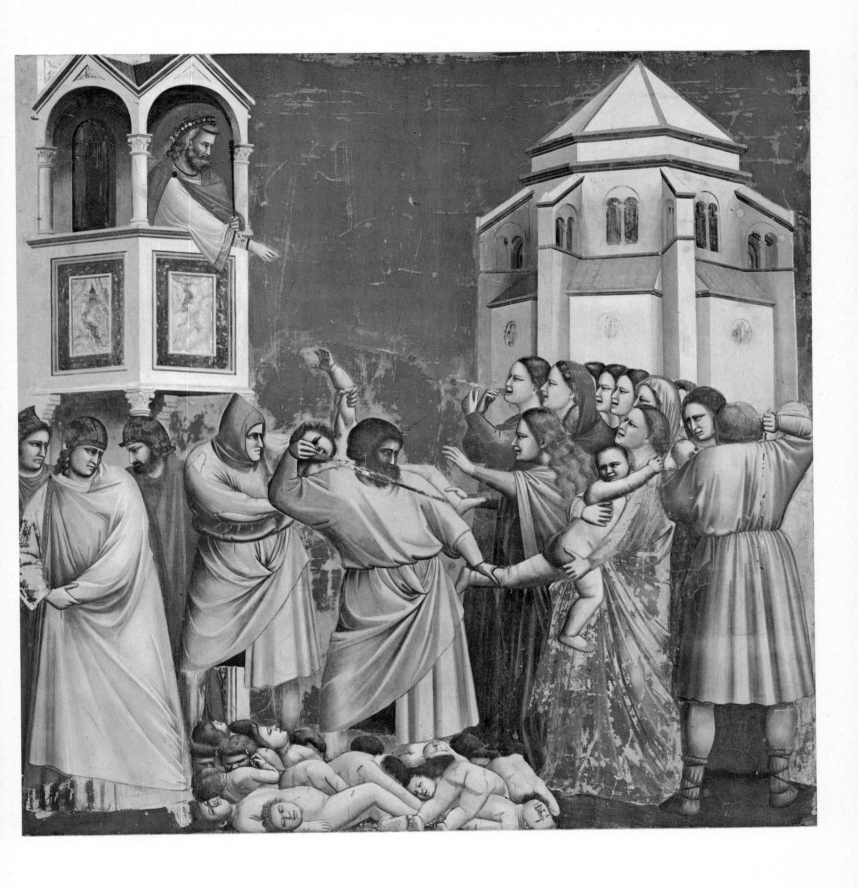

**PLATE XXV**    SLAUGHTER OF THE INNOCENTS  Padua, Scrovegni Chapel
Whole (185 cm.)

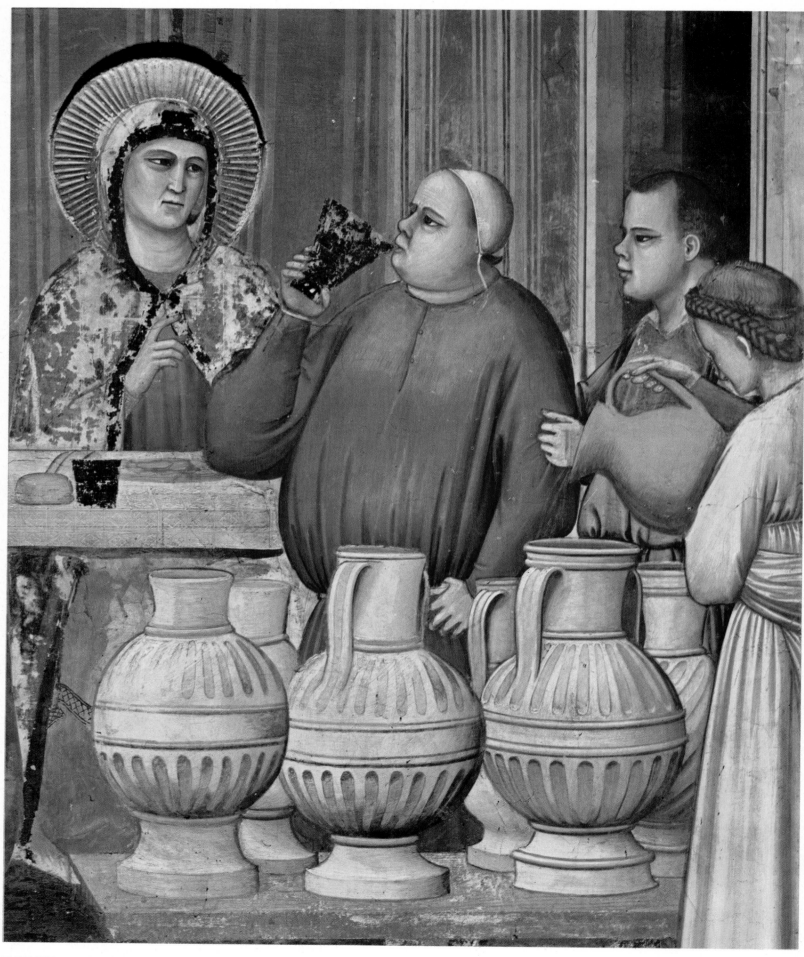

**PLATE XXVI**    MARRIAGE FEAST AT CANA  Padua, Scrovegni Chapel
Detail (73 cm.)

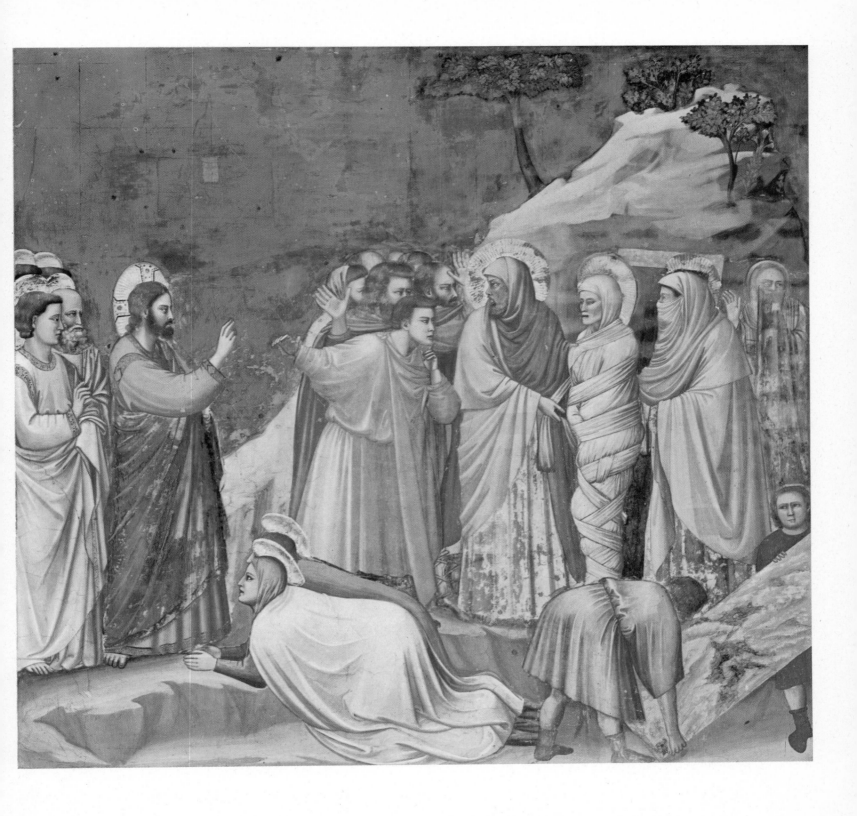

**PLATE XXVII**    RAISING OF LAZARUS  Padua, Scrovegni Chapel
Whole (185 cm.)

**PLATE XXVIII**   TRIUMPHAL ENTRY INTO JERUSALEM  Padua, Scrovegni Chapel
Detail (48.5 cm.)

**PLATE XXIX**    TRIUMPHAL ENTRY INTO JERUSALEM  Padua, Scrovegni Chapel
Detail (52 cm.)

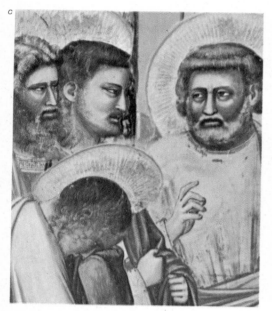

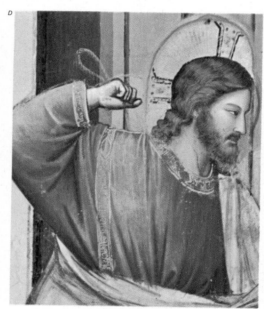

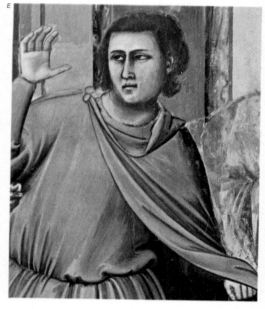

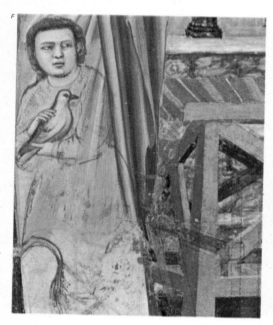

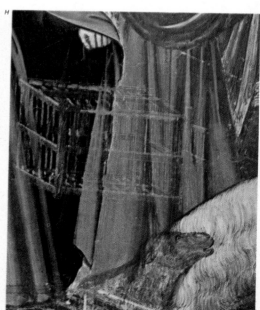

**PLATE XXX**    CLEANSING OF TEMPLE  Padua, Scrovegni Chapel
Details (larger: 67 cm.; small: 31.5 cm.)

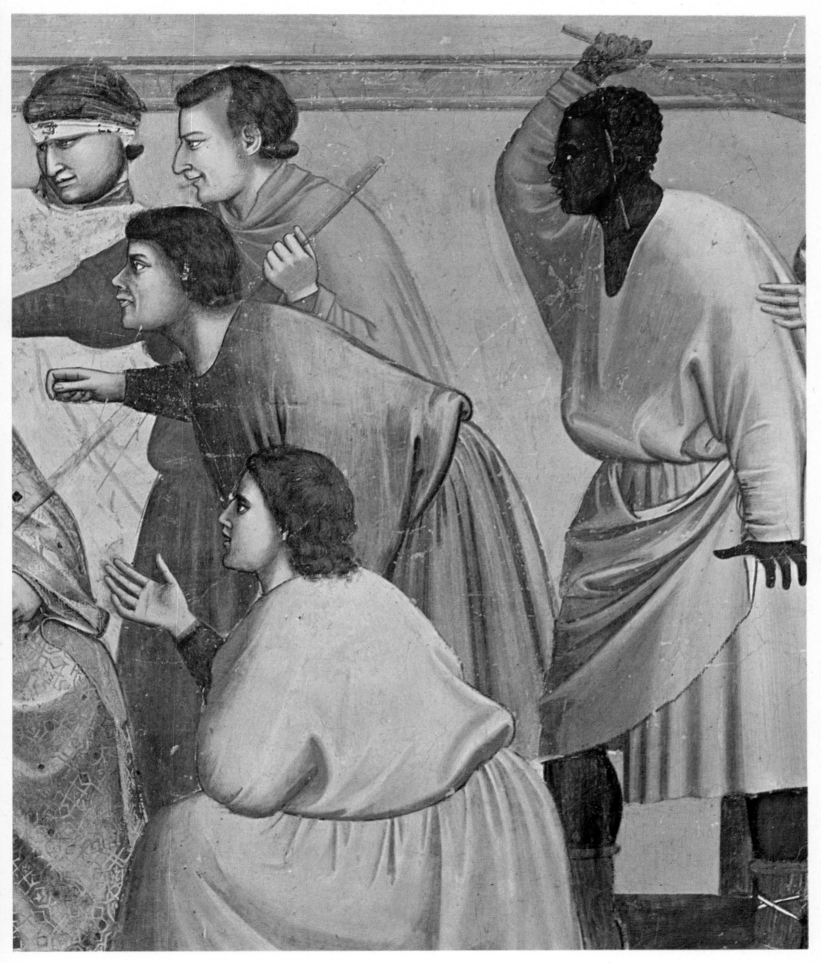

**PLATE XXXI**   FLAGELLATION  Padua, Scrovegni Chapel
Detail (76 cm.)

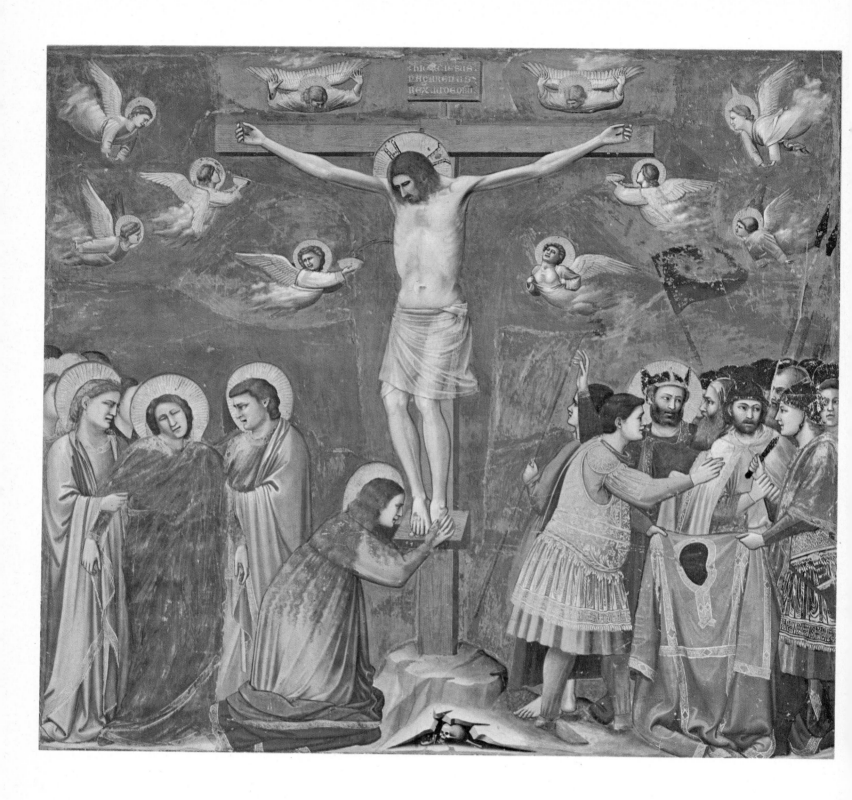

**PLATE XXXII** CRUCIFIXION Padua, Scrovegni Chapel
Whole (185 cm.)

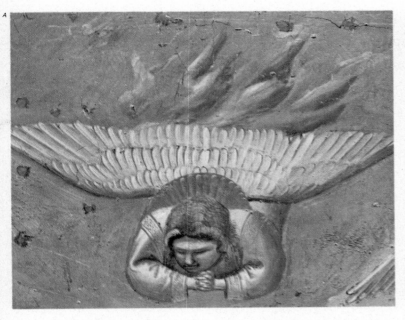

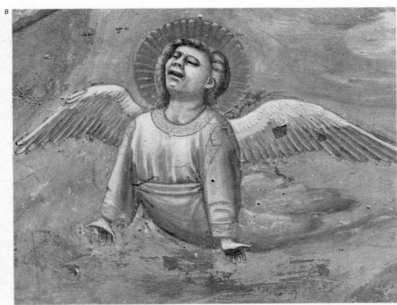

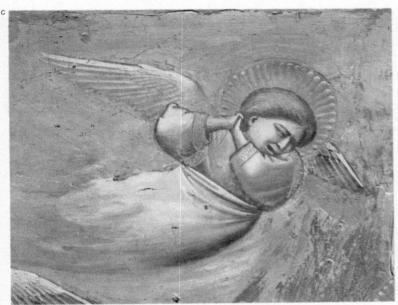

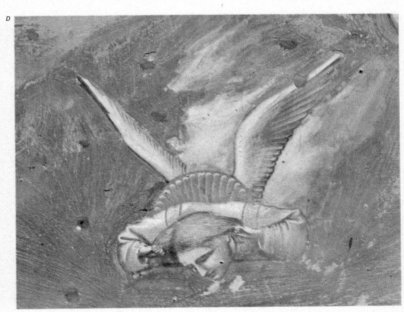

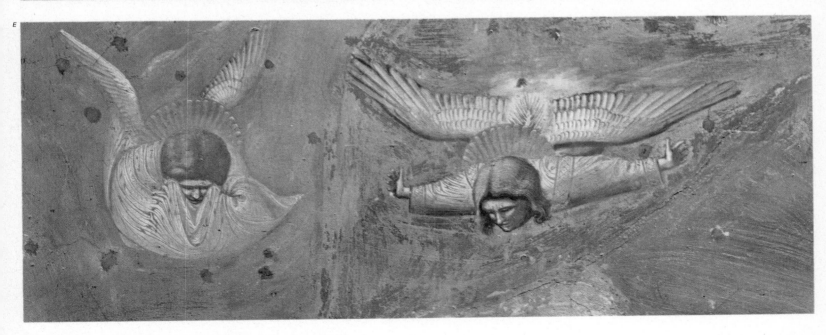

**PLATE XXXIII**     MOURNING THE DEAD CHRIST  Padua, Scrovegni Chapel
Details (small: 28 cm.; larger: 62 cm.)

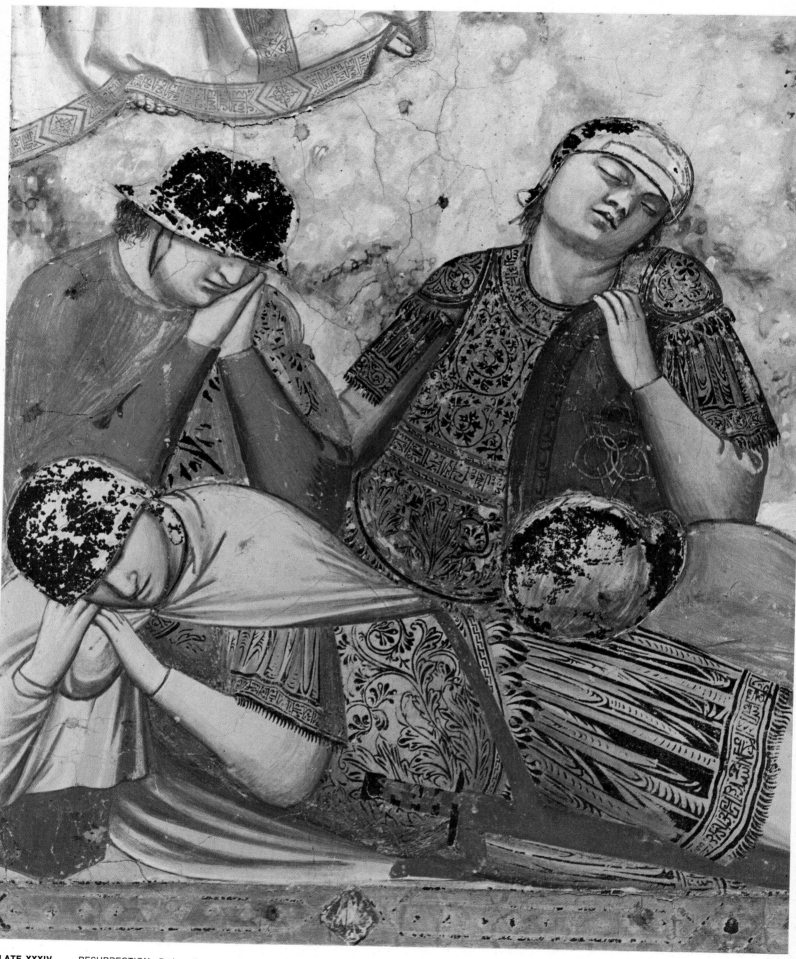

**PLATE XXXIV** RESURRECTION Padua, Scrovegni Chapel
Detail (48.5 cm.)

**PLATE XXXV**    MARRIAGE FEAST AT CANA, MOURNING THE DEAD CHRIST and DECORATIVE MOTIFS  Padua, Scrovegni Chapel
Whole (402 cm.)

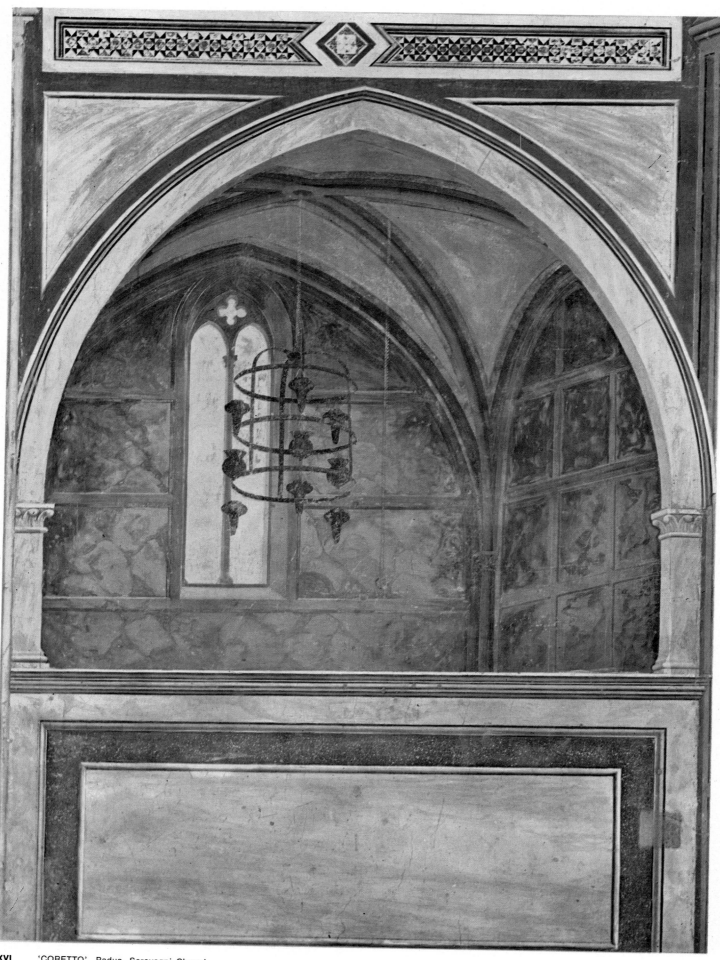

**PLATE XXXVI**   'CORETTO'   Padua, Scrovegni Chapel
Whole (147 cm.)

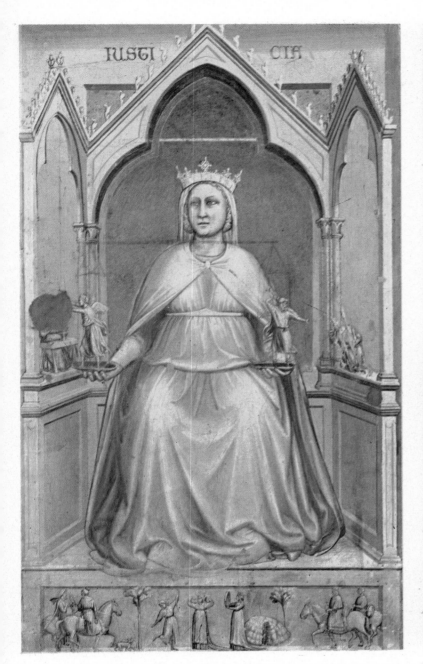

IVSTI CIA

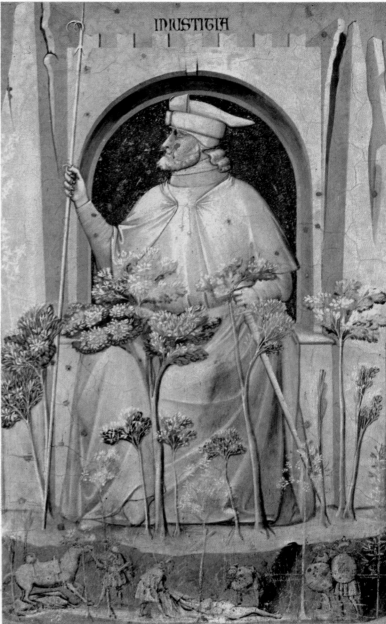

INIVSTITIA

**PLATE XXXVII**     JUSTICE, INJUSTICE and marble effects in skirting.  Padua, Scrovegni Chapel
Whole of each allegory (60 cm.) and detail of skirting (256 cm.)

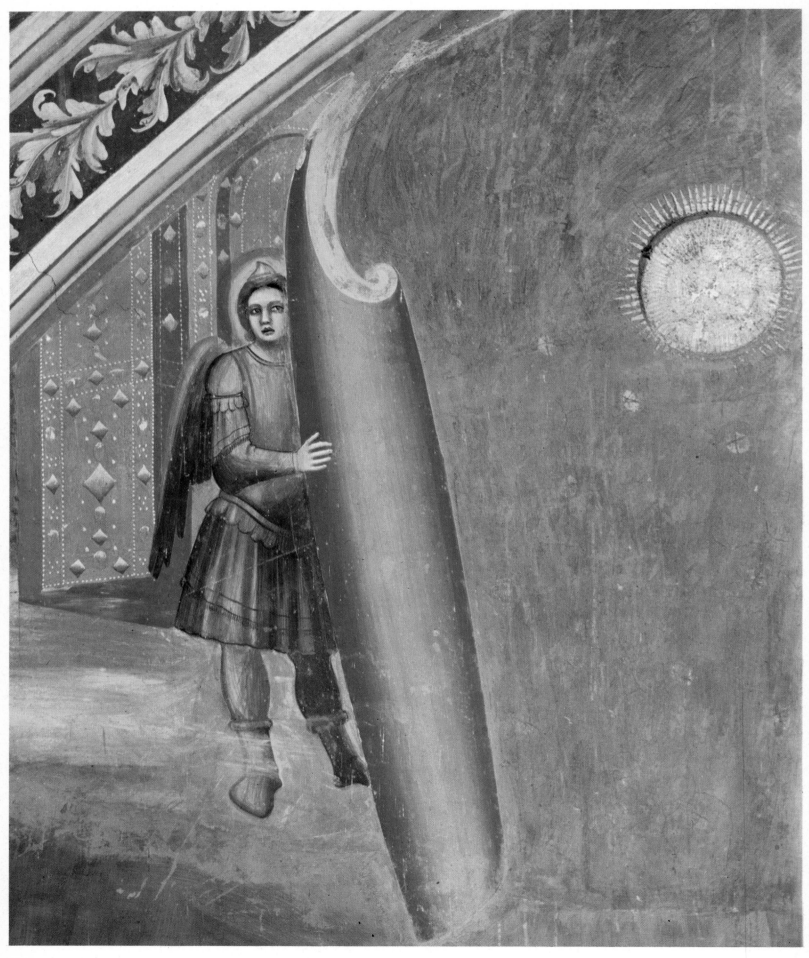

**PLATE XXXVIII**   LAST JUDGEMENT   Padua, Scrovegni Chapel
Detail (113 cm.)

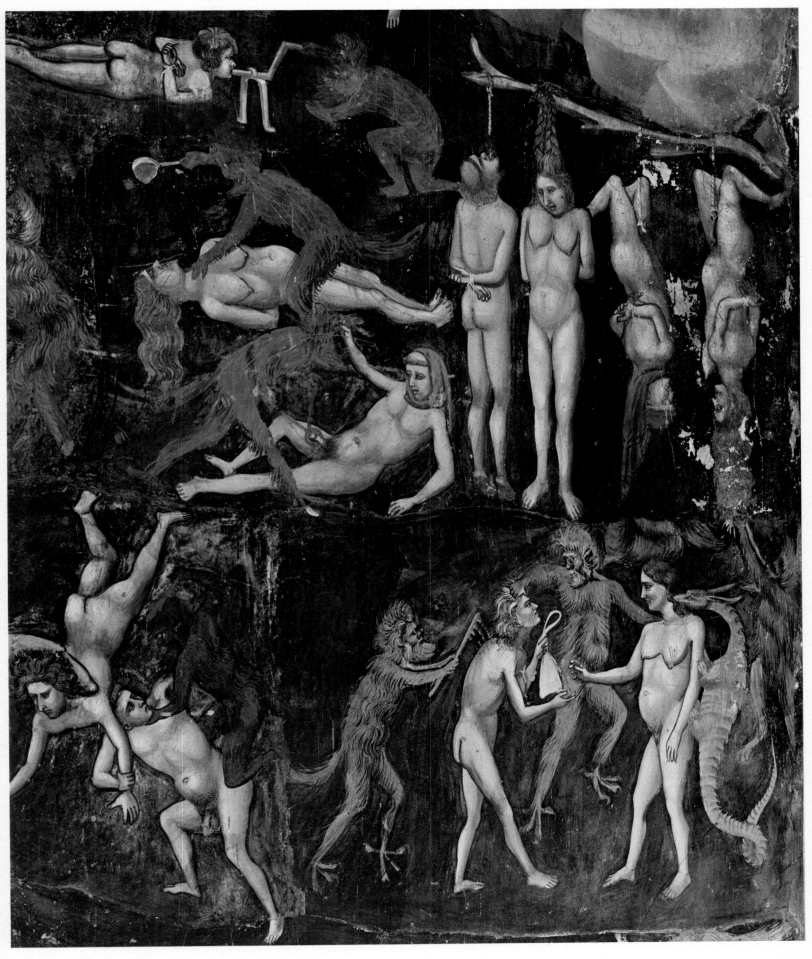

**PLATE XXXIX**  LAST JUDGEMENT  Padua, Scrovegni Chapel
Detail (102 cm.)

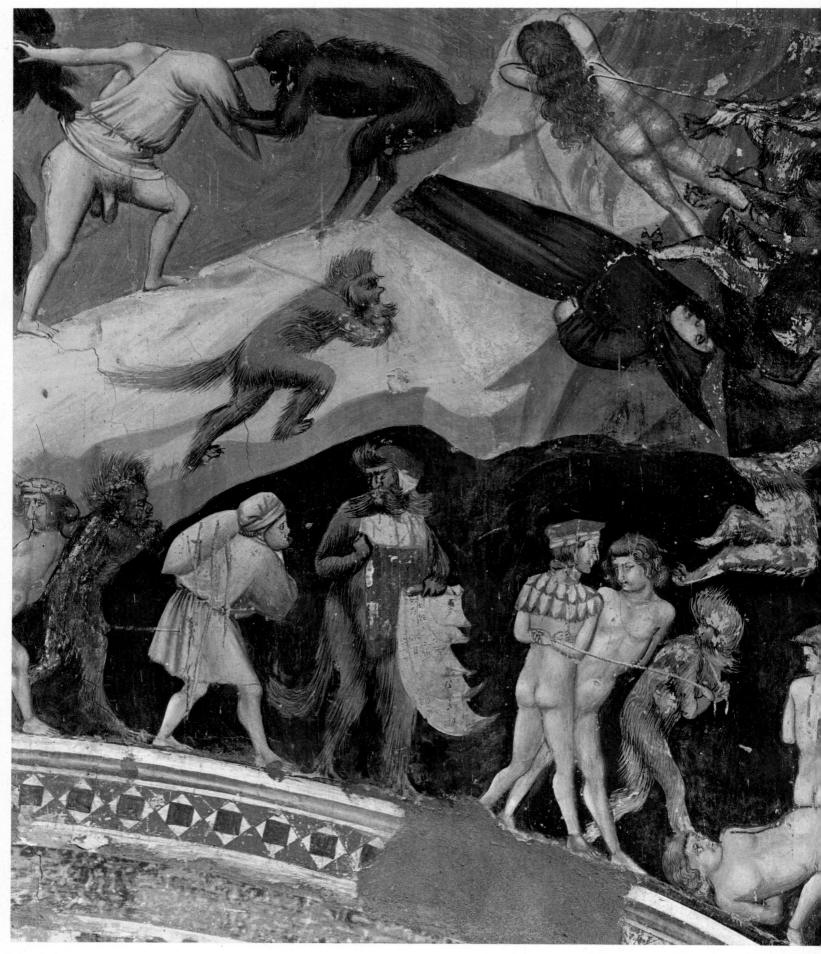

**PLATES XL-XLI** LAST JUDGEMENT Padua, Scrovegni Chapel
Detail (190 cm.)

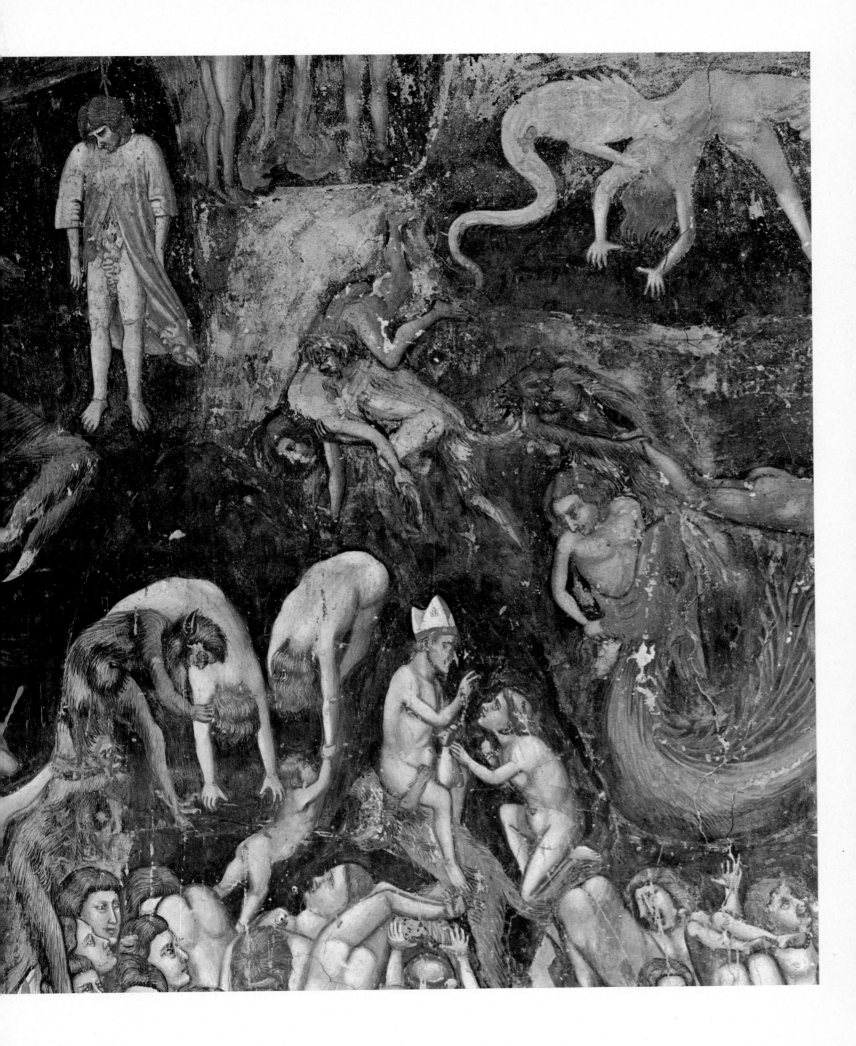

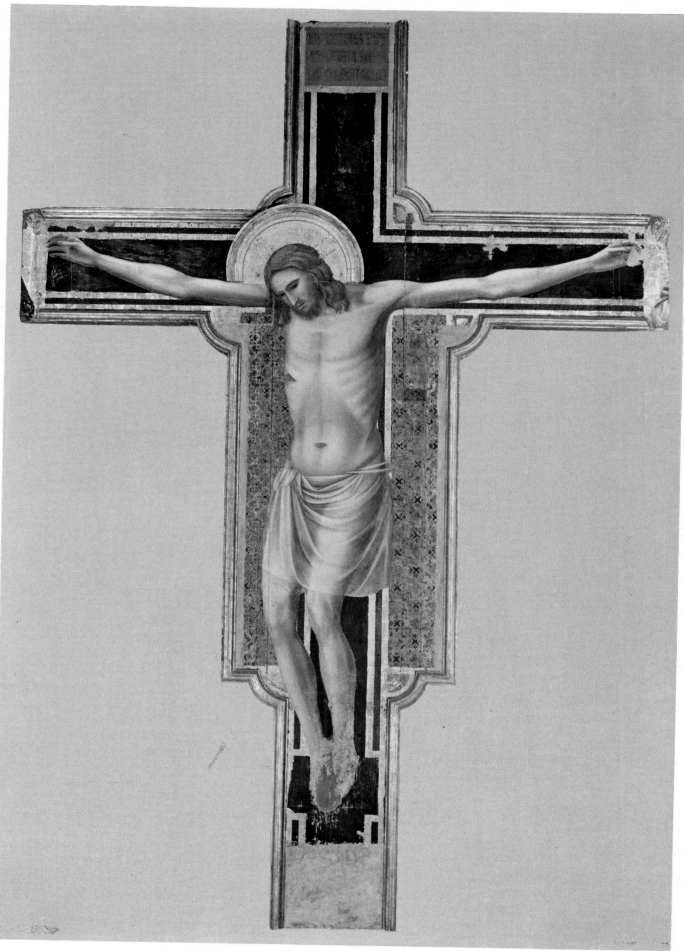

**PLATE XLII**     CRUCIFIX  Rimini, Malatesta Temple
Whole (303 cm.)

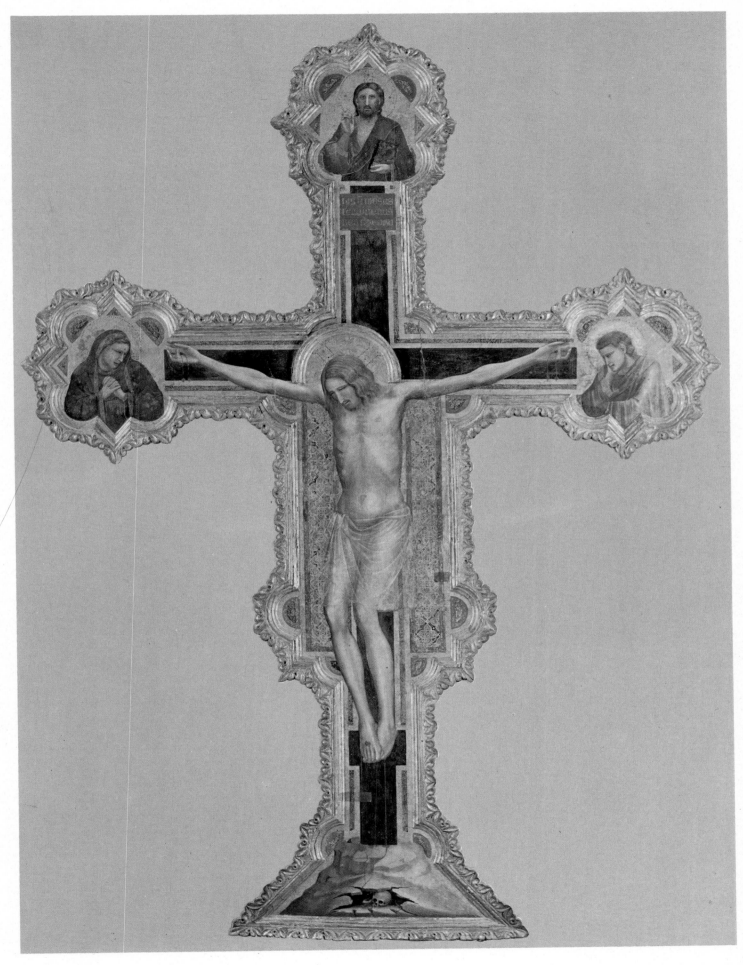

**PLATE XLIII**   CRUCIFIX   Padua, Scrovegni Chapel
Whole (164 cm.)

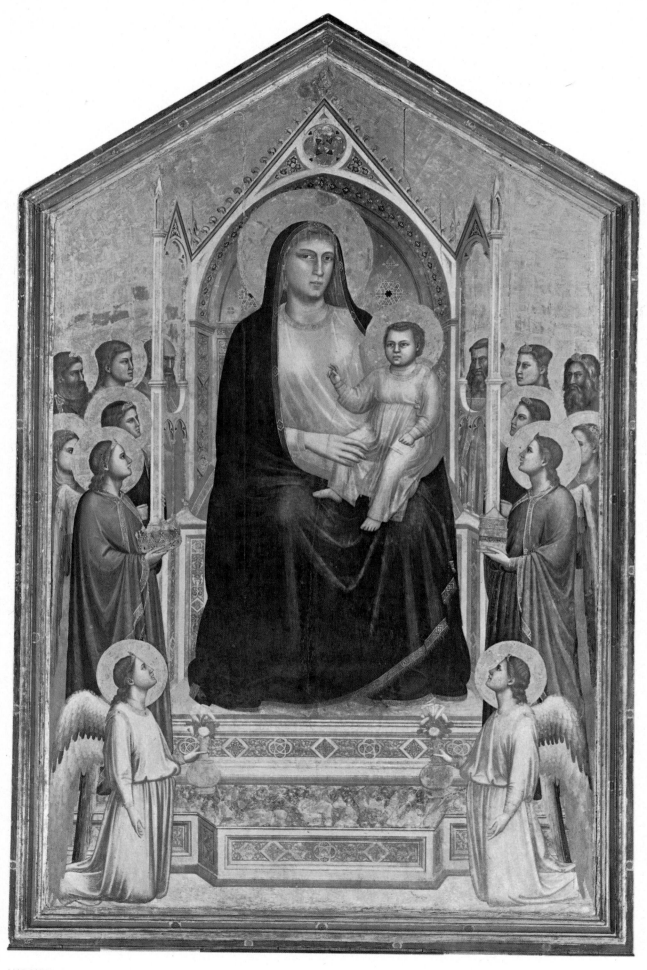

**PLATE XLIV**  MADONNA IN MAJESTY  Florence, Uffizi
Whole (204 cm.)

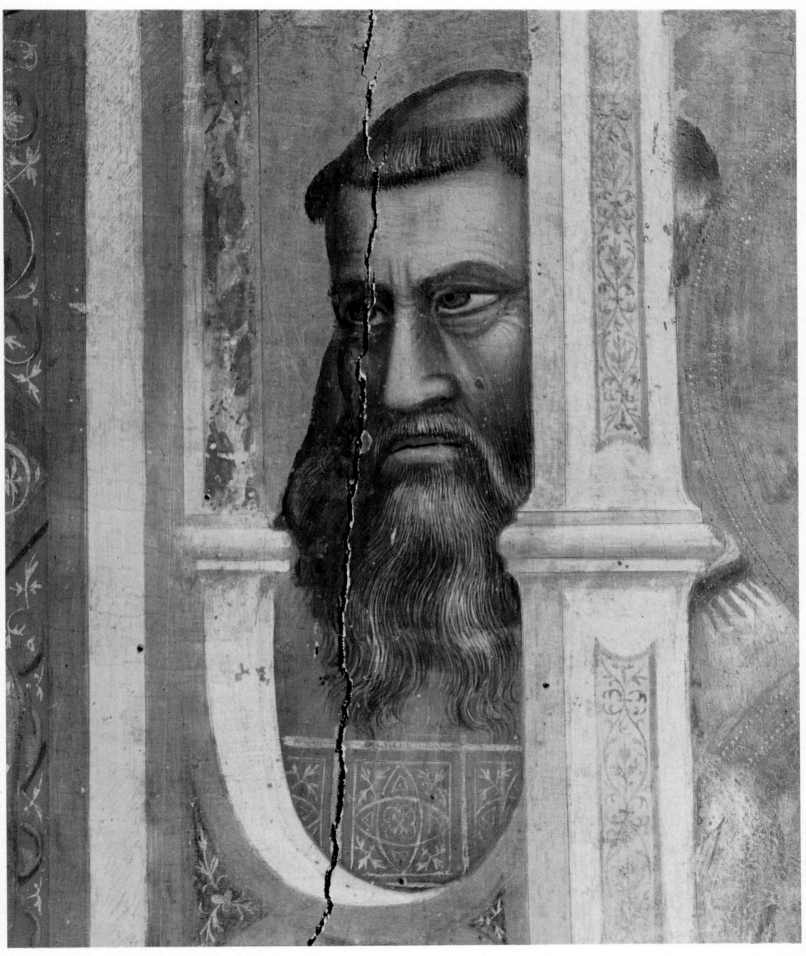

**PLATE XLV**     MADONNA IN MAJESTY  Florence, Uffizi
Detail (25.5 cm.)

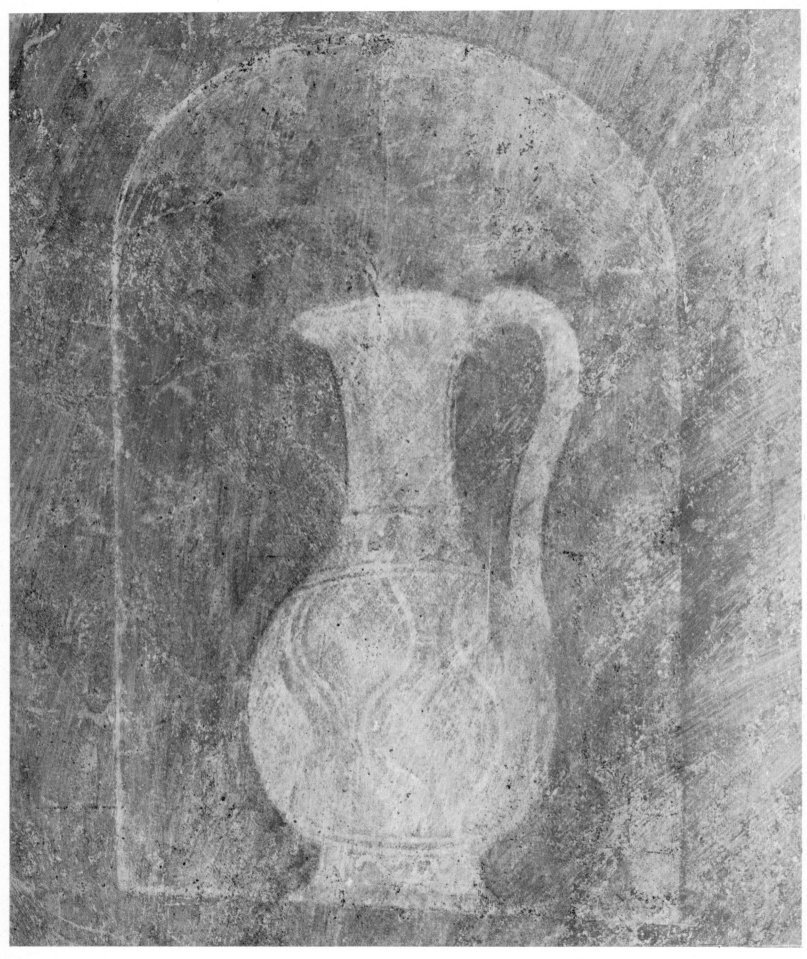

**PLATE XLVI**    BIRTH OF ST JOHN THE BAPTIST  Florence, Sta Croce, Peruzzi Chapel
Detail (30 cm.)

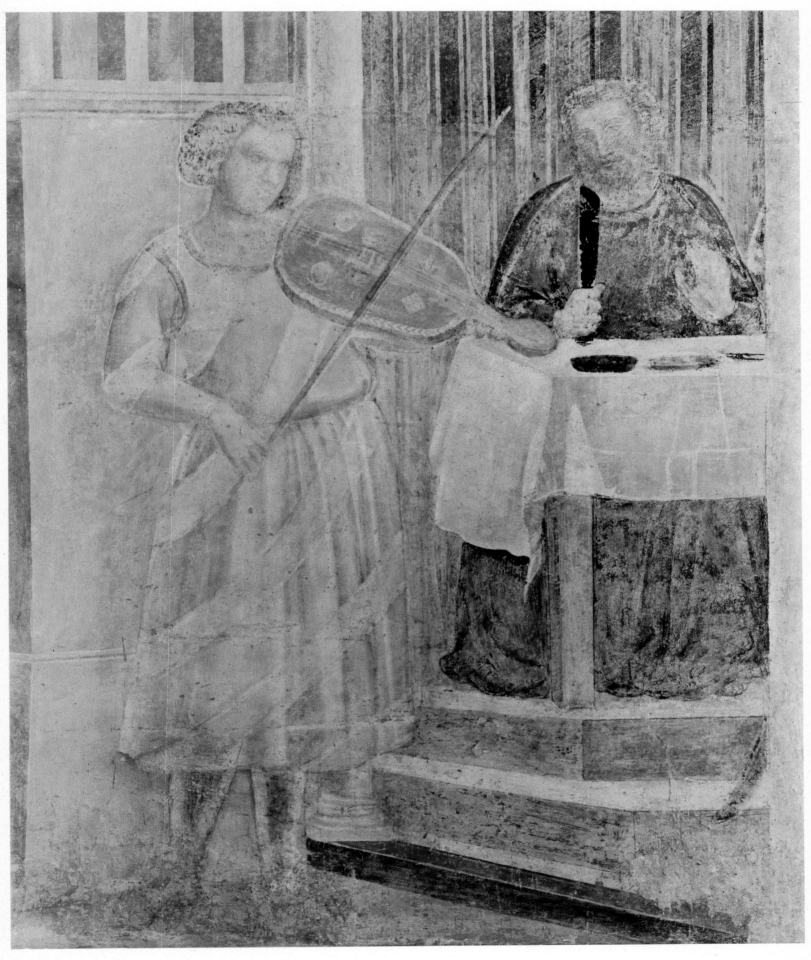

**PLATE XLVII**    HEROD'S FEAST  Florence, Sta Croce, Peruzzi Chapel
Detail (120 cm.)

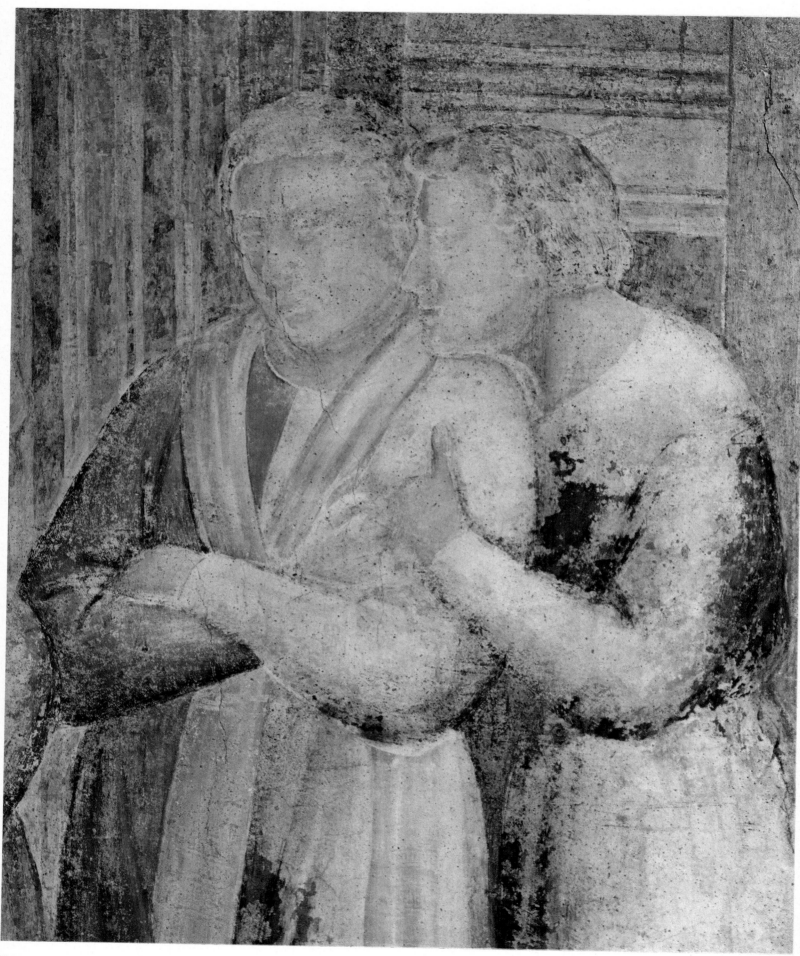

**PLATE XLVIII**    HEROD'S FEAST  Florence, Sta Croce, Peruzzi Chapel
Detail (50 cm.)

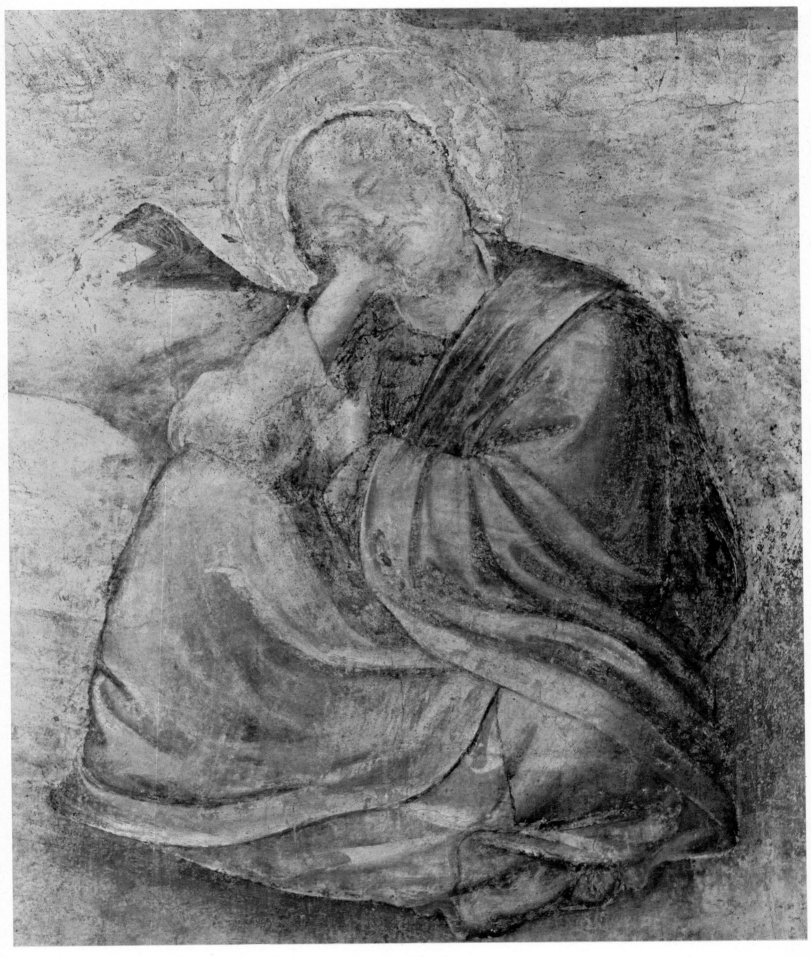

**PLATE XLIX**  ST JOHN THE EVANGELIST ON PATMOS  Florence, Sta Croce, Peruzzi Chapel
Detail (89 cm.)

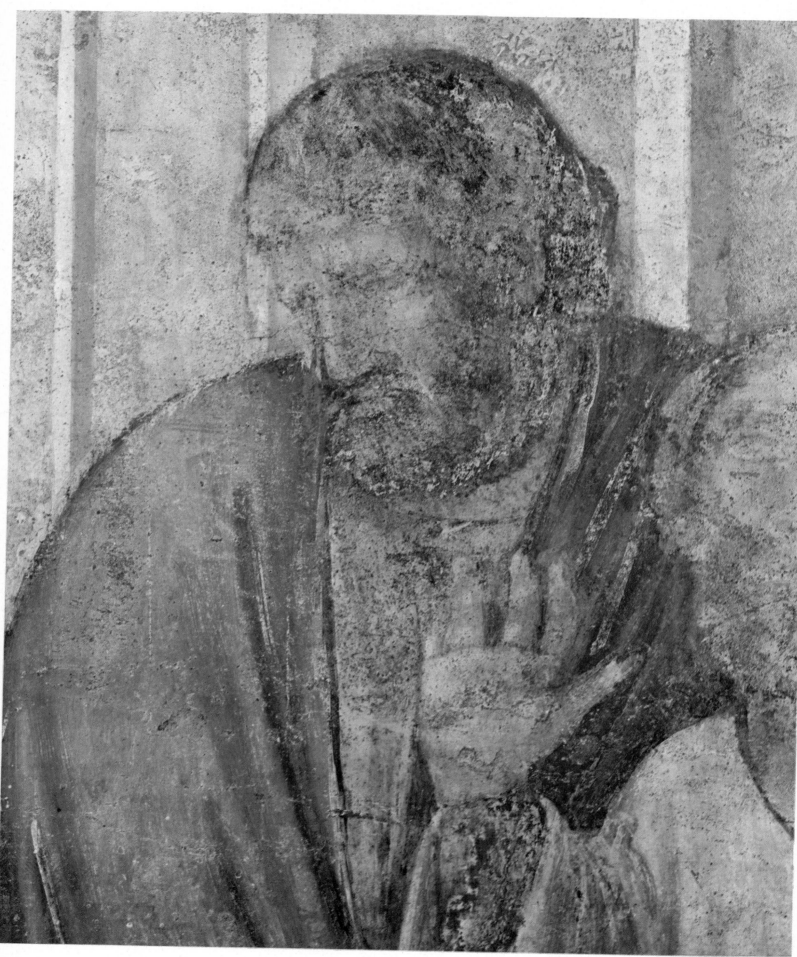

**PLATE L** RAISING OF DRUSIANA Florence, Sta Croce, Peruzzi Chapel
Detail (47.5 cm.)

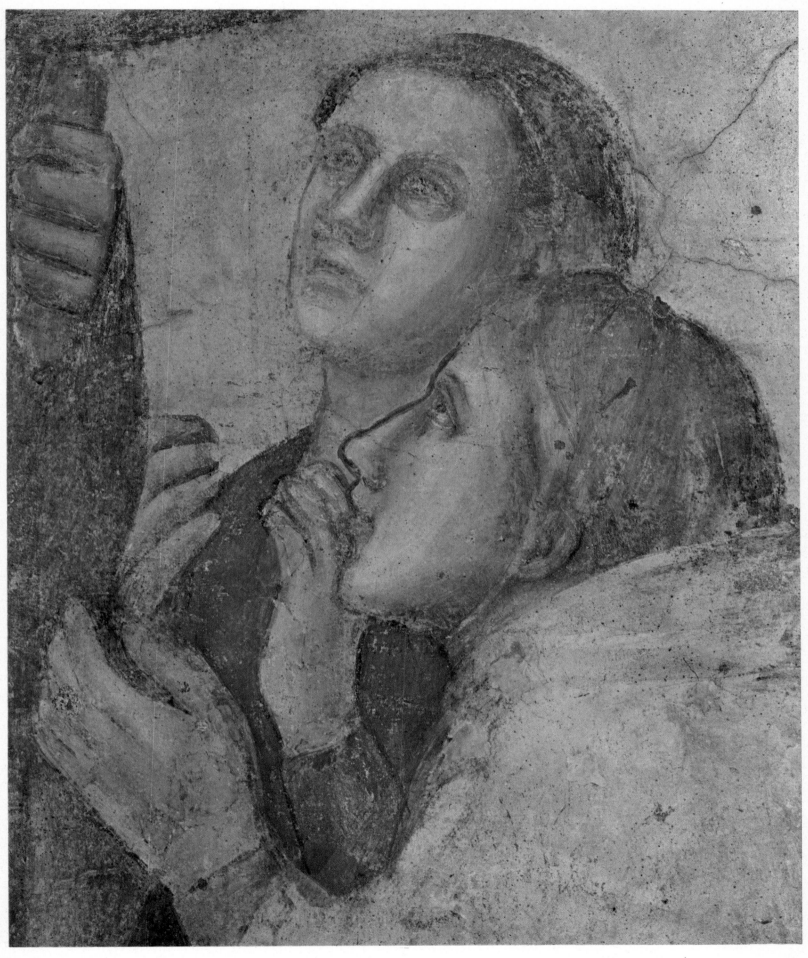

**PLATE LI**     RAISING OF DRUSIANA   Florence, Sta Croce, Peruzzi Chapel
Detail (38.5 cm.)

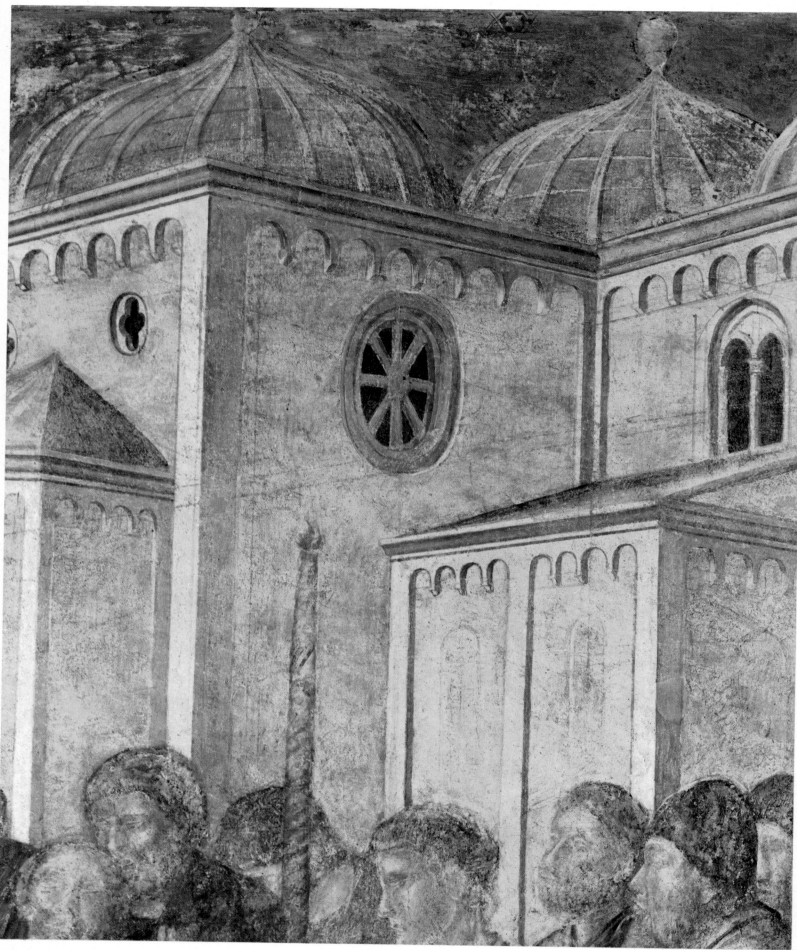

**PLATE LII**   RAISING OF DRUSIANA  Florence, Sta Croce, Peruzzi Chapel
Detail (106 cm.)

**PLATE LIII**    DECORATIVE MOTIF  Florence, Sta Croce, Peruzzi Chapel
Detail (31 cm.)

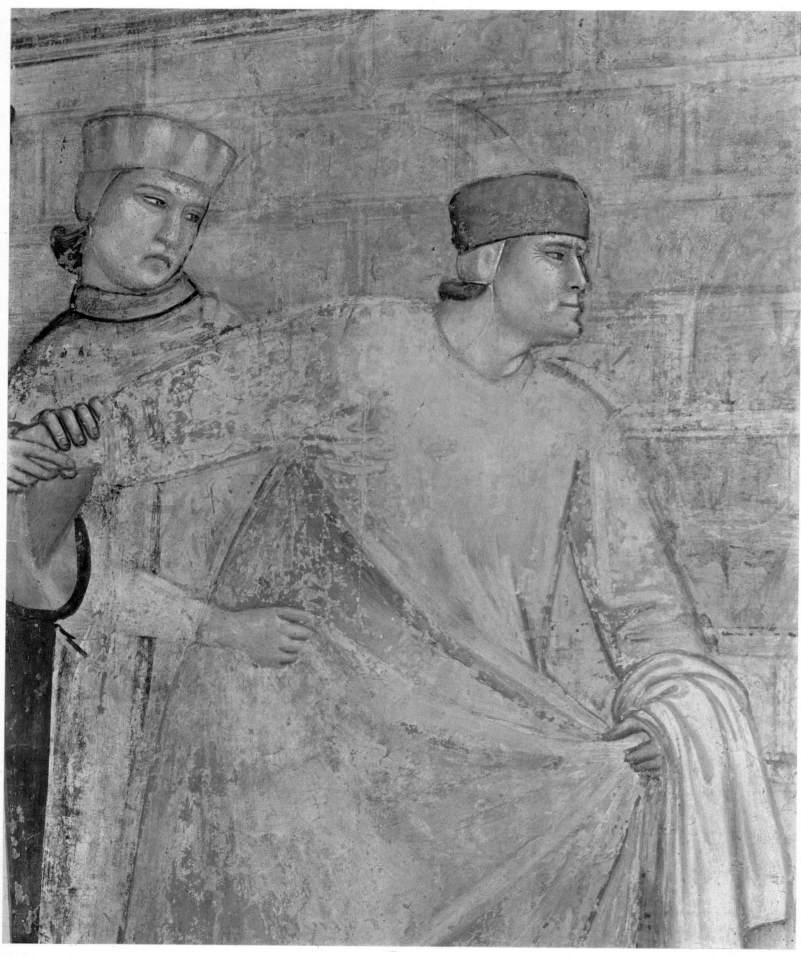

**PLATE LIV**  ST FRANCIS RENOUNCES HIS POSSESSIONS  Florence, Sta Croce, Bardi Chapel
Detail (83 cm.)

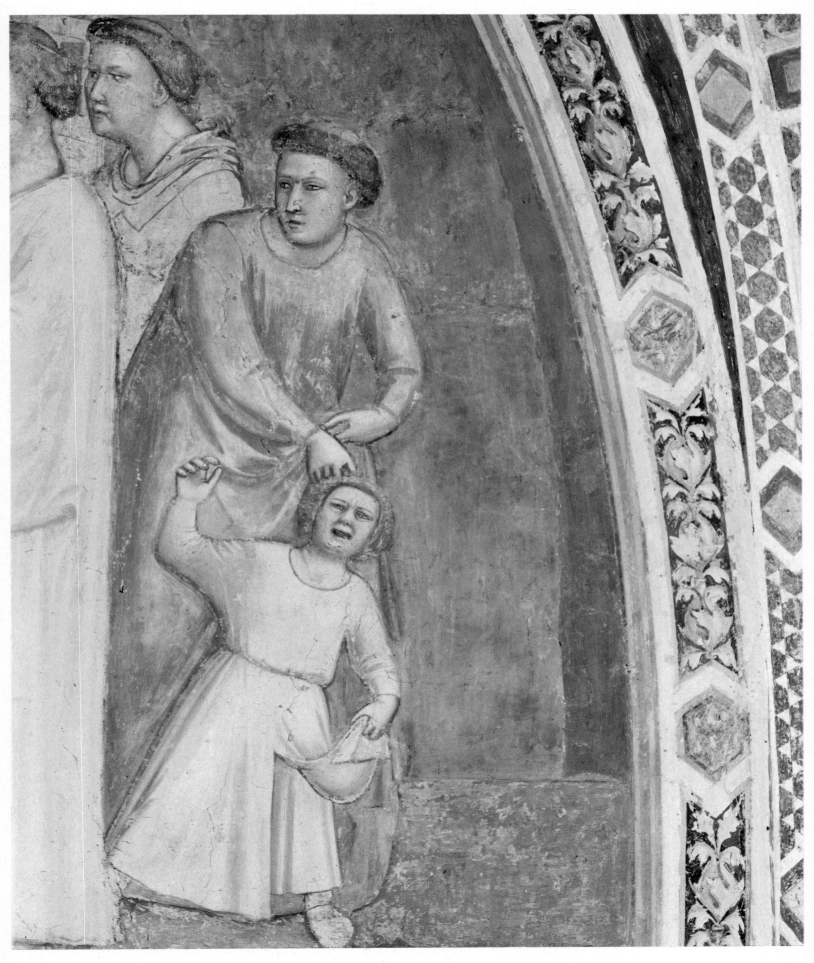

**PLATE LV**    ST FRANCIS RENOUNCES HIS POSSESSIONS   Florence, Sta Croce, Bardi Chapel
Detail (96 cm.)

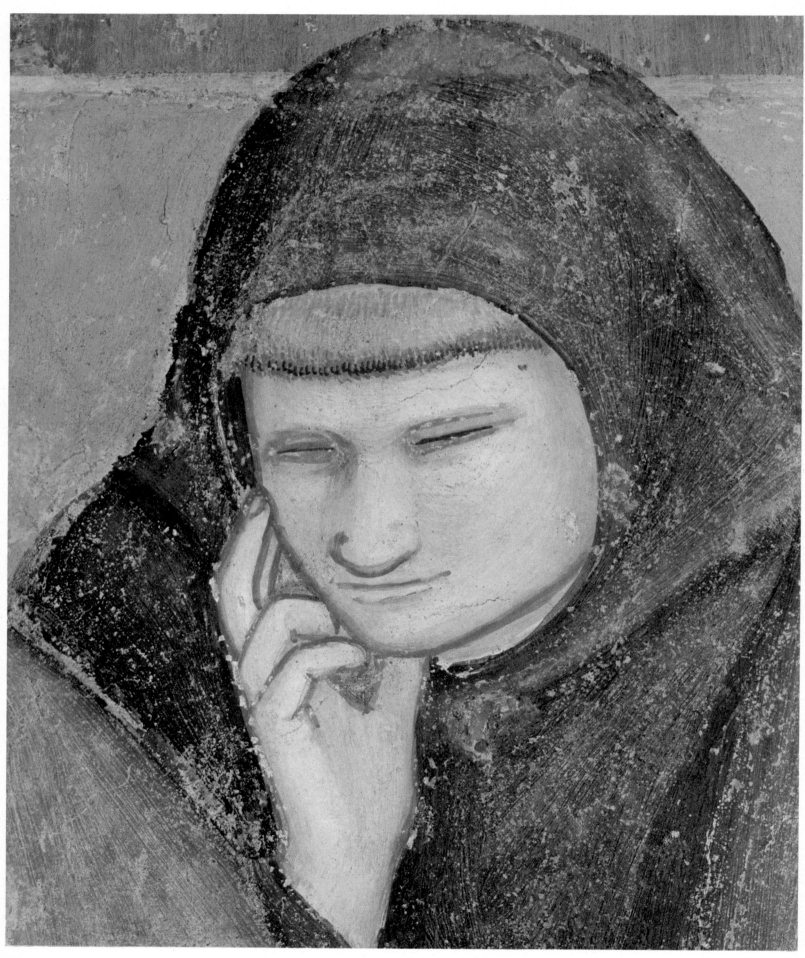

**PLATE LVI**   APPARITION TO THE CHAPTER AT ARLES  Florence, Sta Croce, Bardi Chapel
Detail (actual size)

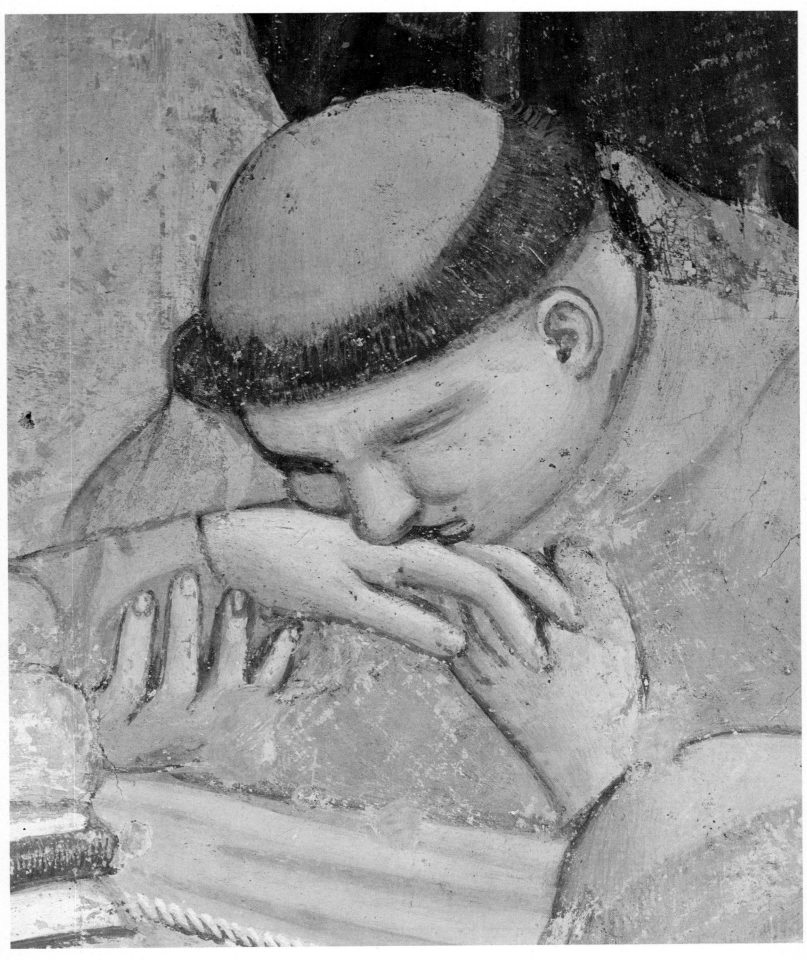

**PLATE LVII**    CONFIRMATION OF THE STIGMATA  Florence, Sta Croce, Bardi Chapel
Detail (31 cm.)

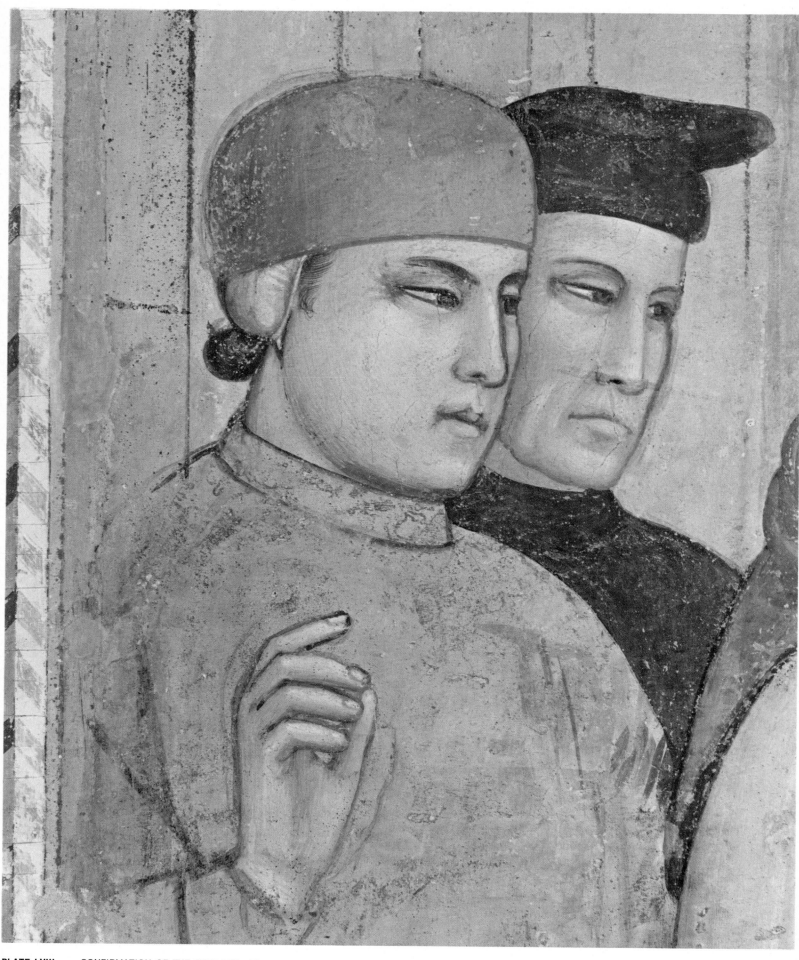

**PLATE LVIII**     CONFIRMATION OF THE STIGMATA  Florence, Sta Croce, Bardi Chapel
Detail (33.5 cm.)

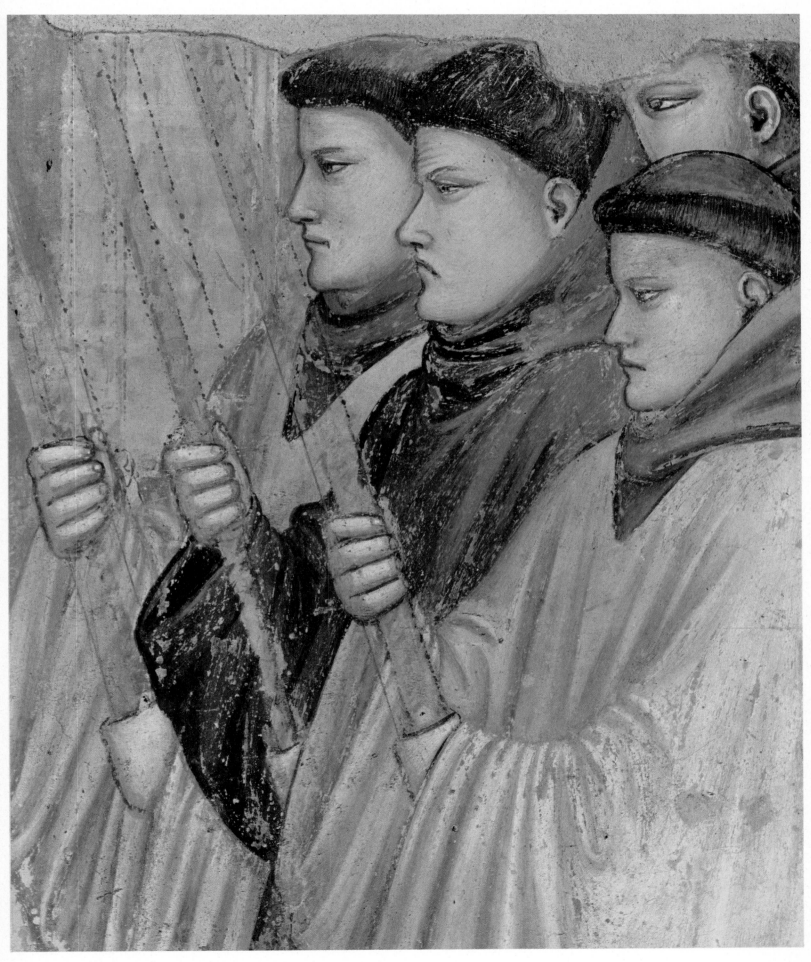

**PLATE LIX**    CONFIRMATION OF THE STIGMATA  Florence, Sta Croce, Bardi Chapel
Detail (58.5 cm.)

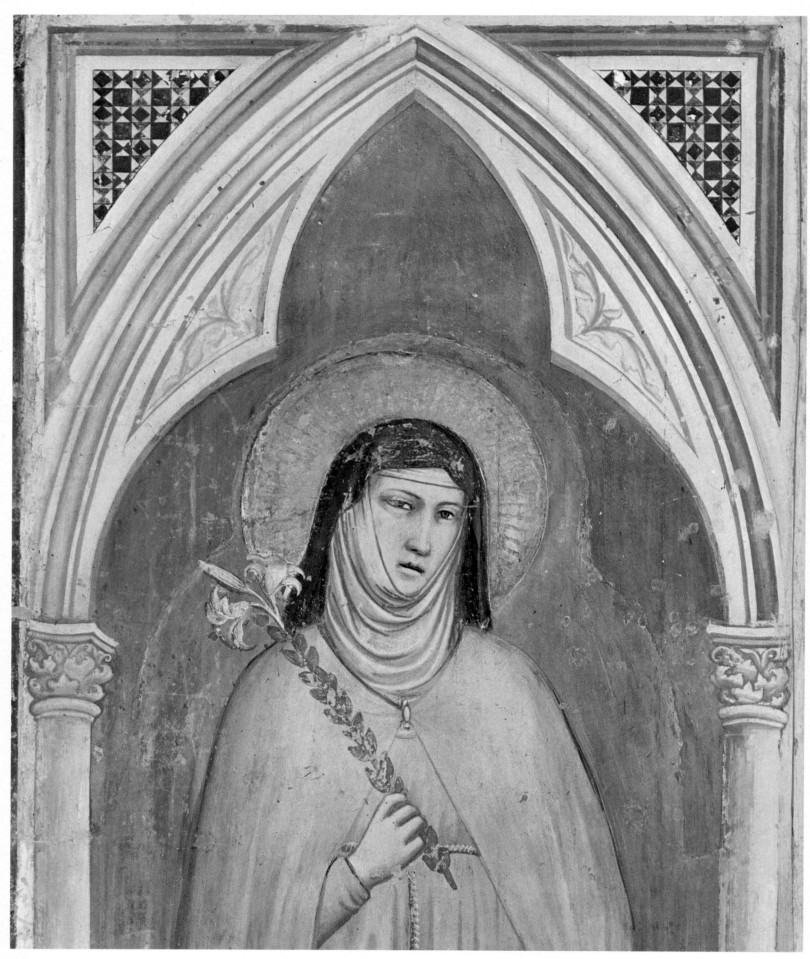

**PLATE LX**   ST CLARE  Florence, Sta Croce, Bardi Chapel
Detail (70 cm.)

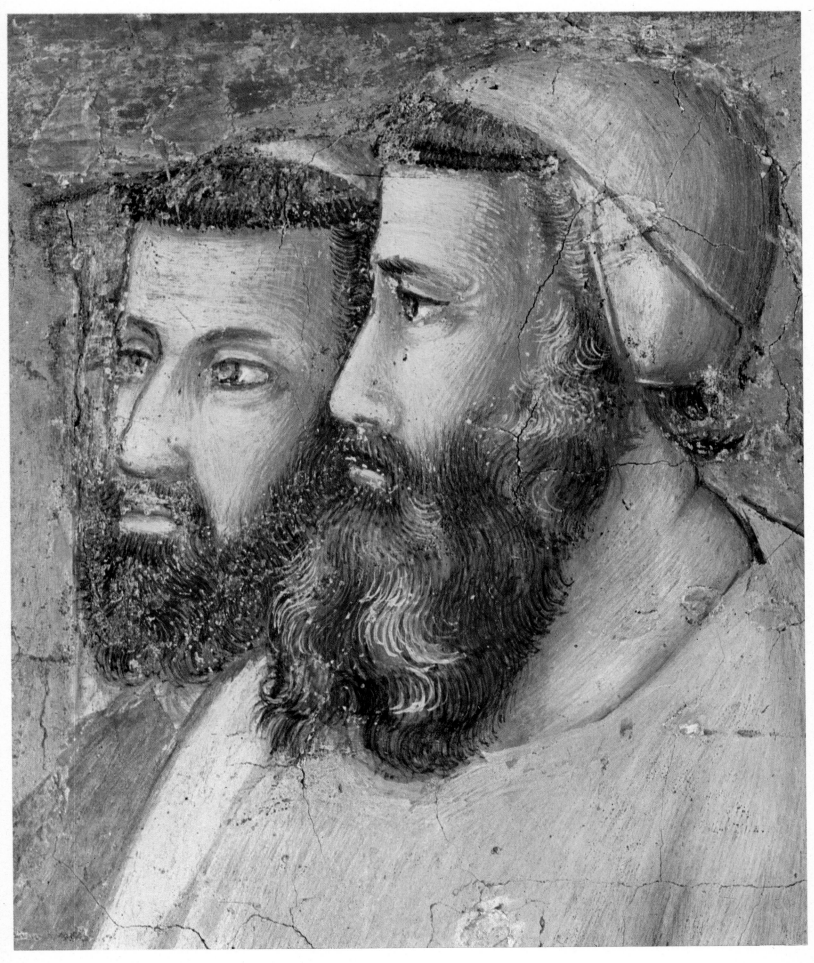

**PLATE LXI**   FRANCISCAN RULE APPROVED   Florence, Sta Croce, Bardi Chapel
Detail (29 cm.)

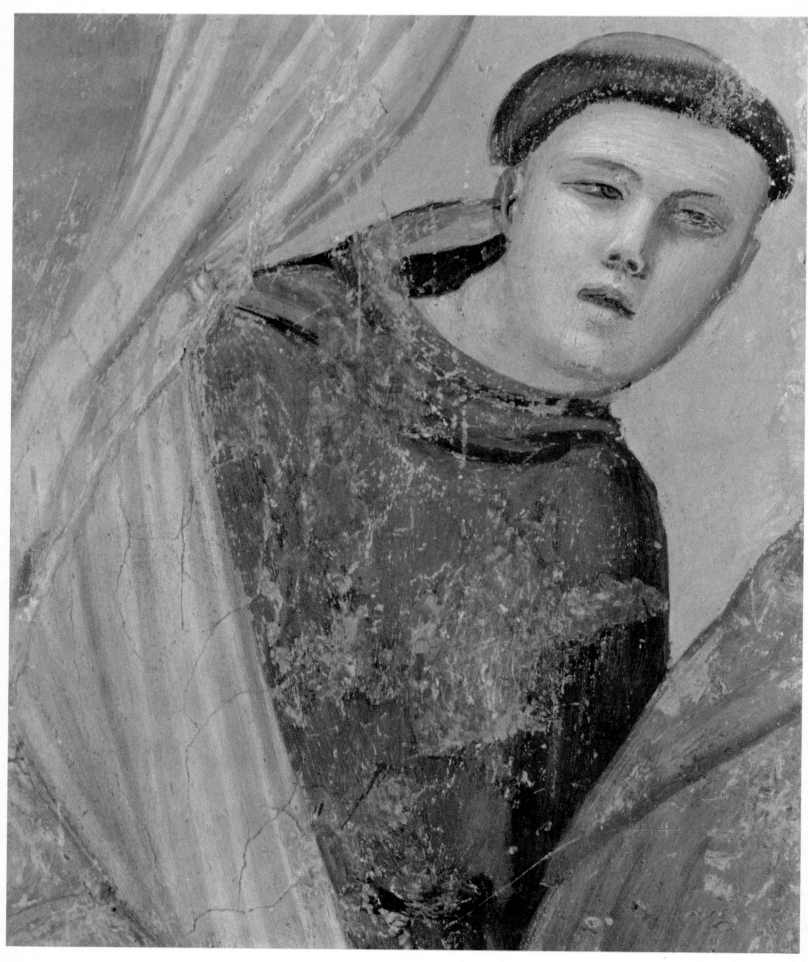

**PLATE LXII**     APPARITION TO FRA AGOSTINO AND THE BISHOP  Florence, Sta Croce, Bardi Chapel
Detail (34.5 cm.)

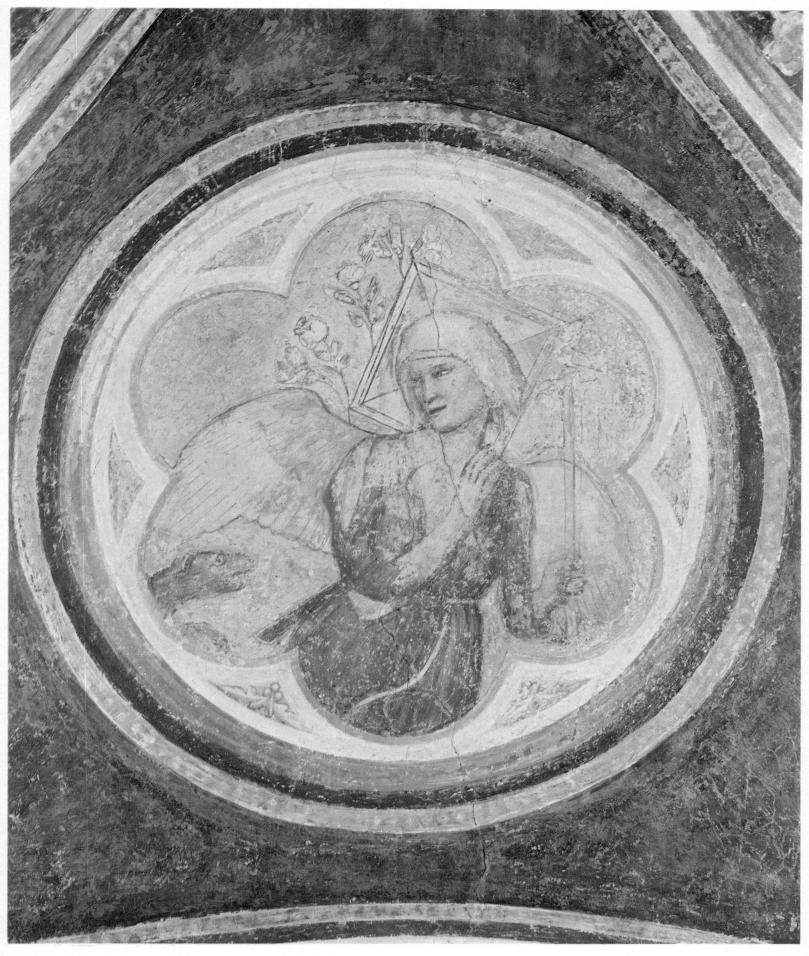

**PLATE LXIII**     ALLEGORY OF THE CHASTITY  Florence, Sta Croce, Bardi Chapel
Whole (136 cm.)

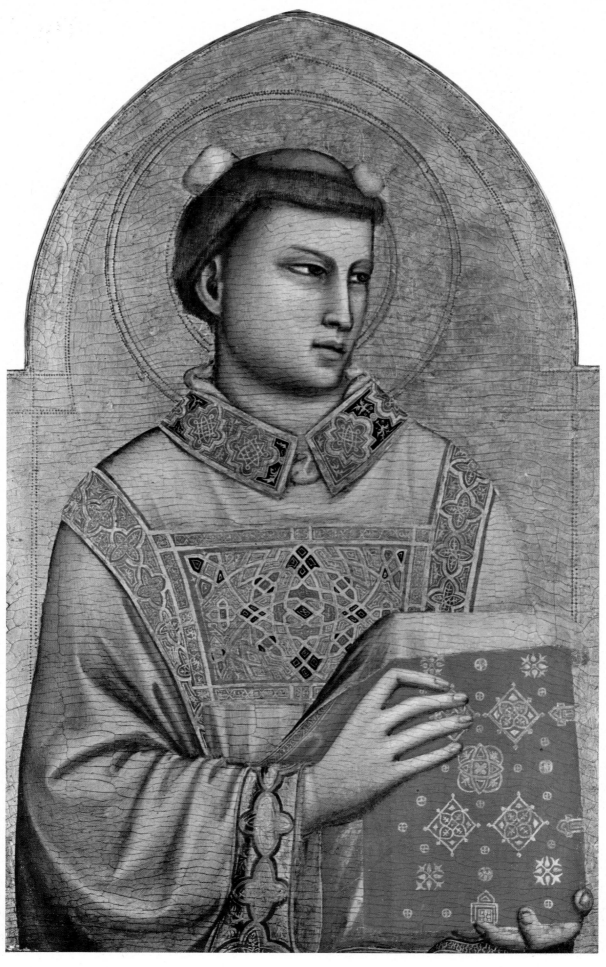

**PLATE LXIV**   ST STEPHEN  Florence, Horne Museum
Whole (54 cm.)

# The Works

# Key to symbols used

# Bibliography

In order to provide a readily accessible guide to the basic data normally required, each sub-section of the Catalogue is preceded by the number of the painting (determined on the basis of the most reliable information available concerning the actual chronological order of execution, and used to identify each work in all references thereto throughout this publication) together with a series of symbols denoting the following: 1 execution of the work, i.e. to what extent it is the artist's own work; 2 medium; 3 base; 4 location; 5 other information such as: whether the work is signed or dated; whether it is now complete; whether it was originally finished. The remaining numerals denote respectively the size, in centimetres, of the painting (height x width) and the date. These figures are preceded or followed by an asterisk in all cases in which the information given is approximate only. All such data are based on the general consensus of opinion in the field of modern art historiography. Outstanding differences of opinion and any further relevant data are discussed in the text.

## Execution

 Artist's own work

Done by artist with assistance

Done by artist and associates

Done by artist with considerable assistance

Work executed in *bottega*

Attributed to artist by most authorities

Execution by artist questioned by most authorities

Traditionally attributed to artist

Recently attributed to artist

## Medium

Oil

Fresco

Tempera

## Base

Panel

Wall

Canvas

## Location

Premises open to the public

Private collection

Whereabouts unknown

Work lost

## Other data

Work signed

Work dated

Work incomplete or now fragmentary

Work unfinished

Key to these symbols provided in text

A full bibliography covering all sources ranging from the very earliest commentators down to 1937 is given by R. SALVINI (*Giotto-Bibliografia*, Rome, 1938). Information concerning all later works may be found in the important *Wende der Giotto-Forschung* by R. OERTEL, published in 'Zeitschrift für Kunstgeschichte', 1943–4; C. GNUDI's fundamental study (*Giotto*, Milan, 1959) should also be consulted. For individual paintings and the problems of authorship, reference should be made to *Pittura italiana del Duecento e del Trecento, Catalogo della Mostra Giottesca di Firenze del* 1937, by G. SINIBALDI and G. BRUNETTI, published in Florence in 1943. In addition to Gnudi's work already mentioned, the following general studies may be consulted: E. CECCHI (*Giotto*, Milan, 1937); C. BRANDI (*Giotto*, in 'Le arti', 1938–9); P. TOESCA (*Il Trecento*, Turin, 1951); R. OERTEL (*Die Frühzeit der italienischen Malerei*, Stuttgart, 1953); R. SALVINI (*Giotto*, Milan, 1952 and 1962); E. BATTISTI (*Giotto*, Geneva, 1960); M. BUCCI (*Giotto*, Florence, 1966) and D. GIOSEFFI (*Giotto architetto*, Milan, 1963). The last-named study, in which the art of Giotto is surveyed from a predominantly 'spatial' point of view, contains full details of all the architectural works either known to have been executed by Giotto or attributed to him; moreover, it includes up-to-date information concerning the principal cycles of frescoes. With particular reference to the frescoes in Assisi, the following may be consulted in addition to the more general works already listed: R. OFFNER (*Giotto – non Giotto*, in 'The Burlington Magazine', 1939); L. COLETTI (*Gli affreschi della basilica di Assisi*, Bergamo, 1949); M. MEISS (*Giotto and Assisi*, New York, 1960); G. PREVITALI (*Gli affreschi di Giotto ad Assisi*, Milan, 1965) and R. SALVINI (*Giotto: gli affreschi di Assisi*, Florence, 1965). For recent restorations and the results of an examination of the paintwork carried out on the actual plaster, see L. TINTORI and M. MEISS (*The Painting of the Life of St Francis in Assisi*, New York, 1962). With reference to the frescoes in the Scrovegni Chapel in Padua, in addition to the more general works already mentioned, the following may be consulted: R. LONGHI (*Giotto spazioso*, in 'Paragone' 31, 1952), in which the emphasis is mainly on the architectural element in Giotto's work; F. ARCANGELI (*Le Storie di Giotto. La vita della Vergine*, Milan, 1952 and 1953); A. PROSDOCIMI (*Il comune di Padova e la cappella degli Scrovegni nell'Ottecento*, Padua, 1961, special edition of 'Bollettino del Museo Civico di Padova') – providing an interesting and fully authenticated account of all the vicissitudes of ownership in the seventeenth century, together with a history of the restoration of the frescoes; G. PREVITALI (*Gli affreschi di Giotto a Padova*, Milan, 1965) and C. SEMENZANO (*Giotto: la Cappella degli Scrovegni*, Florence, 1966). Details of the latest restorations and the various examinations of the plaster are given in an appendix to the work by L. TINTORI and M. MEISS already quoted. In addition to those already listed, the following works may be consulted with reference to the Bardi and Peruzzi chapels in Sta Croce, Florence: E. BORSOOK (*Notizie su due cappelle in Sta Croce a Firenze*, published in 'Rivista d'arte', 1961–2) as also the amply documented work by L. TINTORI and E. BORSOOK (*Giotto. The Peruzzi Chapel*, New York, 1965). Three further works in English should be mentioned; P. MURRAY (*Some Notes on Early Giotto Sources* in 'The Journal of the Warburg and Courtauld Institutes', London, 1953); J. WHITE (*Art and Architecture in Italy*, 1250–1400, Harmondsworth, 1966) and J. WHITE (*Birth and Re-birth of Pictorial Space*, London, 2nd ed. 1966).

# Outline Biography

**1267?** It is fairly generally held that Giotto was born in 1267 at Colle di Vespignano, near Vicchio in Mugello. His father, Bondone, is described by Vasari as 'a tiller of the soil and a simple man'. The date has been deduced from the writings of A. Pucci (1373), who declared that Giotto died at the age of seventy in the year 1337. This date, however, is based on the Florentine method of reckoning, i.e. *ab incarnatione* or dating each year as from 25 March, which might make the true date 1336. The place of birth, as quoted by Vasari, would now also seem to have been identified beyond question (Procacci, 1937) following the prolonged dispute in the nineteenth century over the alleged Florentine origins of the painter. This latter theory had been propounded by E. Dal Badia on the basis of a mistaken interpretation of the records. Baldinucci maintains that Giotto's name is an abbreviation of Angelo or Angiolotto, though others are of the opinion that it is derived from Ambrogiotto, Parigiotto or Ruggerotto ; others, again, hold that Giotto is a name in its own right. The latest theory, advanced by Gioseffi, is that

Giotto is an abbreviation for Biagio, and in support of this view he quotes a fifteenth-century document preserved at Sta Maria del Fiore, Florence, which runs 'Blaxio Angeli . . . known as Giotto'.

**1280–90ca** It is reliably held by most biographers that Giotto was a pupil of Cimabue during this period. The anonymous author of a commentary on the *Divine Comedy*, around 1395, states that Giotto had at first been apprenticed to a wool merchant, but that he used to visit Cimabue's *bottega*, and that his father finally gave in, and apprenticed him to the painter. Ragghianti (1955) maintains that, in his early youth, Giotto was one of the artists who submitted cartoons for the mosaics in the baptistery in Florence ; however, there is no documentary proof in support of this theory, which is shared by Longhi and Bauch.

**1290ca** This is the year in which it is believed (Battisti, 1960) that Giotto married Ciuta (Ricevuta), daughter of Lapo del Pela of Florence. According to Baldinucci, who established the family tree which was subsequently amended by Milanesi, Ciuta bore the artist four sons and four daughters. They were : Caterina, who married the painter Ricco di Lapo (from whom, according to tradition, the painter nicknamed Giottino was descended) ; Chiara, who received a generous dowry of property and lands in Colle when she was married in 1326 ; Lucia, married in Mugello ; Bice, who became a nun attached to the convent of Sta Maria Novella and died shortly after her father ; Francesco, who attained his majority in 1318, became prior of the church of S. Martino a Colle and principal administrator of his father's property ; a second Francesco, who would appear to have been a painter ; Bondone, known as Donato ; and, finally, Niccolò.

**1290–5ca** This period marks the beginning of Giotto's work in Assisi, when he was engaged on the execution of the

biblical frescoes on the upper portion of the walls of the Upper Basilica (first two bays, counting from the doorway). It is very likely that he had, in the meantime, made a journey to Rome where he broadened his artistic education by direct acquaintance with classical painting and with the works of Cavallini and Arnolfo.

**1297–9** He completed the cycle of frescoes illustrating the life of St Francis in the Upper Basilica in Assisi at the behest of Fra Giovanni di Muro, General Minister of the Order.

**1300** Giotto was in Rome to execute the fresco in the Lateran Palace depicting Boniface VIII proclaiming the Great Jubilee (some commentators are of the opinion that he also completed the

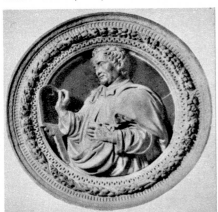

Giotto *by Benedetto da Maiano. Marble medallion executed for memorial tomb in the church of Sta Maria del Fiore, Florence*

*Navicella* mosaic in the atrium of St Peter's at the same time).

**1301** Property owned by Giotto 'outside Porta Panzani' in Florence is mentioned in two deeds dated 25 and 26 May, concerning the sale of an adjoining house. It was probably in this year that he went to Rimini (and then on to Ravenna) where he executed the frescoes (now lost) in the church of S. Francesco, now the Tempio Malatestiano.

**1302–6ca** Giotto spent this period in Padua, having in all likelihood been summoned thither by the Friars Minor, on whose behalf he executed the frescoes (now lost) in the church dedicated to St Francis. He was also commissioned by Enrico degli Scrovegni to execute the cycle in the Arena Chapel. A theory first advanced by Selvatico in 1859 to the effect that the architecture of the chapel was also to be ascribed to Giotto has recently been revived by Gioseffi (1963). There is a tradition that while he was engaged in decorating the Scrovegni Chapel, Giotto was visited by Dante. However, there is no other evidence of his friendship with the poet.

**1305** A document dated November 1305 records the leasing to a certain Bartolo, strap-maker, of a house owned

by Giotto in Florence, in the district of S. Pancrazio and the parish of Sta Maria Novella.

**1310** Probably the year in which he designed the *Navicella* mosaic in the atrium of St Peter's in Rome.

**1311–12** There is documentary evidence of Giotto's having been in Florence at this time : being by now well off, he is recorded as guaranteeing a loan (Battisti) and, on 4 September 1312, he rented a loom to one Bartolo di Rinuccio for a fairly considerable fee.

**1313** In December of this year, he was in Florence, from which he wrote to Benedetto, son of Pace, instructing him to collect all the belongings which he had left at his Roman lodgings

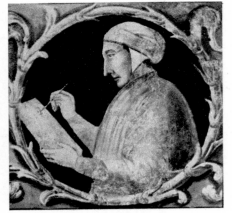

Giotto *by Benozzo Gozzoli. Detail from a 'famous personages' series of frescoes: Museum in the former church of St Francis, Montefalco*

(owned by a certain Filippa di Rieti). From this, we may infer an earlier stay in Rome ; the document in question would seem to suggest that this was round about 1310, the probable date for the *Navicella*.

**1314** Giotto's residence in Florence is again confirmed by documentary evidence.

**1315** OCTOBER Legal dispute with the notary, Grimaldo, son of Compagno da Pesciolo, over land at Colle di Vespignano.

**1317** The artist probably again went to Padua where he executed the frescoes (now lost) in the Palazzo della Ragione (Gnudi, Salvini).

**1318** He formally emancipated his son Francesco *qui hodie moratur Vespignani*, and through him assigned a property located near S. Michele di Aglioni to his daughter Bice.

**1320** Giotto was once again in Florence.

**1320–25ca** He may well have decorated the Bardi and Peruzzi chapels together with two other chapels (frescoes now lost) in Sta Croce in Florence during this period.

**1325** AUGUST He made the final payment in respect of land

*Presumed self-portrait of Giotto. Detail from 'The Blessed' in the Last Judgement in Padua (Catalogue of Works, no. 107)*

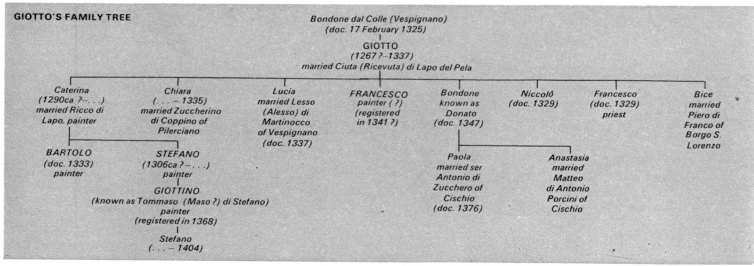

## GIOTTO'S FAMILY TREE

**Bondone dal Colle (Vespignano)**
(doc. 17 February 1325)

**GIOTTO**
(1267?–1337)
married Ciuta (Ricevuta) di Lapo del Pela

| | | | | | | | |
|---|---|---|---|---|---|---|---|
| **Caterina** (1290ca ?–...) married Ricco di Lapo, painter | **Chiara** (...–1335) married Zuccherino di Coppino of Pilerciano | **Lucia** married Lesso (Alesso) di Martinocco of Vespignano (doc. 1337) | **FRANCESCO** painter (?) (registered in 1341?) | **Bondone** known as Donato (doc. 1347) | **Niccolò** (doc. 1329) | **Francesco** (doc. 1329) priest | **Bice** married Piero di Franco of Borgo S. Lorenzo |

**BARTOLO** (doc. 1333) painter   **STEFANO** (1306ca ?–...) painter

**GIOTTINO**
(known as Tommaso (Maso?) di Stefano)
painter
(registered in 1368)

**Stefano**
(...–1404)

**Paola** married ser Antonio di Zucchero of Cischio (doc. 1376)   **Anastasia** married Matteo di Antonio Porcini of Cischio

---

at Colle di Vespignano, purchased from Bettino di Pace in 1322.

**1326** 17 FEBRUARY The marriage contract in respect of his second daughter, Chiara, was drawn up at Colle; shortly afterwards (12 May), the deed of settlement stipulating the dowry for this daughter was also drawn up.

**1327** Giotto, together with Taddeo Gaddi, Bernardo Daddi and others, became a member of the Guild of Doctors and Apothecaries (*Arte dei Medici e Speziali*) to which painters were admitted only as from 1327.

**1327–8** According to Vasari, whose opinion is shared only by Gioseffi among modern scholars, Giotto was at this time engaged in designing the tomb for Bishop Guido Tarlati in the cathedral of Arezzo.

**1328–33** From 1 December 1328 onwards, there is sundry documentary evidence to show that Giotto was the guest of Robert of Anjou in Naples; indeed, the latter appointed Giotto to his suite on 21 January 1330 (H. W. Schulz). All the artist's work in Naples is now lost.

**1329** Acting on his father's behalf, Giotto's son Francesco leased a plot of land at S. Michele di Aglioni.

**1330–4** It would seem that his stay in Naples was broken by a trip to Bologna (Battisti).

**1331** Again acting on his father's behalf, Francesco sold a cottage at Pesciolo.

**1334** In this year, Francesco leased property in S. Michele di Aglioni, acting for his father as before.

**1334** 12 APRIL By public decree, Giotto was appointed *magister et gubernator* of the 'Opera di Sta Reparata' in Florence, i.e. of the body responsible for the upkeep of the cathedral, dedicated to Sta Maria del Fiore. He was also appointed 'architect' of the walls and city fortifications.

**1334** 18 JULY This date marked the laying of the foundations of the cathedral belltower or campanile which Giotto had designed and which was to be named after him, although it was not ultimately completed in accordance with his original design. Pucci claims that Giotto supervised the construction 'up to the level of the first "intagli"', which would mean as far as the lower order of bas-reliefs. Ghiberti is of the opinion that 'the lower storeys ... were carved and designed by him'; in fact, a number of scholars are inclined to believe that some of the existing reliefs in the lower order of the belltower depicting scenes from the Creation, though executed by Andrea Pisano and his *bottega*, were actually designed by Giotto (Ragghianti, etc.) (see also Appendix). It is believed that he also supervised the laying of the foundations of the Ponte della Carraia in Florence in the same year (Gioseffi).

**1335–6**ca If Villani is to be believed ('for our Commune sent him there to serve the Duke'), Giotto went to Milan. The Duke in question was Azzone Visconti and the purpose of the visit was the execution of frescoes which are now lost. Some time after 1334, Giotto was summoned to Avignon by Pope Benedict XII to execute a cycle of frescoes illustrating the history of the martyrs; the artist's death, however, intervened before he could accept the invitation (Ragghianti).

**1337** 8 JANUARY Giotto died in Florence and was buried with full honours in the church of Sta Reparata (Duomo) at the expense of the Commune, 'which was indeed a singular privilege' (Villani). In a document dated July of that year Monna Ciuta is referred to as 'the widow of Giotto'.

**1350**ca Giotto features in one of the tales of Boccaccio's

*Decameron* (Day IV, Tale 5). The tale includes high praise for Giotto's art (see also An Outline of the Artist's Critical History).

**1395**ca Sacchetti, also, introduces Giotto into three of his tales: Giotto, the great painter, is given a shield to paint by an insignificant business man. To show his contempt, he complies with the request, to the utter confusion of the said applicant (LXIII).
While out walking with some companions, Giotto, the painter, happens to be knocked down by a pig; he makes a witty remark and, on being asked about something else, he makes another one (LXXV).
Maestro Alberto proves that the astuteness of Florentine women makes them the best painters in the world and that they contrive to render every diabolical countenance angelic and marvellously to iron out the creases in disguised and twisted faces (CXXXVI).
This third tale is of particular interest since it refers to the gap left by the death of Giotto ... 'among other things, one (Andrea) Orcagna, who was in charge of the noble oratory of Nostra Donna d'Orto San Michele, asked.: Who, apart from Giotto, was the greatest artist? Some replied Cimabue, others Stefano, Bernardo (Daddi) and Buffalmacco and various others. Then Taddeo Gaddi, who was of the company, said: There have indeed been fine painters and they have painted in a manner which would seem impossible to human nature; but such art is becoming increasingly a thing of the past.'

**1490** A public decree ordained the erection of a memorial tomb in the Duomo in Florence, with an effigy of the artist by Benedetto da Maiano and an epitaph by Poliziano (see An Outline of the Artist's Critical History).

**1827** · C. F. Rumohr (*Italienische Forschungen*, II) published for the first time the *Canzone della Povertà*, a long

poem attributed to Giotto which is preserved in two Florentine manuscripts, 47, plut. 9° (Laurenziano) and 1727 (Riccardiano). Rumohr's attribution of the poem to Giotto is supported by Rosini, Milanesi, Carducci and others. However, there is no documentary evidence for this assumption, and modern scholarship is inclined to discount the possibility.

**1829** A 'registered letter with signed receipt of delivery' sent by the *Podestà* of Padua, A. Saggini, to the noble lord Grandenigo, proprietor of the Scrovegni Chapel, effectively prevented the demolition of the building, which was already under way (Prosdocimi, 1961).

**1849** The frescoes in the Peruzzi Chapel in Sta Croce, Florence, which had been whitewashed a century earlier, were again brought to light.

**1852** This year marked the rediscovery of the frescoes in the Bardi Chapel which had suffered the same fate.

**1856–7** An article in *The Times* reporting a fall of plaster from the frescoes in the Scrovegni Chapel, served to highlight again the question of restoration.

**1880** After prolonged negotiations, the Commune of Padua secured ownership of the Scrovegni Chapel.

**1901** Erection in Vicchio, where the Master is held to have been born, of a memorial to Giotto, by Italo Vagnetti.

**1937** Celebrations to mark the sixth centenary of the death of Giotto, and Giotto Exhibition in Florence. This exhibition played a considerable part in promoting study and research into the Master's work, activities which were further stimulated by the discussions and debates concerning the authorship of the Rimini Crucifix (no. 113). As a result, it became apparent that his work had not been confined merely to Assisi, Padua and Florence, as had formerly been supposed.

*Portrait of Giotto reproduced at the beginning of his biography in the second edition of Vasari's Lives (Florence, 1568)*

**GIOTTO PITTORE, SCVLTORE ET ARCHITETTO FIOR.**

# Catalogue of Works

## Biblical Cycle (*Assisi*)

The extent to which Giotto contributed to the execution of the frescoes illustrating scenes from the Old and New Testaments in the nave of the Upper Basilica of S. Francesco in Assisi constitutes a complex and much discussed problem. Most experts are of the opinion that this cycle contains some of the earliest examples of the artist's work. Controversy still rages as to which of these frescoes were, in fact, executed by Giotto, and when. Moreover, the very poor state of preservation of the frescoes themselves (in many cases only a few fragments now remain) renders the problem even more difficult of solution.

Once Cimabue had completed the frescoes in the sanctuary and transept, a number of painters continued with the work of decoration in the direction of the nave. These included some of Cimabue's own followers of the Tuscan and Roman schools, among whom was Jacopo Torriti. It is now very difficult to identify the work of each individual artist in view of the uncertainty concerning the chronology of Cimabue's own work, though it is generally held (cf. Gnudi, 1959; Salvini,

1962, etc.) that this was executed round about 1280. There are two series of parallel frescoes on the upper half of the wall on either side of the nave above the ambulatory (see sketches at foot of page). Scenes from the Old Testament are featured on the right-hand side and from the New Testament on the left (see also p. 88). Four scenes, on two levels, are depicted in each bay, the individual frescoes being approximately three metres square. However, although the lower frescoes are rectangular, the upper ones are tapered on account of the vaulted roof. The last two (*Pentecost* and the *Ascension*) occupy the entire expanse of the west wall, on either side of the rose window, in panels measuring four metres (in width) by five metres (in height). The frescoes attributed to Giotto are those in the third and fourth bays counting from the sanctuary (second and first respectively counting from the doorway); they depict, on one side, the last two episodes in the Isaac cycle (third bay, upper row) and, opposite, the *Way of the Cross* and the *Crucifixion* (third bay, lower row), and also (fourth span) *Christ among the Doctors* and *Baptism of Christ* (upper row) and *Mourning the dead Christ* and *Resurrection* (lower row). The last two scenes from the Gospel, *Pentecost* and the *Ascension*, are normally considered in conjunction with those depicted alongside them on the left-hand wall; however, the probability of their having been executed by Giotto is completely discounted by recent critics.

The theory that this series of frescoes does, in fact, afford some of the earliest examples of Giotto's work carries a certain amount of weight if the dating of Cimabue's work in the region of 1280 is accepted. This would mean that the biblical scenes here discussed were executed

over a fairly long period after that date but at some time prior to the cycle featuring the Legend of St Francis, executed below the frescoes in question, presumably in the years 1296–7. However, if we accept Brandi's theory (1951 and 1956) that Cimabue was at work in the years 1288–90, then the possibility of Giotto's having worked on the biblical cycle becomes problematical. It was Thode (1885) who first attributed to Giotto the Isaac cycle and all the frescoes in the fourth bay. His theory has been fully endorsed by many later scholars, including Berenson, Cecchi, Longhi, Gnudi and Salvini. Coletti (1949) is, however, of the opinion that only the frescoes in the fourth bay are Giotto's work. Like many earlier scholars, including Thode and Toesca, Coletti therefore attributes the remaining frescoes under discussion to a mature but unknown painter, referred to as the 'Maestro di Isacco'. Other scholars incline to the view that Giotto's share in these frescoes was even more restricted. Salmi attributes to him only part of the *Mourning the dead Christ* and the *Resurrection*; Bauch (1953) grudgingly recognizes his hand only in the Isaac cycle; Brandi (1951 and 1956) refuses to see here any trace of Giotto's work at all, maintaining that the earliest examples of his art are to be found in the lower cycle of frescoes, devoted to the Legend of St Francis. Indeed, Brandi points out that the Doctors of the Church, depicted in the vault over the fourth bay (which makes them earlier than the wall frescoes) and attributed by some scholars to Filippo Russuti, are in fact stylistically more advanced than even the cycle of Franciscan frescoes. Moreover, he continues, they cannot have been executed prior to 1295, the year in which the cult of these Doctors was solemnly raised to the same degree as that of the

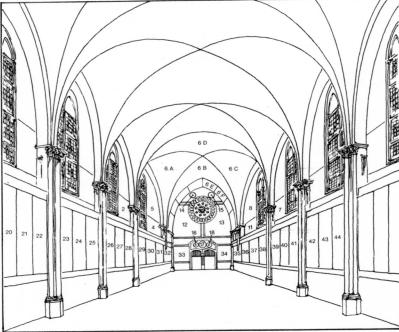

*Diagram showing location of paintings in Upper Basilica of S. Francesco in Assisi, the numbers being* *those used throughout this Catalogue. Above right: view of basilica from high altar looking towards main* *entrance. Above left: plane diagram of the same area with walls folded outwards for ease of reference*

1

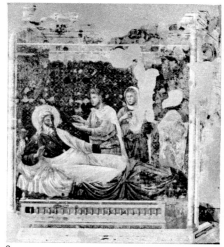

2

3

5

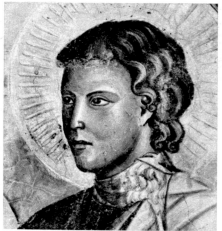

*Jacob (detail of painting no. 1)*

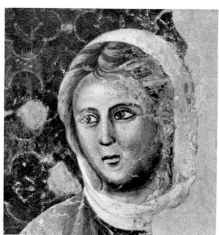

*Young bystander (detail of no. 2)*

4

*One of Joseph's brothers (detail of no. 4)*

86

Evangelists (who are portrayed in the vault above the choir). It would therefore seem, runs Brandi's argument, that the decoration of the vault and of the upper portion of the walls in this fourth bay cannot have preceded the execution of the Legend of St Francis. In this case, there is no basis for the view that the frescoes in the third and fourth bays contain any of Giotto's work; in fact, Brandi attributes them to some other artist, possibly older than Giotto but influenced by him, and working in Assisi at a time when the Franciscan cycle was at least partially completed. Gnudi (1959) holds that the frescoes portraying the Doctors of the Church were painted over some earlier theme between the years 1297 and 1300, though he shares the view that the biblical frescoes date from approximately 1290. Brandi's questioning of Giotto's share in the execution even of the Isaac cycle arises out of considerations of a chronological nature connected with the decoration of the transept of the Basilica of Sta Maria Maggiore in Rome (cf. no. 19). Salvini held that there were insufficient grounds to render such considerations valid. Battisti (1960) attributes the Isaac cycle to a great Roman painter – possibly Cavallini, who had already been influenced by Giotto – while opting for the view that the Joseph cycle is the work of a pupil of Cimabue, also influenced by Giotto; moreover, he dates the latter cycle somewhat after the execution of at least the early frescoes in the Franciscan cycle. Gnudi has lent much weight to the argument that the biblical cycles in question are in fact Giotto's work; he also inclines to the view that Giotto's hand is to be seen in the right half of the *Way of the Cross* and reckons that the order of execution of the various frescoes was as follows: *Way of the Cross*; the (Old Testament) Joseph cycle and the fragment of the *Slaying of Abel*; Gospel scenes in the fourth bay and, finally, the Isaac cycle. In Gnudi's view, the differences in style which are apparent in the various frescoes can be accounted for by the broadening influence of the artist's repeated trips to Rome, the first of which was made before his earliest efforts in Assisi. In the course of it, not only did Giotto benefit from the teaching of Cimabue, but he was also able to study the Cavallini frescoes of St Paul (now lost) and get acquainted with the art of classical antiquity. If it is believed that he made a further trip to Rome during which he was able to study Cavallini's mosaics in Sta Maria di Trastevere (1291), there are plausible grounds for attributing the Isaac cycle to Giotto. The subsequent further development in style apparent between this cycle and the Franciscan Legend frescoes beneath may be accounted for by yet another trip to Rome, during which the vital meeting between Giotto and Arnolfo took place. It should at least be pointed out that Meiss (1960)

*Isaac (detail of no. 2)*

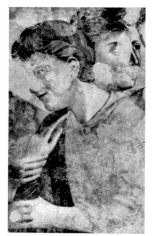

*Brothers supporting Joseph (detail of no. 3)*

would seem to endorse the view which dates the Isaac cycle *after* 1291, and that he, too, has detected the iconographic connection between this cycle and the Cavallini mosaics in Sta Maria di Trastevere in Rome. Salvini supports his view that the frescoes in the third and fourth bays are Giotto's work by pointing to undeniable affinities between these and some of his other works of unquestioned authenticity, though he recognizes the marked inequalities of style. His dates for the Isaac cycle are 1291–2 and for the frescoes in the fourth bay 1294–5. While he agrees that there are grounds for believing that Giotto had some hand in executing the *Way of the Cross,* he points out that there can be no definite proof of this. He further shares the view that neither *Pentecost* nor the *Ascension* is Giotto's work.

The frescoes have been considerably damaged by damp which has, in many cases, caused the plaster to fall away completely; the New Testament cycle has suffered most.

Although (indeed, in a sense, because) the question of attributing the biblical cycle to Giotto is still an open one, it is worth noting that there are certain features in these frescoes which constitute an ideal

stepping stone for Giotto's later work in the Franciscan cycle. The influence of Cimabue is to be detected in particular in certain largely external features: faces defined and emphasized by the use of light, smooth, simplified modelling of features and clothes. However, there is nothing of Cimabue in the sense of drama, which is both more restrained and more intense, in the conveying of a sense of space and in the range of rich and luminous colouring. Giotto's study of classical painting, coupled with his acquaintance with the work of Cavallini and Arnolfo, undoubtedly equipped him with the appropriate means for expressing a reality which differed, in his eyes, from that of his first tutor and which, for him, possessed a less transcendent and more human quality. All these elements may be detected, in varying degrees, in the individual frescoes of the biblical cycle, while they are seen to have been assimilated into an organic whole in Giotto's later work.

The various frescoes are here reviewed in order, starting from the third bay in the transept and taking first the right-hand and then the left-hand wall (Old and New Testament cycles respectively).

## Old Testament Cycle

### (right-hand wall)

**1**  *300×300*

**Jacob Receives the Blessing of the First-Born**
Isaac, old and blind, is given a dish of meats by Jacob, in the presence of Rebecca. Jacob is wearing his brother's clothes and his neck and hands are covered with goatskin, thus simulating the hairiness of Esau (Genesis, 27). The rather monotonous brick-red colouring used in this and the next fresco, in contrast to the rich colouring used in the fourth bay, was one of the reasons put forward by Coletti (1949) for questioning Giotto's authorship. However, subsequent cleaning operations revealed that the alleged difference was an illusion (Salvini, 1962). A number of scholars have drawn attention to the sense of spatial unity conveyed by enclosing the figures in a sort of 'perspective box'. This quality, together with certain marked affinities with classical culture (Gioseffi, 1963), betrays some Gothic influence, 'denoted by certain significant similarities between the artist's handling of architectural themes and the style of the miniatures in the St Louis Psalter (Paris, National Library), which may be dated between 1251 and 1270' (Schrade, 1959). The fresco is now incomplete; much of the architectural detail in the upper left-hand corner and some of the lower part of the picture is missing.

**2**  *300×300*

**Isaac rejects Esau**
Esau offers to Isaac, who is in bed, the food which he has prepared. His father is puzzled, since he has already received and blessed Jacob (Genesis, 27). There is a young woman, probably Rebecca, on Esau's right and to the extreme right of the picture there is another figure, now almost lost. The spatial setting is the same as in the previous fresco. The fact that the centre of the painting is a great deal clearer makes it possible to detect a marked iconographic affinity with Cavallini's *Birth of the Virgin* in Sta Maria in Trastevere in Rome.

**3** *300×300*

**Joseph is thrown into the Pit** or **Joseph is sold by his Brethren**
Owing to the very poor state of preservation of the fresco, it is impossible to say exactly which episode is here portrayed. It would seem, however, that the theme is taken from Genesis, 37, and portrays either Joseph's brethren who, consumed with jealousy, strip from him the coat of many colours given to him by his father (left-hand group) and let him down into a pit (right-hand group) or the brothers' subsequent decision to get rid of Joseph in some other way by selling him to some merchants (left-hand group), having first rescued him from the pit (right-hand group). The clearest sections are two mountainous spurs rising on either side of the centre of the picture.

**4** *300×300*

**Cup found in Benjamin's Pack**
To the right Joseph (haloed) is seated on a richly adorned throne; behind stands a soldier. Joseph's brothers kneel before him; standing upright in the background is a servant who is accusing them and showing Joseph's silver cup, found in Benjamin's pack. The episode in which Joseph causes a silver cup to be concealed in his youngest brother's pack in order to put them all to the test is recounted in Genesis, 44. The background features a city, much of the right half of which is lost. A new depth is conferred on the figures in the bottom centre by the sense of atmosphere conveyed by the architectural features in the background.

**5** *300×300*

**Slaying of Abel**
As the fresco has been almost completely lost, its theme can only be deduced. Only a portion of the countryside remains. This includes the outline of two hills rising away to left and right. There are trees growing on the hill on the right: '(Giotto's) first tender view of nature'. (Gnudi)

## Doctors of the Church and Saints

### (Vault and intrados in fourth bay)

**6** *1297-1300*

At the top, in each case, and surmounting the architectural setting comprising the alcoves and seats (adorned with Cosmatesque columns), there is a representation of the head of the Redeemer in a semicircle of clouds. The Doctors may be identified from the legends, which appear in these clouds: they are St Ambrose (S. AMBROSIVS/DOCTOR); St Jerome (S. IERONIMVS/ DOCTOR); St Augustine (S. AGVSTINVS/DOCTOR) and St Gregory the Great (S. GREGORIVS/DOCTOR). The last-named inscription has largely faded. Vasari alone attributed these paintings to Cimabue, and Della Valle questioned this as early as 1791. As has already been pointed out, there is considerable disagreement among modern critics on this point: Strzygowski opted for Giovanni

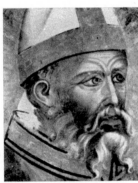

*Head of St Augustine in cell 6 C*

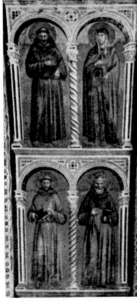

*Detail of intrados of arch beyond fourth bay; the figures are (top to bottom and left to right): St Francis and St Clare (6 E) St Anthony and St Benedict (6 F)*

di Cosma, Hermanin for Torriti, A. Venturi for Rusuti and Sirén and Van Marle for an unknown painter of the Cavallini school; while Supino inclined to the view that the frescoes represented an early work of Cavallini himself. Though there are exceptions, the current opinion is that they do, in fact, date from the early days of Giotto's artistic activity

and that he either worked on them himself in conjunction with one or more assistants (Schnaase, Zimmermann, Wulf, Kleinschmidt, etc. up to and including Previtali) or that they were executed by a follower (Nicolson, etc.) — but see p. 86. The ambitious nature of the design, the various details of form and iconography (e.g. the figure of the cleric depicted in

*Cell in ceiling featuring St Ambrose (no. 6 A)*

*Cell in ceiling featuring St Jerome (no. 6 B)*

*Cell featuring St Augustine (no. 6 C)*

*Cell featuring St Gregory the Great (no. 6 D)*

7

*Madonna (detail of no. 7)*

8

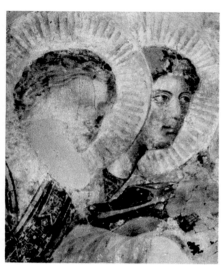

*One of the Baptist's assistants (detail of no. 8)*

9

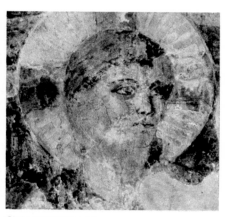

*Christ (detail of no. 9)*

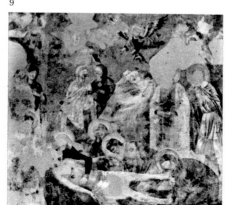

10

11

the cell with St Jerome) coupled with the magnificent quality of the actual execution make it in fact impossible not to think in terms of the Master's work.

On either side of the intrados, various saints are depicted in pairs in double apertures separated by a spiral column adorned with Cosmatesque motifs. The names of these saints had been painted above their heads, and some are still legible. On the left-hand side, counting from the top, we have: two bishop saints, then Dominic and Peter the Martyr (S. DOMI/NICVS and S. PETRVS), Rufino and Vittorino (S. RVFIN/VS and S. VICTO/RINVS); below these, there are two martyrs. On the right-hand side (again counting from the top) we have Francis and Clare (S. FRAN/CISCVS and SCA CLA/RA); Anthony and Benedict (S. ANTO/NIVS and S. BENE/DICTVS), Agapito and Laurence (S. AGA/BITVS and S. LAVR/ENTIVS), followed by a king and another saint.

## New Testament Cycle

### (left-hand wall)

**7** ⊞ ✛ *300×300* 目 ⋮

**Way of the Cross**
Christ proceeds escorted by soldiers and ruffians; the Virgin Mary accompanied by another woman (depicted with halo) follows in his footsteps. Gnudi has commented on the great difference in style between the left and right halves of the picture. He holds that only the latter is the work of Giotto and that it was executed at a time (probably round about 1290) when the artist was still strongly influenced by Cimabue. He attributes the remainder of the fresco to a Florentine artist, the 'penultimo Maestro del Battistero'. However that may be, the painting had been studied apart from Giotto's other work as early as 1930 by Nicolson, who was inclined to classify it with the series of works attributed to the so-called 'Maestro di Isacco'.

**8** ⊞ ✛ *300×300* 目 ⋮

**Baptism of Christ**
All that remains of this fresco are two heads, each with a halo, on the left of the picture, while part of a figure is still visible on the right. Salvini is of the opinion that the fresco is of the Giotto school. However, Gnudi holds that the two angels' heads show marked affinities with the style of Duccio.

**9** ⊞ ✛ *300×300* 目 ⋮

**Christ among the Doctors**
The only section of this fresco still decipherable is a fragment of the haloed head of Christ against an architectural background. Gnudi has drawn attention to the similarities between this head and those in the *Way of the Cross* (no. 7).

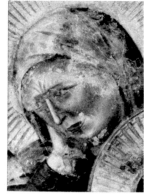

*Head of mourner (detail of no. 10)*

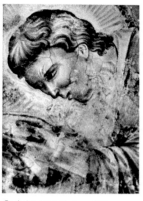

*St John (detail of no. 10)*

**10** ⊞ ✛ *300×300* *1290* 目 ⋮

**Mourning the dead Christ**
In the foreground, we have the figure of the dead Christ, mourned by the three Marys and St John, all of whom are bending over the body. In the background, which is well defined by a mountain slope, there are a number of other figures. These include a veiled woman to the left, two others in the centre, while two further figures, complete with haloes, are depicted to the right of the mountain. In the sky, there are angels in flight. The head of Christ, as well as those of the two figures in the right background, is now lost. Most critics have commented on the marked dramatic effect of the composition in which the knitting of figures and setting in a vital spatial unity displays beyond doubt Giotto's attainment of his style.

**11** ⊞ ✛ *300×300* *1290* 目 ⋮

**Resurrection of Christ**
There remain traces of the figures of soldiers asleep in front of the sepulchre, of which only the base is visible. Further up, and towards the centre, there are a few fragments of a garment which probably formed part of the figure of the risen Christ. These few fragments are vitally important because they display a 'bold and complex handling of the problems of perspective presented by the numerous figures involved' which, moreover, are here foreshortened (Coletti, 1949); they are 'bathed in a clear light' (Gnudi) and this has the effect

of establishing a new relationship between the sleeping figures and their setting.

## New Testament Cycle

### (end wall)

The frescoes on the upper portion of the end wall of the basilica (*Ascension, Pentecost,* medallions with the heads of *St Peter* and *St Paul*) are normally studied in conjunction with the remainder of the New Testament cycle (nos. 7–11) and, generally speaking, the opinions of the experts concerning them are much the same as in the case of the latter. Writing in 1959, Gnudi considered them independently and attributed them to 'assistants who may even have been from Rome, and who were

the figure of an angel with, above that of Christ. Most of the plaster from the lower half is now lost.

**14**  diam. 50*

### St Paul
This medallion is in a reasonably good state of preservation.

**15**  diam. 50*

### St Peter
This medallion, too, is fairly well preserved.

**16**  diam. 60*

### Angel
This and the companion medallion, together with that of the Madonna (no. 17, q.v.), may be dated between the Old and New Testament cycles and the

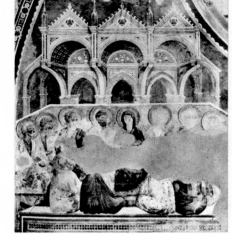

12

13

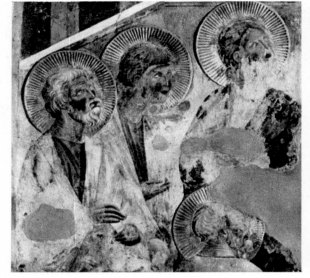

*Apostles (detail of no. 12)*

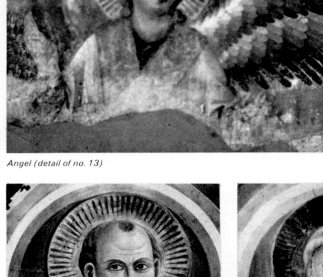

*Angel (detail of no. 13)*

responsible for the presence of certain more archaic elements and differences in style at a time when Giotto himself was already engaged on the Franciscan cycle'. A study of the handling of the various problems of perspective in these frescoes and of the affinities between these and the last-signed frescoes in the Franciscan cycle led both Gioseffi (1957 and 1963) and Salvini (1962) to conclude that they were executed shortly before Giotto began work in Padua. Salvini held that the frescoes were the work of a Giottesque artist.

**12**  *500×400*

### Pentecost
The seated figures of the Apostles and of the Virgin are badly damaged : a large portion of plaster has come away in the centre of the fresco. However, the architectural details and the dove are reasonably preserved.

**13**  *500×400*

### Ascension
Only the upper portion of this fresco remains intact, including

Franciscan cycle. Although Gnudi recognizes a certain affinity with the corresponding figures executed by the Master of St Cecilia in the so-called 'Madonna of St Margaret' at Montici, he asserts nevertheless that they display marked characteristics of Giotto.

**17**  diam. 110*

### Madonna with Child
This medallion was probably executed round about the time when work began on the Legend of St Francis in the same basilica. The colouring is more solid than in the Old Testament cycle which decorates the upper part of the walls, while the light is both more pronounced and handled with a surer touch. The figure of the Virgin clearly displays 'a move towards an almost monumental style in the sense of solidity and three-dimensional quality with which the figures are endowed' (Gnudi).

**18**  diam. 60*

### Angel
See no. 16 above.

14                              15

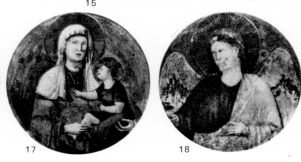

16                  17                  18

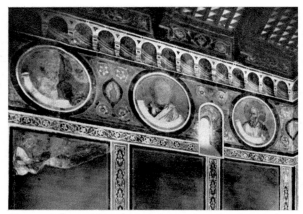

*Three medallions with heads of prophets and remains of panel with God the Father (see this page) in Sta Maria Maggiore, Rome (no. 19)*

## Biblical Figures (Rome)

## 19 ⊞ ⊕ ⚊ ⊟ ⋮

The figures are a series of seven medallions in the Basilica of Sta Maria Maggiore in Rome portraying a number of prophets, together with the remains of a panel beneath depicting God the Father. The frescoes are at the very top of the left transept and probably mark the commencement of a cycle which was never finished (Salvini, 1962). The theory that they represent some of Giotto's early work is shared by most of those critics who also attribute to him the Isaac cycle in the upper basilica in Assisi. Others, while recognizing the similarities in style between the two sets of medallions, nevertheless hold that these are not Giotto's work. Toesca (1904 and 1914) was the first to study these medallions and he attributed them to Giotto, setting the date of execution around 1295. Salmi (1937) endorsed this view and suggested that the decoration of the basilica had been interrupted by the election of Boniface VIII, since he was at loggerheads with the Colonnas who had commissioned the work; the Pope deprived them of all their property in a decree dated 1297. Coletti (1949) attributed the medallions to an unknown artist whom he terms a

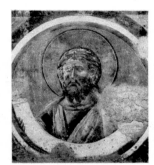

*Prophet (unidentified) in medallion (no. 19)*

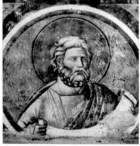

*Prophet (unidentified) in medallion (no. 19)*

'Maestro dei Clípei' and describes as someone influenced by the young Giotto, but whose style was more archaic. Gnudi (1959) inclines to Berenson's view and attributes them to a Roman painter of the Cimabue school.

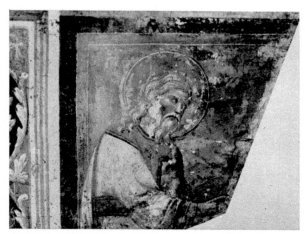

*God the Father blessing – from the incomplete panel below the medallions (see this page) in Sta Maria Maggiore, Rome (no. 19)*

# Franciscan Cycle (*Assisi*)

This cycle adorns the lower half of the walls on both sides of the nave and the end wall on either side of the doorway in the Upper Basilica of S. Francesco in Assisi. It comprises a series of twenty-eight scenes arranged in groups of three per bay, with the exception of the first bay from the doorway end, where there are four scenes, the fourth in each case appearing to the right and left respectively of the door. Each fresco has been set in a frame composed of horizontal decorative motifs, interspersed with spiral Cosmatesque columns, which are, of course, also painted.

The actual iconography of the cycle is based on the *Legenda maior* written by St Bonaventure between the years 1260 and 1263 and based, in turn, on oral tradition and earlier biographies of the saint. The frescoes have always been attributed to Giotto, although there is no documentary proof to this effect. Riccobaldo Ferrarese, the chronicler (1312), refers to the Master's activity in Assisi without specifying in what this activity consisted. Round about 1450 Ghiberti declared that Giotto 'painted in the church at Assisi owned by the Order of Friars Minor, nearly all the lower part'. It was this phrase which led many critics, particularly in the nineteenth century, to attribute some of the frescoes in the lower basilica to Giotto, a theory largely discounted nowadays. Gioseffi has recently pointed out (1963) that Ghiberti was almost certainly referring to the fact that the Franciscan cycle occupies the portion of the wall 'below the triforium' which separates it from the upper cycle of biblical frescoes. In the second edition of his *Lives* (1568), Vasari is clearly referring to the Franciscan cycle and it is only through an oversight that he mentions thirty-two and not twenty-eight scenes. Thereafter, the opinion that the frescoes were in fact the work of Giotto remained unquestioned until Witte (1821) and Rumohr (1827) denied their authenticity on stylistic grounds. After this, there seem always to have been some scholars who have questioned the traditional attribution of these frescoes to Giotto. In fact, Rintelen (1912), Fisher (1956) and Meiss and Smart (1960) have all drawn attention to the marked differences between this cycle and the corresponding cycle in Padua, particularly as regards the overall spatial concept. As Salvini (1962) has rightly said, for some time now Italian scholars (who hold – almost unanimously – that the Assisi cycle is in fact the work of Giotto) have been engaged on a critical reconstruction of the whole of Giotto's work with a view to proving that,

notwithstanding the undeniable differences in style as compared with the frescoes executed in Padua and Florence, the pictorial handling of the Assisi cycle does not differ basically (nor, therefore, in its treatment of space) from that of the other frescoes known to have been executed by him. Assuming that the frescoes are in fact Giotto's work, they can be dated to within fairly narrow limits. Vasari asserts that the work was commissioned by Fra Giovanni di Muro della Marca, General Minister of the Franciscans from 1296 to 1305. However, most modern scholars are inclined to support the view (critically discussed by Murray, 1953) that the frescoes date from the years 1291–2. One positive piece of information is afforded by the date 1305, the year in which the Torre del Popolo in Assisi was completed. As this is shown, still unfinished, in the fresco portraying the homage paid to St Francis by a man in the street (no. 20), we may conclude that the cycle must have been executed at some time prior to this. Moreover, Giotto is known to have been at work in Padua in 1305, and all the critics are agreed that the Assisi cycle preceded his activities in Padua. Finally, bearing in mind the fact that he was engaged on the Lateran fresco in Rome in the year 1300, it would seem to be

fairly certain that at least the portion of the Assisi cycle not entrusted to assistants or collaborators was completed before this date. All this data would seem to argue in favour of dating the cycle in question between the years 1297–8 and 1300.

The considerable extent to which Giotto was assisted in the execution of this cycle can be accounted for by the fact that he had to leave for Rome in the year 1300. It would seem that the work continued for a number of years after that (Gnudi), on the basis of designs or sinopias (under-drawings) provided by the Master. Salvini shows that there is less and less of Giotto's own work in the last nine frescoes (with the exception of that depicting the *Poor Clares mourning the death of St Francis*, which is based on his own composition). It is generally held that the last three (*Healing of an Injured Man at Lerida; Raising of a Woman to Life; Release of Pietro d'Assisi*) are the work of the so-called Master of St Cecilia. For this reason, these three frescoes are not discussed here. In the last analysis, in spite of the considerable contribution

*Sketch showing the painting procedure for no. 25. The extent of each day's work is shown by a continuous black line where it has been possible to determine the position accurately; otherwise a dotted line has been used. The numbers represent the probable sequence of 'days'. The shaded portions represent areas of the fresco now missing. These symbols have been used in all similar sketches reproduced in the course of the Catalogue. Most of the data has been derived from Tintori and Meiss (1962)*

made by assistants and pupils, the 'entire cycle clearly shows the hand of a great artist' (Salvini). An important recent contribution is Gnudi's detailed survey of the individual scenes which represented the first serious attempt to establish which portions of the frescoes were, in fact, executed by Giotto, and also the identity of his assistants. Other important contributions in this field have been made by Battisti. Gioseffi

(1963) concerned himself in particular with the question of the handling of perspective by Giotto and has produced a detailed study of the treatment of buildings in this cycle.

In the course of the centuries the greatest damage to the frescoes has been caused by damp, as a result of which much of the colour has faded and the actual plaster fallen away, particularly in the case of the frescoes on the left-hand wall. There is a record of some restoration having been carried out by Carlo Fea in 1798, when the frescoes had become 'almost invisible on account of the dust and nitrous calcareous deposit' (Fea, 1820). Much of the original 'dry' work has now disappeared (Zocca, 1936). Of the many remedial measures later adopted, the recent work of restoration and preservation executed by Tintori is of particular interest. Tintori and Meiss (1962) are also responsible for the interesting light which has been thrown on the actual sequence of execution and the area of fresco covered in each day's work.

The frescoes are here studied in their 'chronological' sequence, taking them in order, therefore, from the right of the altar (the right in this case being that of anyone standing with his back to the door). With certain exceptions, this particular order is also that in which the frescoes were in fact executed.

The Franciscan cycle in Assisi confirms the artistic development which had already been foreshadowed towards the end of the Old Testament series. It reveals how the art of Giotto synthesizes the extremes of the Gothic tradition which, in Nicola and Giovanni Pisano and in Arnolfo, had manifested itself in a marked feeling for a freer and more lifelike representation, tending to move further and further away from the more abstract iconography of the Byzantine style. The work of Giotto, even as exemplified in the Old Testament cycle, fits neatly into this pattern, since it makes use of three-dimensional groupings so arranged as to convey an impression of a human quality in order to express a new reality – the reality of the artist's own time. It is through this natural, though imaginative, quality that Giotto imbues his work with his own extraordinary artistic genius, for which he may be said to have devised his own language. In the Assisi cycle, the lyrical quality of the inspiration is expressed in a manner which is at once gentle (the artist was undoubtedly assisted by the popular nature of the Franciscan tradition) and imbued with a vibrant emotion.

## 20 Man in the street pays homage to St Francis

*270×230* 1300*

Though this is the first episode in the cycle, all the experts agree that the fresco itself was among the last to be executed. Coletti suggests that the actual theme was altered, either because the Friars who had commissioned the work kept changing their minds or because Giotto himself changed his. Others are of the opinion that when the frescoes were started, the work of erecting the architrave for the iconostasis was still under way, thus making it impossible to execute the fresco at that stage. In any case, it cannot be dated any later than 1305 because this was the year in which the Torre del Popolo was completed, and the fresco shows it still half built. Acknowledged to be not entirely the work of Giotto, many scholars have detected in this fresco the hand of the Master of St Cecilia, chiefly on the ground of affinities of style between it and the last few frescoes on the opposite wall which are, in fact, generally attributed to this same artist. The fresco has suffered some damage in the top right-hand corner, the portion affected representing one of the buildings. St Francis' tunic has also suffered in that much of the dry finish has fallen off. A study of the plaster has shown that a full 'day' was devoted to executing the head of the saint alone; this was almost certainly largely on account of the halo, which is both elaborate and done in relief (Tintori and Meiss).

The *titulus* states that the man declared that Francis was worthy of all reference as a man destined to achieve great things.

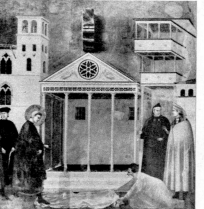

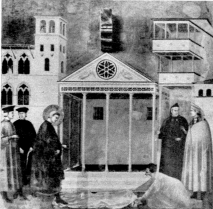

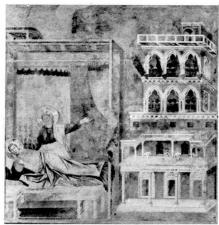

20  Plates II-IV

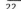

21

22

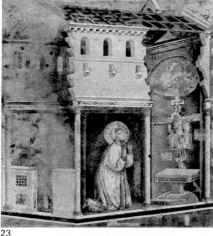

23

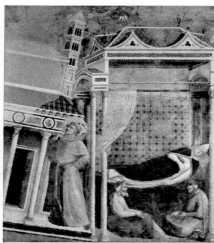

24

25

## 21 The Cloak Incident

*270×230* *1297-99*

The episode featured is the occasion on which the 'blessed Francis met a knight of noble birth but poor and ill-clad and, being moved to compassion by his plight, the saint at once took off his cloak and gave it to him'. Nearly all the critics agree that this was the first fresco of the cycle to be executed. The handling of the figures, which is entirely Giotto's work, is held by many critics to reveal many characteristic features of his style. A semicircular portion of the fresco is missing to the extreme left at the top, corresponding to the gate of the city, which has been identified as Assisi. As in the previous painting, tempera has been responsible for the deterioration.

## 22 The Saint sees a Building in a Dream

*270×230* *1297-99*

The *titulus* runs as follows : 'The next night, while the blessed Francis was asleep, he saw a great and splendid palace with armaments . . .'. The picture is divided into two. In the left foreground we have the room in which the saint lies asleep. Standing beside him is the figure of Christ pointing to the symbolic vision of the palace, representing the Franciscan 'army' of the future and depicted slightly to the rear. The fresco is in a reasonably good state of preservation, though more extensively damaged than the first two. There are some bare patches towards the bottom and round the head of Christ. Salvini has shown that, as in the case of the next fresco, some of Giotto's pupils had a limited share in the execution of the painting.

The gold decoration on Christ's mantle is now missing.

## 23 The Crucifix at San Damiano speaks to St Francis

*270×230* *1297-99*

According to the original inscription 'while the blessed Francis was praying before the Crucifix, he heard a voice from the Cross which said to him three times: "Francis, go and repair my house which is falling in ruins"' . . . the reference being to the Church of Rome'. The building shown is the abandoned church of S. Damiano near Assisi (the exhortation was taken by Franciscan commentators to refer also to the reconstruction of this church). The foreshortening of the architectural setting has been seen by many experts (and most recently by Gioseffi) to foreshadow the characteristic spatial treatment of Giotto's mature work.

The left-hand side of the fresco is much damaged.

## 24 St Francis renounces his Worldly Possessions

*270×230* *1297-99*

The fresco depicts the saint 'when he returned all he possessed to his father and, having taken off his clothes, renounced all his father's and, indeed, *all* temporal goods, saying to his father: "Henceforth I can say with confidence 'Our Father, who art in heaven' since I have been cast off by Pietro di Bernardone" '. The scene portrays the moment at which Francis, having taken off his clothes, and his nakedness having been covered up by the bishop as best he could, invokes the Eternal Father (only a hand remains of what was probably a symbolic representation of the Father in the top centre of the picture) while he is confronted by an irate Pietro di Bernardone, who is held back by one of his retainers. Gnudi maintains that Giotto did not execute the entire fresco himself: some of the heads in Bernardone's suite and possibly also the bishop's head may have been the work of another.

The expressive unity of the figures and of the architectural setting has been emphasized by many critics.

*91*

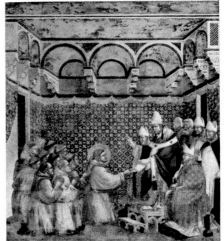

26 Plates V-VI

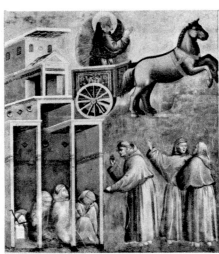

27 Plate VII

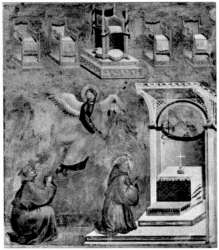

28 Plate VIII

*Sketch showing painting procedure for no. 28*

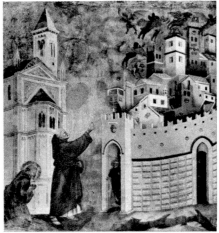

29 Plates IX-X

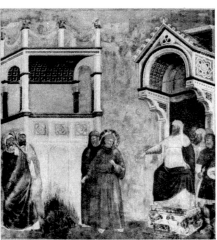

30

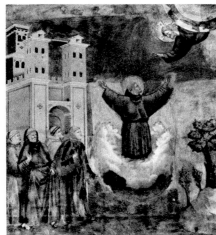

31

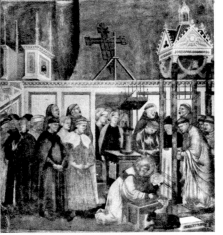

32 Plate XI

## 25 *270×230* *1297-99*

### Innocent III's Dream

The fresco shows the dream of Pope Innocent III or 'how the Pope saw the Lateran palace about to collapse and how it was held up by a poor man (who is understood to be the blessed Francis) who has placed his shoulder under it to prevent it from falling'. The essential similarity between the spatial concept in this fresco and in the Isaac cycle, coupled with the more marked influence both of Arnolfo and of the Cosmati, are all features which have been studied and commented on by recent scholars, and particularly by Gnudi. The actual execution is believed to be entirely Giotto's work. The figure of St Francis appears to have been better preserved than in the previous scenes because, in this case, his friar's tunic was executed entirely by the 'true' or *buon fresco* method (the technique employed for the blue tunic worn by the saint in the previous scenes involved the application of the colour to the dry plaster as was the custom at the time largely owing to the need to economize on the use of the precious lapis lazuli powder).

## 26 *270×230* *1297-99*

### Franciscan Rule Approved

In this fresco we have the occasion on which 'the Pope (Innocent III) approved the Rule and charged him to preach penance and ordered that the friars who had accompanied him be given the tonsure so that they could preach the word of God'. Some critics (Coletti and others) have seen in the highly individualistic treatment of the friars' features a hand other than Giotto's. Others, however (Gnudi, etc.), maintain that the Master here displays something of the characteristics of a storyteller and that this very factor marks the great strides which his art has taken away from the hieratical patterns of the Middle Ages. The technical perfection of the perspective is a feature to which Gioseffi draws special attention. The decoration of the room was originally a great deal richer: much of the ornamentation, applied by the dry fresco method, has now been lost (Tintori and Meiss).

Many critics have drawn attention to the contrast between the earthly image of the Church in its splendour and the austerity of the friars, as the Church's spiritual image.

## 27 *270×230* *1297-99*

### Vision of the Fiery Chariot

'While the blessed Francis was praying in a cave and the friars were assembled in another cave outside the city, the saint being physically separated from the rest of the band, behold they saw the blessed Francis in a glowing fiery chariot pass through that place at about midnight, bathing the entire cave in a bright light. Those who had been awake were amazed and they roused their sleeping companions and terrified them with their tale'. The artist's choice of focal points here contrasts the side view as seen from the right in the lower half of the picture, and the left side view shown in the upper portion. White maintains that this contrast has been used to emphasize the antithesis between the 'unearthly' nature of the vision and the reality of the world. The fresco is in a reasonably good state of preservation though, unfortunately, the saint's face is no longer very clear.

## 28 *270×230* *1297-99*

### Vision of the Thrones

This fresco depicts the vision granted to one of St Francis' companions who saw 'in heaven a number of thrones and one, more elaborate than the others, glowing with every possible adornment; and he heard a voice saying: "This throne belonged to one of the fallen angels, but now it is destined for the humble Francis"'. The portion of the painting depicting the 'earth' — comprising the friar on his knees receiving the vision of St Francis (who is at prayer in the chapel) — is presented from a viewpoint different from that used for the upper portion, featuring the five thrones in a row. The 'link' between the two sections of the fresco is provided by the angel. Part of the painting to the left of the friar is missing and there has been some peeling of the angel's face.

## 29 *270×230* *1297-99*

### The Devils are Driven from Arezzo

The event depicted is 'the occasion on which the blessed Francis saw the devils rejoicing above the city of Arezzo and said to his companion: "Go, and in the name of God cast out those devils . . .". His companion did as he was bid and . . . the devils fled and peace was restored'. St Francis is seen kneeling in the left foreground; in front of him, his companion addresses the devils; to the right, we have the city of Arezzo. The whole is topped by the devils in flight. In the background, to the left, is the apse of a large church. There is no really serious deterioration.

## 30 *270×230* *1297-1300*

### Trial by Fire

This fresco concerns 'the occasion on which the blessed Francis, on account of his faith in Christ, wanted to step into a great fire together with the priests in the service of the Sultan of Babylon, but none of them dared to brave the fire with him and they all fled from his sight'. Giotto is believed to have had little to do with the execution of this fresco

(Coletti; Tintori and Meiss). The architectural details of the fresco would also appear to have been executed by assistants (*idem*).

There are traces of nails having been driven into the plaster towards the base of the left-hand building at an earlier date.

## 31 *270×230* *1297-1300*

### Ecstasy

The painting shows 'how the blessed Francis, while praying fervently one day, was seen by the friars to rise from the ground with his arms extended; at the same time, a bright cloud enveloped him'. Most critics are agreed that the actual composition and design of the architectural features of the fresco are to be attributed to Giotto, though, in all probability, his assistants were largely responsible for its execution (Coletti, Gnudi, Salvini, etc.). In Gnudi's view, the artists in this case were those responsible for the last two frescoes in the New Testament cycle.

## 32 *270×230* *1297-1300*

### The Crib at Greccio

The incident here recorded is 'how the blessed Francis, in memory of the birth of Christ, ordered the preparation of a crib, complete with straw, ox and ass; and how he preached on the birth of the poor King; and also how, while the holy man was still speaking, a knight saw the (real) Child Jesus in place of the figure which the saint had brought'. The scene is set in the church of the village of Greccio; the baldacchino on the right shows the undoubted influence of Arnolfi. The 'panelled' reverse view of the crucifix in the upper part of the picture is justly famous and has aroused much interest among scholars and critics. Nearly all are agreed that the actual design is Giotto's, though his assistants were entrusted with much of the execution (Gnudi, Salvini, Gioseffi and others). This was one of the least decipherable of the frescoes in the entire cycle when it was restored in 1798 (Fea, 1820).

There is an extensive crack on the left-hand side.

## 33 *270×200* *1297-1300*

### The Miracle of the Spring

'As the blessed Francis was making his way up a mountain riding on the ass of a poor man on account of an infirmity with which he was afflicted, the poor man begged for a drop of water as he was parched with thirst. Thereupon, the saint brought forth water from a stone, the like of which has never been seen before or since'. Giotto is believed to have executed only part of this fresco; nevertheless, the critics hold that he was entirely responsible for the overall design and for the actual painting of the man drinking: a

figure made famous by Vasari who referred to him as 'the man whose thirst is so great that his whole being expresses the longing for water'. As in the case of the previous fresco, before being thoroughly cleaned in 1798, this painting had been much damaged by damp (Fea).

## 34 *270×200* *1297-1300*

### St Francis preaches to the Birds

'While the blessed Francis was on his way to Bevagna, he preached to a flock of birds who, for joy thereat, stretched their necks, spread their wings, opened their beaks and touched his tunic; all this was witnessed by his travelling companions'. Down through the ages, this painting has been the subject of a great deal of discussion, both critical and general; and it is this, more than any other work, which has been seen as the basis for the link between the personality of Giotto and the Franciscan ideal. The birds had originally been painted by the dry fresco method and are much damaged.

## 35 *270×230* *1297-1300*

### Death of the Cavaliere di Celano

The fresco features 'the occasion on which the blessed Francis prayed for the repose of the soul of a knight of Celano who had invited him to dine. The said knight, having confessed his sins and made known his will concerning his house, while the others sat down to eat, suddenly breathed forth his soul and fell asleep in the Lord'. The composition is regarded as the most dramatic of the entire series; even the earliest commentators were aware of the marked and deliberately emphasized contrast between the left-hand section, portraying the friar sitting quietly at the table, set ready for a meal, and the group of mourners around the dying man. In discussing this and the next two frescoes, Gnudi has suggested the possibility of their having been executed by an assistant possessing considerable talent, whose powers of imitative naturalism and three-dimensional presentation are quite distinct from those of Giotto. Be that as it may, the critics all agree in attributing the actual design of the fresco to Giotto himself. Gioseffi has drawn attention to the typically classical balcony incorporated in the architectural structure.

## 36 *270×230* *1297-1300*

### The Saint Preaches before Honorius III

The event depicted is 'when the blessed Francis, in the presence of the Pope and the Cardinals, preached with such fervour and persuasion that it was clear that he spoke not with the learned words of human wisdom, but by divine inspiration'. In Gioseffi's view, the corner-on

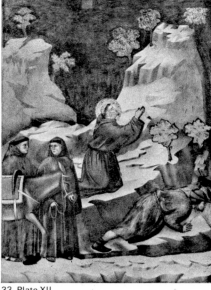

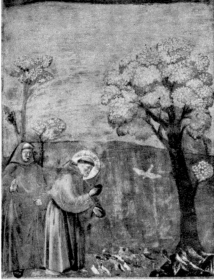

33 Plate XII

34 Plate XIII

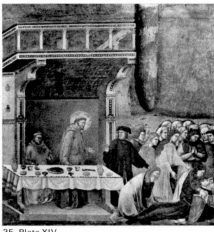

35 Plate XIV

*Sketch showing painting procedure for no. 35*

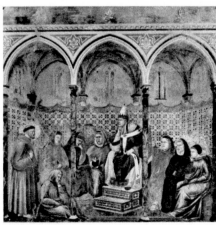

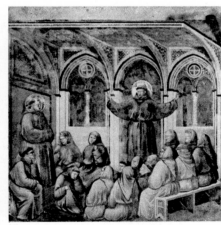

36 Plate XV

37

view of the throne, framed as it is in a spacious Gothic structure seen from the front, is a device which has been used repeatedly throughout the cycle in order to convey a specific figurative meaning. The decoration of the upper part of the fresco was certainly added after the arches had been painted in, and possibly even after the entire fresco had been completed (Tintori and Meiss).
The critics have repeatedly commented on the vivid expressiveness of the various individuals, particularly the Pope, Honorius III.

## 37 *270×230* *1297-1300*

### The Saint appears to the Chapter at Arles

'While the blessed Anthony was preaching about the Cross to

the Chapter at Arles, the blessed Francis, though physically absent, appeared and, extending his hands, was seen by Friar Monaldo to bless the friars who all derived much consolation therefrom'. The setting portrays 'with a marked sense of spaciousness, the Gothic chapter house of a monastery' (Gnudi). All the critics attribute the actual design to Giotto, though, as regards the execution, he was probably responsible only for the figure of St Anthony who is seen standing on the left; the remainder of the fresco was entrusted to the artist's assistants (Gnudi).
Fea (1820) reported that when he carried out the restoration in 1798, this was one of the worst affected of the frescoes.

## 38 *270×230* *1297-1300*

### The Stigmata

'While the blessed Francis was praying on Mount Verna, he saw Christ in the form of a crucified seraphim, who impressed on his hands and feet and in his right side, the marks of the Cross of Our Lord Jesus Christ'. Most of this fresco is held to be Giotto's work: it is quite probable that, before leaving for Rome, Giotto made sure that he himself worked on the final episode in the earthly life of the saint. Nevertheless, it would seem that the figure of the friar seated on the right of, and in a sense almost outside, the picture, was executed by an assistant. The crucified seraphim has suffered from much peeling. Parts of the fresco are unfortunately damaged.

93

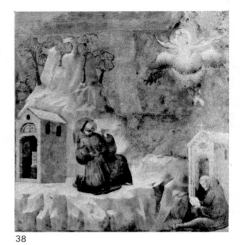

38

*Sketch showing painting procedure for no. 38*

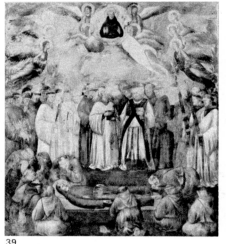

39

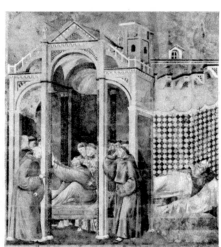

40

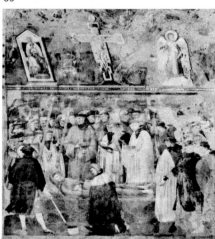

41

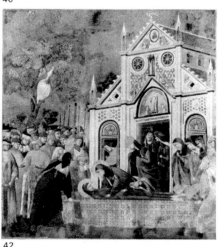

42

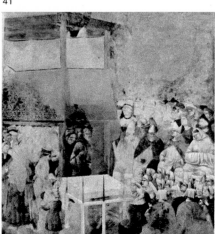

43

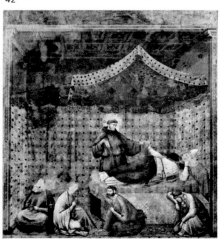

44

## 39 *270 × 230* 1300*

### Death of St Francis

The fresco illustrates 'how, at the very moment when the blessed Francis died, one of the friars saw his soul ascending to heaven in the form of a bright star'. This fresco marks the point from which Giotto's share in the design and execution of the cycle progressively decreases (Salvini and others). Gnudi goes so far as to assert that there is a complete change in style from here onwards.

## 40 *270 × 230* 1300*

### Apparition to Fra Agostino and the Bishop

The original inscription beneath the fresco ran as follows: 'The servant of God, in Terra di Lavoro, being ill and close to death, and having for some time lost the power of speech, called out and said: "Wait for me, Father, I am coming with you", upon which he died and followed the Holy Father. Moreover, while the bishop was on the Mount of St Michael the Archangel, he saw the blessed Francis, who said to him: "See, now I am on my way to heaven", and so it happened at that very moment'. The reference here is to two incidents which occurred simultaneously with the death of St Francis: one of these was his appearance to Fra Agostino, and the other was his apparition to Guido, Bishop of Assisi. Most of the picture is taken up with the architectural details of a church where Fra Agostino lies surrounded by his brethren. To the right, the bishop is seen reclining in a tiny corner-like room. The critics hold that the entire fresco was executed by Giotto's assistants. Indeed, even the design would appear to be somewhat foreign to Giotto's own technique of handling space. The faces of several of the friars are damaged and are no longer visible, and the dry fresco sections likewise.

## 41 *270 × 230* 1300*

### Confirmation of the Stigmata

The series of frescoes devoted to the funeral of the saint includes the scene during which the fact that St Francis had received the stigmata was confirmed. On his death, the news of the miracle had aroused the interest and curiosity of friars and laymen alike, and a doctor verified it. The skilled hand of the Master is here apparent, particularly in the upper portion of the fresco featuring a number of sacred images resting on an iconostasis. The cross in the centre is the same as that depicted in *The Crib at Greccio*, only this time it is seen from the front (Gnudi). There are traces of repainting, indicating that there had originally been an apse in the background to the right of the picture. Furthermore, an examination of the plaster has revealed that the panels resting

on the screen were added after the remainder of the fresco had been completed (Previtali).

## 42 *270 × 230* 1300*

### Poor Clares Mourn the Death of the Saint

Most of the critics are agreed that the fresco was executed almost entirely by Giotto's assistants in accordance with his instructions. Gnudi thinks the artist responsible may well have been the man who also executed the *Death of the Saint* and *Confirmation of the Stigmata*. Certainly the figure of the child climbing a tree in the background to the right of the picture would appear to emulate a feature of Giotto's own work (cf. no. 76). Some of the critics have detected similarities between the church on the right of the fresco and the cathedral at Orvieto (Coletti) and also with Arnolfo's designs for the church of Sta Maria del Fiore (Gioseffi). Coletti has also commented on the similarities in style between this fresco and no. 20 on the opposite wall.

## 43 *270 × 230* 1300*

### Canonization of St Francis

The fresco depicts 'the occasion on which the pope came in person to the city of Assisi and, having carefully investigated the miracles, on the advice of the friars canonized the blessed Francis and placed him among the saints'. The painting would appear to be entirely the work of an assistant, the style and technique being possibly more foreign to that of Giotto than those of any other fresco in the series (Coletti, Gnudi, etc.). Much of the fresco has been damaged by rainwater.

## 44 *270 × 230* 1300*

### Apparition to Gregory IX

Most of the critics agree that the style here is much closer to that of Giotto than in the preceding frescoes. Nevertheless, although few question the attribution of the actual design to Giotto, most hold that he did not have any share in its execution. Some, including Gnudi and Salvini, are inclined to the view that all or most of the fresco is to be attributed to the so-called Master of St Cecilia, who also painted the last three frescoes in the cycle. Gioseffi points out that this fresco affords the first example of an asymmetrical front view presentation, a feature which was to become so characteristic of the later Giotto cycles in Padua and Florence. The heads of the two figures on the left have now almost disappeared, as has much of the design on the material hanging from the ceiling.

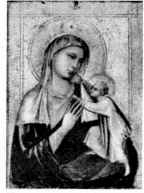

**45**  33×24 1300*

**Madonna with Child** –
Oxford, Ashmolean Museum
The work has been in this
museum since 1913. Having
been mentioned by Borenius
(1914), it had originally been
attributed by Sirén (1917) to the
Master of S. Niccolò and later
(1923) to Stefano
Fiorentino ; Van Marle (1924)
connected it with Pacino di
Bonaguida, while Berenson
(1932, etc.) listed it among the
works to be attributed to
unknown artists contemporary
with Giotto ; Oertel went further
(1937) and attributed it to an
artist from Giotto's own *bottega*.
Volpe (1963) holds that it was
executed by Giotto himself some
time after 1300 and he includes
it among the 'masterpieces of
intelligence and pictorial
representation' produced by
Giotto at this time.

**46**  314×162 1300*

**Stigmata of St Francis** Paris,
Louvre
The artist has used a single
panel of wood on which to
depict the main 'story' and
three minor incidents, which
are grouped together in the
predella. The smaller pictures
feature the *Dream of Innocent
III*, the *Approval of the
Franciscan Rule* and *St
Francis preaches to the Birds*.
the work is signed : 'OPVS
JOCTI FLORENTINI'. An
accurate description of this
painting, then in the church of
S. Francesco in Pisa, is given by
Vasari. From there it was moved
to the church of S. Niccolò, and
thence to the Camposanto, both
in Pisa. It found its way to Paris
together with the rest of the
booty seized by Napoleon. The
general opinion concerning the

quality of the work is
unfavourable ; there is, indeed,
a theory that the work was
commissioned by the
Franciscans in Pisa but that
Giotto entrusted its execution
to his *bottega* somewhere in the
region of the year 1300 (cf.
Gnudi, etc.). This brings us very
close to the dating of the
Franciscan cycle in Assisi and,
in fact, the four scenes here
depicted are directly related,
iconographically, to the
corresponding ones in that
cycle (see nos. 38, 25, 26 and
34). In view of this, Gnudi
suggests that the panel was, in
fact, designed by Giotto himself.
Salvini, however (1962), holds
that the panel represents no
more than a second-rate
*bottega* effort. The contrary view
is taken by Volpe (1963) who
maintains that the panel is the
work of Giotto himself –
painted round about 1300 – and
that it displays marked pictorial
skill, particularly in the case of
the smaller episodes. This would
seem to be a more acceptable
position, subject to a possible
rider to the effect that the
pictorial quality of the larger
panel may well have been
adversely affected by a thick
layer of dirt. Even those who
refused to entertain the
possibility that the work was by
Giotto have recognized the
importance of the fact that the
panel bears his name.

**47**  54×39 1300*

**Franciscan Saint** Settignano
(Florence), Berenson Collection
(Harvard University)
This work was attributed to
Giotto by Mather in 1925, and
his view has been supported by
Berenson, Toesca, Suida,
Cecchi and Gamba. Brandi
discounts it, while other critics
are uncertain. Gnudi (1959),
supported by Salvini (1962),
holds that it was produced by
the artist's *bottega*.

# Church History (Rome)

**48**  110×110 1300

**Boniface VIII proclaims the
Great Jubilee**
This is the only extant fragment
– now in the Basilica of St John
Lateran in Rome – of a much
larger work depicting Pope
Boniface VIII proclaiming the
Great Jubilee and blessing the
crowd from the balcony of the
Lateran Palace with, at his side,
an acolyte, a cardinal (in all
probability Francesco Caetani)
and other prelates. We know
from the writings of Panvinio
(1570) that the fresco,
together with the *Baptism of
Constantine* and the
*Construction of the Lateran
Basilica* (both of which are now
lost and although it is quite
probable that they were, in fact,
either executed or designed by
Giotto we have no other
information about them),
adorned the loggia known as the

46

*thalamum* or *pulpitum
Bonifacii* erected by the
Caetani Pope on the façade of
the building which he himself
had caused to be added to the
old Lateran palace. The
fragment in question was cut
away from the wall and moved
to the cloister in 1586, when the
loggia itself was demolished.
Two centuries later it found its
way into the basilica and was
erected, at the instance of the

*Miniature from manuscript of
Instrumenta translationum by
Jacopo Grimaldi (1622;
Milan, Ambrosian Library, F.
inf. 227) reproducing no. 48 as
it was originally*

Caetani family, in a niche and set
against one of the pillars. Art
scholars in the sixteenth and
seventeenth centuries refer to
the Lateran frescoes, some
attributing them to Cimabue

(Panvinio, 1570 ; Santorio,
1595), and others to Giotto
(Chacon, 1630 and 1677) ;
others are content merely to
chronicle the two schools of
thought on this point (Rasponi,
1657). At a later date, the
attribution to Giotto gained
wider credence. In 1952, the
'Istituto Centrale per il
Restauro' in Rome undertook to
clean and repair the only
remaining fragment, which had

suffered much at the hands of
would-be retouchers, and
restored it as far as possible to
its original condition (Brandi,
1952 and 1956). It is now
believed (only Meiss, 1960, has
questioned the fact) that the
painting was commissioned
from Giotto and completed
before the end of the year 1300.
There is, however, considerable
divergence of opinion as to how
much of the fresco is actually
Giotto's work. Brandi holds that
it is entirely his and sees in the
'three-dimensional quality' of
the remaining fragment a
foreshadowing of the style of the
Scrovegni Chapel frescoes ;
Gnudi (1959) has many
reservations both on stylistic
grounds and because the very
short space of time during which
the fresco could have been
executed would seem to suggest
that Giotto must have been
assisted in its completion.
Salvini (1962) shares this
opinion, though he argues that
the discovery of the fresco is of
great importance, in that it
provides further proof of both
Giotto's authorship of the
Franciscan cycle in Assisi and
of the dating of this cycle
immediately prior to 1300.

**49**  578×406 *1290-1300*

**Crucifix** Florence, Sta Maria
Novella
The earliest commentators, from
Ghiberti onwards, mention a
*Crucifix* by Giotto in the church
of Sta Maria Novella in Florence.
When this panel was cleaned on
the occasion of the Giotto
Exhibition in Florence in 1937, a
close study became possible.
As a result, most of the critics
(Coletti, Salmi, Oertel, Toesca
and Longhi) endorsed the view
that it could well be attributed to
Giotto. Perkins and Offner
(1939) stood out against this
opinion, but then the latter does
not accept any of the early
works attributed to Giotto.

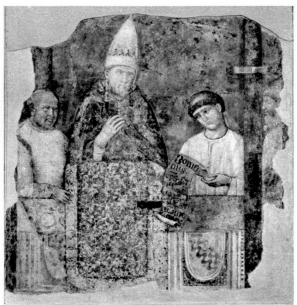

48

Brandi, too (1939), refused to accept the identification of this Crucifix with that mentioned by the early chroniclers, quoting, as his authority, Cavalcaselle, (1875) who had maintained that the Crucifix had at that time been moved to another chapel in the same church. There is no other confirmation of this assertion, whereas the remaining sources are unanimous; it would therefore seem reasonable to suppose that Cavalcaselle was mistaken (Salvini, 1962). Writing some years earlier, Brandi (1956) suggested that the painting could well have been partially executed by Giotto round about the year 1300, though he attributed the half figures of the Virgin and St John in the arms of the cross to the artist responsible for the fresco in Assisi featuring the *Mourning of the Dead Christ* (no. 10), whom he holds *not* to have been Giotto. In further support of his contrary view, Offner links the Crucifix with an artist whom he

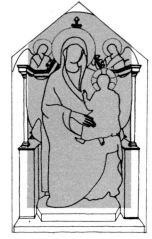

*Reconstruction of* Madonna with Child Enthroned *(no. 50) proposed by R. Offner (1956)*

damaged panel now preserved there. In fact, the panel had been cut along the sides and at the bottom in order to adapt it to the baroque decoration when the church was altered some time before 1705. As a result, the panel lost part of the throne, the steps of which were also eliminated, together with the Virgin's right foot (see diagram above). It was Offner (1956) who sketched a reconstruction of the original panel and it was he who had earlier (1927) attributed the work to the rather old-fashioned artist of the Giotto school, known as the Master of St Cecilia. This hypothesis was accepted by Toesca. Oertel, writing in 1937, attributed the work to Giotto himself, and he has been supported by Longhi (1948), Salvini (1952), Bauch (1953), Gnudi (1959) and Battisti (1960). In the meantime, Offner (1956) revised his original opinion, and attributed the panel instead to the 'Maestro della Croce di Sta Maria Novella'. There is much controversy, too, over the dating: Longhi holds that it is contemporary with or not much

later than the *Crucifix* in Sta Maria Novella (no. 49), whereas Oertel (who further maintains that the artist was much assisted in its execution) is inclined to date it round about the year 1300 – i.e. immediately after the work in Assisi and Rome and before the period in Padua (again, with assistance). Gnudi discusses at length the very serious loss caused by the mutilation of the panel, as a result of which it now lacks all sense of perspective; however, on the basis of an ideal reconstruction of the original perspective which, more than any other feature, serves to distinguish this *Madonna* from similar works by Cimabue, he inclines to the view that it should be dated after a visit by the artist to Rome but prior to the execution of the Franciscan cycle in Assisi (1295). The panel is much damaged and in some places the green ground shows through. There has been much over painting and retouching; the two main figures were once crowned.

## Madonna Cycle
(Florence)

**51** ⊞ ⊕ *1300-05* ▤ :

Vasari described as 'the earliest paintings by Giotto' a number of works which, according to him, were situated 'in the chapel of the high altar' (in the Badia) and 'deemed beautiful . . . particularly one of the Annunciation'; this, coupled with other details, would certainly seem to justify the identification of these works with those in the choir referred to by Ghiberti, 'Billi', the

*Fragment of fresco showing front elevation of a church from the cycle of paintings in the Badia, Florence (no. 51)*

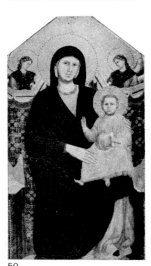

50

describes as the 'Maestro della Croce di Sta Maria Novella'. Among those who attribute the work to Giotto, there is much diversity of opinion as to dating: Longhi, Gnudi and Battisti opt for the year 1290 or thereabouts; Salvini is in favour of the years 1295–6; Toesca holds that it was executed even later, and indeed not much before the great cycle in Padua. Finally should be drawn attention to the great importance attached by Gnudi (1959) and Schöne (1959) to this particular work from the point of view of the development of the traditional iconography of the cross. The painting is in reasonably good condition, though the figures are somewhat flat and there has been some restoration.

**50** ⊞ ⊕ 180×90 *1295-1300* ▤ :

**Madonna with Child Enthroned** Florence, S. Giorgio alla Costa
Ghiberti and all commentators thereafter speak of a 'panel' by Giotto in the church of S. Giorgio, though not all are now agreed in identifying this with the mutilated and much

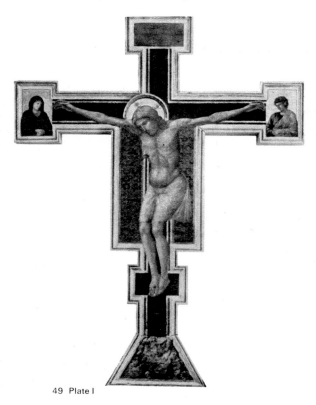

49 Plate I

'Anonimo Magliabechiano' and Gelli. The extant fragments of these frescoes were brought to light a few years ago by the 'Soprintendenza ai monumenti' in Florence. The entire cycle had previously been concealed in the space between the original wall and a second one which was erected in front in the course of architectural alterations to the Badia undertaken in 1625. The frescoes in question were shown at an exhibition in

Florence (Forte Belvedere – 1966) and comprise the two figures in the Annunciation scene (both, unfortunately, headless) together with a number of other fragments, including the architecture of a church and the extremely expressive hooded figure of a man. Procacci (1966) and other scholars have no hesitation in attributing these fragments to the hand of the Master, and they are almost certainly right.

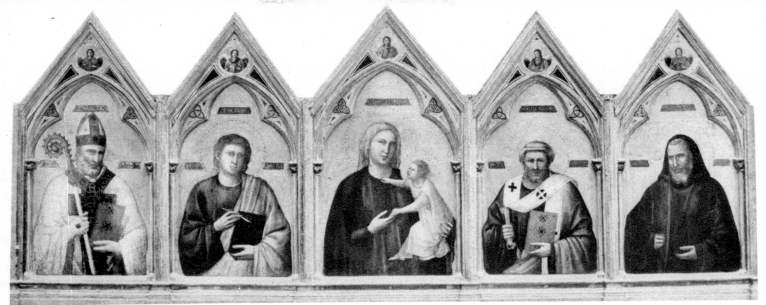

52 A-E

Fragment of fresco showing head and shoulders of a shepherd from the cycle of paintings in the Badia, Florence, and featuring episodes from the Life of the Virgin (no. 51)

# The Badia Polyptych

**52** ▦ ⊗ 91×340 ·1301-02· ▤ ⦂

Writing in 1943, Procacci showed that this polyptych is the one from the high altar in the Badia in Florence (now in the care of the 'Soprintendenza alle Gallerie' in Florence) attributed to Giotto by both Ghiberti and Vasari. On it are portrayed the Madonna with Child (centre panel) flanked by St Nicholas and St John the Evangelist on the left and St Peter and St Benedict on the right. According to Procacci, a certain Jacopo d'Antonio had, in 1451, executed the heads of cherubim in the cusps containing the figures of angels. These later accretions were removed when L. Tintori cleaned the polyptych a few years ago (Baldini, 1958). The entire polyptych was taken from the church in the year 1568 and moved to the monastery nearby, where it remained until the time of the suppression of the monasteries under Napoleon. In 1813, it was returned to Sta Croce rather than to the Badia (Procacci). The appalling state of preservation of the panel which, before it was cleaned, was much damaged by rubbing and peeling (in addition to having been considerably painted over), made it very difficult to identify the original artist. In 1885, Thode had attributed it to Giotto, and this hypothesis was supported by Suida, Fabriczy, Beenken, Coletti and – to a certain extent – by Longhi, who dated it somewhere in the first decade of the fourteenth century. The majority of the experts, however, placed it much later, i.e. round about 1330. Procacci alone was inclined to see in it one of Giotto's early works and therefore dated it more or less at the same time as the frescoes in Assisi. There are scholars who hold that the polyptych was executed by Giotto's *bottega* (Oertel, Salmi, etc.) or even by one of his imitators (Sirén, Volbach, Rintelen, Van Marle, Berenson, Offner, Brandi, Toesca).

## A. St Nicholas
This figure appears at the extreme left of the polyptych and is perhaps the least distinguished from the point of view of style; nevertheless, its handling betrays an intermediate phase in the artist's search for greater naturalism following his experience in Assisi.

## B. St John the Evangelist
All the latest studies and commentaries have drawn attention to the excellence of this figure, which has many affinities with corresponding figures in similar attitudes in the Padua frescoes.

Medallion with head of angel executed in cusp of no. 52 (E)

## C. Madonna with Child
The traditional iconographic representation of the Madonna would here seem to have been transmuted in an effort to convey a more touching humanity. Gnudi compares the firm, sharp profile with those of some of the figures in the Padua frescoes. In Battisti's view, the enhanced three-dimensional quality foreshadows the icons of the Sienese school.

## D. St Peter
This figure is set in its frame with much of the statuesque vigour apparent in some of the frescoes of the Franciscan cycle in Assisi and of the early frescoes in the Scrovegni Chapel in Padua (Gnudi).

## E. St Benedict
The three-dimensional quality has much in common with the figure of the woman in black featured in the *Meeting of Joachim and Anna at the Golden Gate* (no. 58), one of the Padua frescoes (Gnudi). Until the recent restoration this figure had a rather serious crack.

Reverse side of no. 52 showing later insertion of an upper portion between the main panel and the cusps. This section was removed when L. Tintori restored and repainted the panel

# The Scrovegni Chapel

The Scrovegni Chapel at Padua is also known as the Arena Chapel, on account of the adjacent Roman Amphitheatre, as the church of the Madonna dell' Arena, of the Madonna della Carità or of the Annunciata. Its dimensions are as follows : length – 29.26 metres ; breadth – 8.48 metres ; height (measured from floor to apex of vault) – 12.8 metres. The frescoes, which cover the whole of the single nave, depict scenes from the life of Christ, ranging from events preceding his birth (Life of Joachim, Life of St Anne and of the Virgin) to Pentecost. The *Last Judgement* is on the west wall. The various scenes are depicted in strictly chronological sequence in a series of three cycles of frescoes set one beneath the other. The series begins, in the upper fresco on the right wall next to the archway, with the first of six episodes drawn from the life of Joachim and continues (from the doorway end) in the corresponding position on the opposite wall with six scenes from the life of the Virgin, thus bringing us to the two paintings devoted to the *Annunciation,* on either side of the arch. The crown of the arch shows God the Father (painted on a panel let into the fresco) entrusting to the Archangel Gabriel the message which he is to carry to the Virgin. The *Visitation* shown below the kneeling figure of the Virgin of the Annunciation concludes the 'prehistory' of Christ. The central series of frescoes on the right-hand wall, starting from the archway as before, depicts five episodes drawn from the life of Christ, covering events from the *Nativity* to the *Slaughter of the Innocents.* The series continues on the opposite wall, starting from the door, with a further six episodes ranging from *Christ among the Doctors* to the *Cleansing of the Temple.* (The number of frescoes differs on each side in this and in the lower cycle on account of the windows let into the right-hand wall.) To the left of the archway we have the *Betrayal of Judas.* The tale is taken up in the lower cycle on the right-hand wall starting from the arch with five scenes from the Passion, going from the *Last Supper* to the *Flagellation,* the series terminating on the opposite wall with the last six scenes which run from the *Way of the Cross* to *Pentecost.* On either side of the archway, the frescoes immediately below the scenes depicting the *Betrayal of Judas* and the *Visitation* show the interior of an architectural structure with ribbed vault and mullioned window with two lights. Each fresco in the cycle is set in an ornamental frieze (also done in fresco) in which decorative motifs alternate with compositions designed to present a synthesis of events from the Old Testament as a foil for the New Testament scenes depicted in the main frescoes ; these friezes also feature the heads of saints. Below the frescoes on all three walls and at the foot of the archway there is a plinth painted to resemble marble ; inserted therein is a series of monochrome allegorical figures representing the seven Virtues (right-hand wall) and the seven Vices (left-hand wall), carefully arranged in paired opposites. The barrel vault has been painted to resemble a starry sky and is divided into two sections by means of three transverse decorative strips. The section of the vault closest to the archway contains the figure of Christ set in a medallion which, in turn, is surrounded by four other medallions framing a number of prophets, one of whom is John the Baptist. A corresponding medallion of the Virgin surrounded by others depicting the prophets, Malachi, Baruch, Isaiah and Daniel has been executed in the second section of the vault. Of the three transverse strips used to divide the ceiling into sections, the one next to the archway includes alternate figures of angels and saints. The other two are devoted to the portrayal of saints with crowns, who may very well represent the precursors of Christ (Salvini).

The attribution of this cycle of frescoes to Giotto is attested by a well-founded and unanimous tradition running right back to fourteenth-century sources. Riccobaldo Ferrarese and Francesco da Barberino. The cycle can be dated with a fair degree of approximation on the basis of available documentary evidence. We know, for instance (Tolomei, 1881 and 1884), that Enrico degli Scrovegni bought the Arena property on which to build his own house (now demolished) and the chapel in the year 1300. Bishop Ottobono dei Razzi, who died on 31 March 1302, authorized the erection of the chapel (Ronchi, 1935–6), the foundations of which were laid in 1303 (though the reference may be to the consecration of the ground). On 1 March 1304, Benedict XI granted an indulgence to all who visited the chapel, which was consecrated on 16 March, 1305 (Selvatico, 1859). The mention of the frescoes by Riccobaldo Ferrarese and Francesco da Barberino (1312–13) furnishes us with a definite terminal date. Gnudi (1959), whose theory is supported by Salvini (1962), holds that Giotto was asked to come to Padua by the Franciscans and not by Enrico degli Scrovegni and that, once there, he first executed the frescoes (now lost) in the Basilica del Santo. As for the Arena frescoes, Gnudi postulates a date in the years 1309–10 on the grounds of style and of comparisons with other subsequent works. He therefore discounts the importance (from the point of view of dating the cycle) of the document dated 9 January 1305, in which a group of Augustinians lodged a complaint against Enrico degli Scrovegni for having unlawfully instigated the public cult of St Francis in his own chapel and erected a bell tower (Ronchi). Salvini points out that the presence of an Augustinian alongside Enrico degli Scrovegni in the *Last Judgement* fresco does not, in fact, argue in favour of a date very much later than the traditionally accepted one of 1304–6 which he supports, because it is very likely that an agreement with the friars was quickly reached. In outlining his theory in support of the earlier dating as compared with that adduced by Gnudi, Salvini draws attention, among other things, to a number of affinities of style with the later frescoes in the Assisi cycle, and also to some very interesting parallels with other Giotto works in Assisi which have been extensively studied by Meiss.

It was Longhi (1952) who first undertook a detailed study of the two frescoed architectural interiors on either side of the archway. Gioseffi (1957 and 1963), Gnudi and others have gone further into the subject and in so doing have raised far wider problems than those connected with the actual design. In the meanwhile, Salvini rightly points out that they provide clear evidence of Giotto's growing maturity and of his development of 'an almost Brunelleschian touch in the handling of problems of perspective : for not only is each architectural setting absolutely correct – though drawn freehand – from the point of view of perspective, but each is drawn in relation to a single viewpoint situated in the centre of the chapel'. As for the undeniable defects apparent in the decorative and iconographic handling of the link-up between the triumphal arch and the walls, Gnudi maintains that this was done after the actual painting was well under way and is defective precisely because there was a change in plan concerning the architecture of the chapel itself.

It is widely held that Giotto was assisted with these frescoes to a far lesser extent than in the corresponding cycle in Assisi. Nevertheless, the work of other artists is apparent in some scenes in the Life of the Virgin (Toesca, 1951), in the *Triumphal Entry into Jerusalem* and above all in the *Last Supper* and *Way of the Cross.* The same is true of the medallions and decorative strips in the vault, of a number of the Allegories in the plinth and of the *Last Judgement.* In all cases, however, this assistance was directly supervised by Giotto himself who 'has stamped the whole with the unifying imprint of his own personality' (Salvini).

Not all scholars are agreed as to the actual chronology of execution of the frescoes : Romdahl (1911), Arslan (1923) and Baumgart (1937) incline to the view that the customary method of decoration was in this case reversed and that the upper frescoes were, in fact, painted after the lower sections had been completed. In support of this contention, they adduce stylistic arguments (e.g. the cycles featuring the lives of St Anne and the Virgin possess certain affinities with French Gothic sculpture, an influence which Romdahl accounts for by postulating an – unlikely –

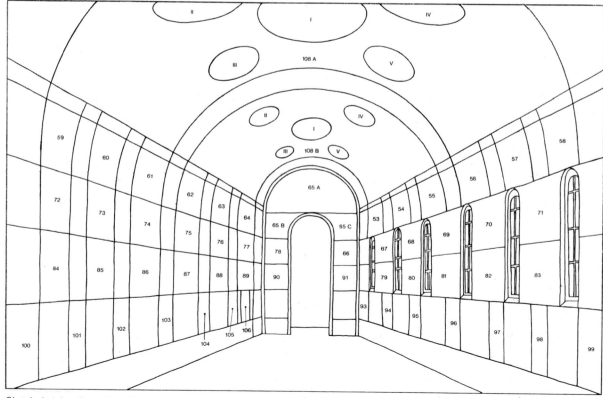

*Sketch showing disposition of the paintings in the Scrovegni Chapel (from the doorway), the numbers are those of the Catalogue.*

visit by Giotto to Avignon) coupled with a number of external factors, as for instance the relatively greater space devoted to the Life of the Virgin as compared with the extent of the entire cycle. Battisti again voiced this view in 1960 when he suggested the following chronology: *Last Judgement* (1304); Life of Christ (1304–05) and finally Life of the Virgin (1305 and beginning of 1306). Gnudi, on the other hand, argues in favour of the 'undeniable precedence' of the lives of Joachim and the Virgin over that of Christ. Salvini, too, questions the validity of the chronology as outlined, preferring to believe that the traditional method – from top to bottom – was followed here too. He discusses the various aspects of the theory and points out that, stylistically, the *Last Judgement* would seem to have been executed last. In any case, Giotto's own share in this fresco was probably limited to the execution of the figure of Christ the Judge, those of the Virgin and the saints in her immediate entourage, and those of the group featured as present at the dedication of the chapel, plus one or two other sections. The actual technique used for these frescoes differs from that employed in Assisi in that the tempera method of touching up here occurs far more frequently (P. Selvatico, 1836).

The Arena frescoes are universally regarded as marking the peak of Giotto's maturity. Between them and the Assisi cycle there is a marked though by no means radical divergence in style; here as in Assisi the three-dimensional quality is used to convey the same intense dramatic effect but, here it is both more serene and less restrained. The geometric synthesis of the landscape here acquires new powers of suggestion (cf. the scenes of the Life of Joachim in particular) while the human figure is given greater solidity and stands out in sharper relief, thanks to the softer handling of outline. As in Assisi, both colour and light are seen as a function of depth, however here they are more closely fused with a touch that is both broad and sure. The three-dimensional, realistic aspect of Giotto's art, fundamental to both cycles, here achieves a more majestic expression; in later works of the artist, this quality is further developed.

## Life of Joachim

### 53 ⊞ ✧ *200×185* *1304-06*

#### Joachim is driven from the Temple
The aged Joachim has come to the temple to offer a lamb but is turned away by the priest because his marriage with Anne has been without issue, this being regarded as a sign of disgrace among the Jews. The scenes from the life of Joachim

and of Mary were probably taken from the Protevangelium of James. Most of the experts believe that this particular episode was also the first to be executed (though Battisti maintains that the Joachim and Virgin cycles were painted last) and they have often commented on the clear evidence it provides of the extent to which Giotto was influenced by his earlier classical studies and experience. In fact, the temple reproduces the inside of the sacrarium of an ancient Roman basilica. The comment is Gnudi's, who has also drawn attention to the fact that the architectural structure in this and in the last fresco of the series (no. 58) is so arranged as first to open up and then to seal off the scene, thus in a sense marking the beginning and end of the narrative.
An examination of the plaster has revealed a number of *pentimenti*, notably the head of the young man in the temple.

### 54 ⊞ ✧ *200×185* *1304-06*

#### Joachim joins the Shepherds
After being turned away from the temple, Joachim retires to do penance among the shepherds of his own flock. All the critics have commented on the intense unity of expression conveyed by every line of men, animals and rocks which form the picture, in the upper part of which there is a transverse crack.

### 55 ⊞ ✧ *200×185* *1304-06*

#### Annunciation to St Anne
While at prayer in her house, Anne is told by an angel that she is to become a mother. In the next room a serving maid is seen spinning. Once again, the classical style of the architectural setting is to be noted, as also is that of the figures 'in sharp perspective' (Gnudi). This fresco, too, has a number of transverse cracks near the top.

53

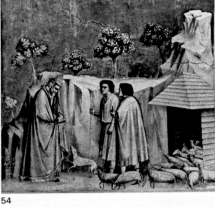

54

55 Plate XVI

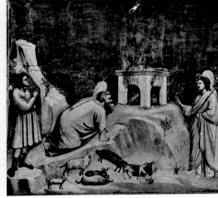

56

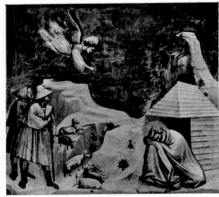

57 Plate XVII

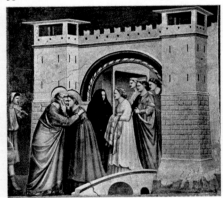

58 Plate XVIII

*Sketch illustrating painting procedure for no. 53 (for key see p. 90). Tintori and Meiss commented on the fact that the head of the young man to the right of the priest seems to have been executed partly on 'day' 2 and the rest on 'day' 4. This almost certainly means that the artist changed his mind and, having completed section 2, decided to move the angle formed by the two walls to the right. This meant lowering the upper edge of the wall, so making it necessary to fill in the lower portion of the head*

### 56 ⊞ ✧ *200×185* *1304-06*

#### Sacrifice of Joachim
Unaware of the tidings conveyed to Anne, Joachim offers sacrifice to God from his place of retreat. The sacrifice is acceptable; the hand of the Eternal Father is visible at the top of the picture and the Archangel Gabriel is seen standing on the right. Just above the altar, where the victim has been consumed, may be detected a tiny praying figure with face turned heavenwards. There are several cracks about halfway up the fresco.

### 57 ⊞ ✧ *200×185* *1304-06*

#### Joachim's Dream
Joachim is asleep in front of the sheepfold; while he sleeps an angel appears to him in a dream to tell him of the forthcoming birth of the Virgin. The angel, seen in flight, bears in one hand a sceptre surmounted by a clover leaf, symbolizing the

Trinity (Selvatico). In 1937, Fiocco rightly drew attention to the affinity between the figure of Joachim in this fresco and a similar figure executed by Arnolfo in the pulpit in Siena. There is a horizontal crack about half way up the painting.

### 58 ⊞ ✧ *200×185* *1304-06*

#### Meeting at the Golden Gate
The Archangel Gabriel had told both Joachim and Anne that they would meet, one day, at the Golden Gate in Jerusalem. This meeting is now witnessed on Joachim's side by a shepherd (depicted on the left) and on Anne's side by the women in her retinue, shown behind her. Toesca (1951) is of the opinion that, with the exception of the woman in black, the figures in Anne's retinue were not executed by Giotto. Gnudi and others have drawn attention to the marked expressive effect of the 'plastic pyramid' enclosing the two main figures. Gioseffi

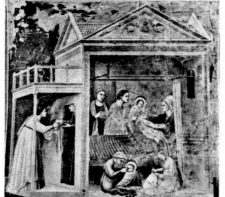

**59 Plate XIX**

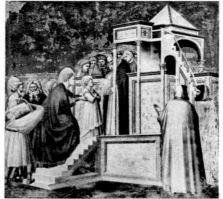

**60 Plate XX**

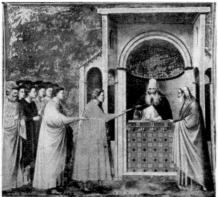

**61**

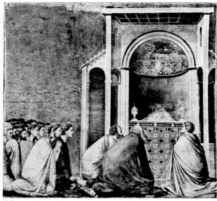

**62**

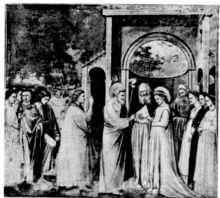

**63**

**64**

partner chosen by God may be identified. On the extreme left, close to the dark heads of the young men, may be seen the haloed elderly figure of Joseph.

Iconographically and otherwise, the overall design would appear to be closely bound up with that of the next two scenes – in all three, a view of the temple façade serves the purpose of a backdrop for three successive incidents in the *Marriage of the Virgin*. The fresco is faded in the top left-hand corner. Toesca (1951) has detected the work of assistants in this and in the other Espousal frescoes.

**62** ✦ *200×185* *1304-06*
**Prayer for the Miracle of the Rods**
Having placed the rods on the altar, priests and aspirants to Mary's hand kneel in prayer and await the promised miracle. Many of the critics, Salvini in particular, have highlighted the sense of emotional tension conveyed by the scene. The painting is in a good state of preservation (see also no.61)

**63** ✦ *200×185* *1304-06*
**Marriage of the Virgin**
The rod carried by the elderly Joseph is the one which has flowered and a dove is seen to hover over it. The priest therefore performs the marriage. Toesca, Gnudi and others have detected the work of assistants in the execution, with the result that the overall expression of the figures themselves is somewhat muted. Unfortunately the fresco is considerably faded.

**64** ✦ *200×185* *1304-06*
**Wedding Cortège**
There is some difference of opinion as to the precise subject

matter of this fresco. If we are to go by the Protevangelium of James (X), then the scene depicts the Virgin Mary and seven other virgins being escorted by temple servants to the high priest so that he may entrust to them the precious materials to be used in making a new curtain for the temple. On the way, the maidens encounter three musicians and pause to listen. However, some scholars are of the opinion that the scene is concerned with the newly married couple, Mary and Joseph, as they make their way to their new home escorted by serving maids and musicians. Others maintain that it features Mary, with seven companions, on her way to her parents' home in Galilee. The somewhat formal setting, and in particular the slender elegance of outline in some sections of the painting, is regarded by some as evocative of contemporary French sculpture (cf. in particular, the rather pointed features of the female figures, as also the grace of the figure of the Virgin, so typical of Gothic sculpture in France). Toesca maintains that there are clear signs of other hands than those of Giotto having been at work here (see also no. 61). Tintori and Meiss have shown that there is evidence of at least one change of plan or *pentimento* in the clothing of the figure seen walking ahead of the Madonna (see caption and commentary to sketch, below). Some of the tempera sections of the painting are now much deteriorated, and the whole is damaged by rainwater.

**65** ✦ *230×690* *1306*
**A. Angel Gabriel is entrusted with Mission to the Virgin**
See no. 65B.

**65** ✦ *150×195* *1306*
**B. Angel of the Annunciation**
This and the next fresco (65C), together with no. 65A, constitute the *Annunciation*. The entrusting to the Archangel of the mission to the Virgin provides, in a sense, a 'heavenly prologue' to the actual Annunciation, and so the three scenes are essentially part of a single concept. In heaven, we have the Eternal Father, surrounded by legions of angels, decreeing that the event shall take place; at each side of the arch, we have a portrayal of the implementation on earth of this decree with, on the left, the Archangel Gabriel bearing the tidings and, on the right, Mary receiving the heavenly message. Both figures are portrayed framed in identical architectural structures, the perspective of which projects outwards and towards the centre. The figure of God the Father is painted on a wooden panel let into the wall. The top left-hand portion of the fresco is much damaged and some of the angels have now almost disappeared. The fact that the attention of the visitor is caught at once by the striking

holds that the portrayal of the Golden Gate is directly reminiscent of the Roman monuments in Rimini (cf. no. 53 as regards the layout). Due note should also be taken of the powerful figure of the veiled woman in black who, in the opinion of many critics, is reminiscent of the later painting of Manet.

## Life of The Virgin

**59** ✦ *200×185* *1304-06*

**Birth of the Virgin**
The architectural setting used for this episode is the same as that used in the *Annunciation to St Anne* (no. 55). In the larger room, St Anne holds out her arms to the new-born child while, in the foreground, the servants are engaged in washing the infant Mary. Gnudi has seen fit to compare these latter figures with some of the pulpit

figures carved by the two Pisanos. The actual paint to the right of the picture and also in the top left-hand corner has worn away considerably.

**60** ✦ *200×185* *1304-06*

**Presentation of the Virgin in the Temple**
In accordance with Jewish practice, Mary's parents took her to the Temple when she was five years old and she is here seen being presented to the priest. The temple is the same as that depicted in *Joachim is driven from the Temple* (no. 53) but this time it is seen from the other side. In this fresco, too, the paint is worn in the top left-hand corner.

**61** ✦ *200×185* *1304-06*

**Ceremony of the Rods**
All the aspirants to the hand of the Virgin present themselves at the temple and offer to the priest a dry rod so that the

*Sketch illustrating painting procedure for no. 64 (for key see p. 90) An interesting feature is the pentimento or artist's change of mind apparent in the figure in front of the Madonna. Giotto wanted to convey a sense of movement first by causing the lower hem of the garments to incline upwards to the right, an effect which he achieved by painting in a suspicion of the background colour below them. Then he added a flowing red line from bottom left up to knee level. He thus turned a heavy cape into a light mantle (Tintori and Meiss)*

extreme moral gravity (Gnudi), characteristic with which she is endowed throughout the remainder of the cycle.
It should be noted that the original effect conveyed by this figure of the Virgin has been damaged, as has the fresco itself, particularly towards the bottom.

**65** ⊞ ⊕ *150×195* 1306* 目 **⋮**

**C. Virgin of the Annunciation**
See no. 65B

## Life of Christ

**66** ⊞ ⊕ *150×140* 1306* 目 **⋮**

**The Visitation**
The gospel story continues with the meeting between Mary and Elizabeth, both of whom are pregnant, after which the frescoes depict other well-known gospel scenes requiring no specific commentary here.

**67** ⊞ ⊕ *200×185* *1304-06* 目 **⋮**

**The Nativity and Apparition to the Shepherds**
The entire composition projects towards the foreground yet each feature has been carefully situated in the overall setting, a factor which marks the transition from simple variation in the size of the figures to convey a sense of perspective (as applied by Giovanni Pisano) to that care and consideration in

*Sketch illustrating painting procedure for no. 65 B (for key see p. 90). The investigations of Tintori and Meiss (1962) have confirmed the impeccable use by Giotto, here, of true or buon fresco. It has nonetheless proved impossible to locate exactly the joins denoting that a full day was devoted to the execution of the head of Gabriel, though it would seem logical to suppose that this was the case*

figures of the Virgin and the Archangel is attributed by many experts to the artist's desire to 'highlight the sacred Mystery to which the Chapel is dedicated' (Gnudi) (cf. also the general introduction to these frescoes, page 98). With particular

reference to the Madonna, attention has been drawn to the fact that the figure here portrayed is no longer the slender and apprehensive girl of the earlier frescoes; she has now acquired a 'dramatic quality' conveying an impression of

*Sketch illustrating painting procedure for no. 65 C. As in the case of no. 65 B (q.v.), although Giotto used buon fresco throughout, it is impossible to delineate exactly the day's work presumably devoted to the head of the Virgin. In view of the height of this panel from the ground, the artist probably employed a faster technique which enabled him to fill in the curtain and other background details incidentally to the execution of the head*

the actual placing of the figures so characteristic of Giotto (Gnudi). This comparison with Giovanni Pisano is suggested also by the apparent suddenness of the Virgin's movement towards the Child. Writing in 1836, Selvatico had commented

on how very dark and worn the fresco had become, particularly the lapis lazuli used for the Madonna's gown; this had probably been applied by the customary 'dry fresco' (fresco secco) method, hence the inevitable discoloration.

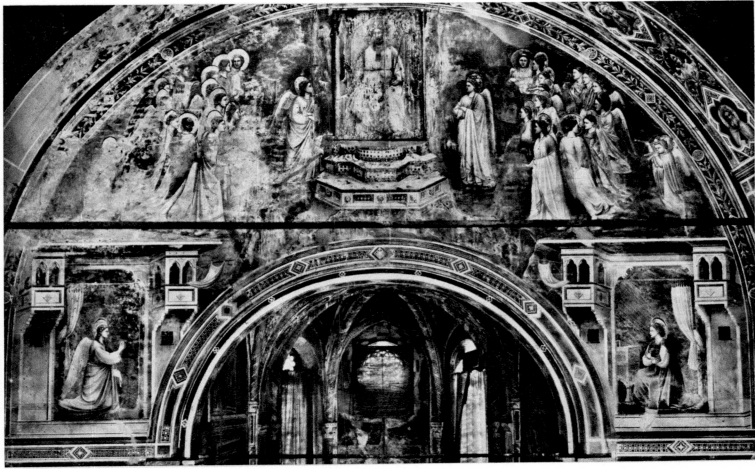

**68** ⊞ ⊕ *200×185* *1304-06* 𝌆 ⦂

**The Epiphany**
The 'Gothic' and 'Pisano-like' elements in this fresco have been the subject of comment by Gnudi. Salvini, too, has drawn attention to the almost bas-relief quality of these early episodes in the life of Christ, and to their affinity with the preceding frescoes of the Joachim cycle, as evidenced by a certain uniformity of style in the handling of both figures and landscapes. The Virgin's gown and parts of the background are now somewhat faded. The addition of the camel was an attractive innovation.

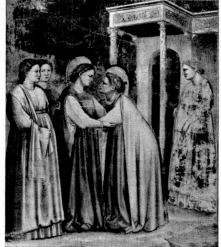

66

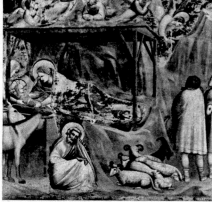

67  Plate XXI

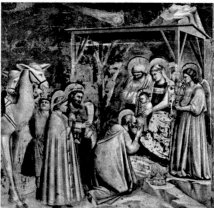

68  Plate XXII

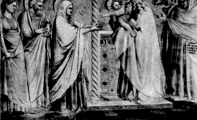

69

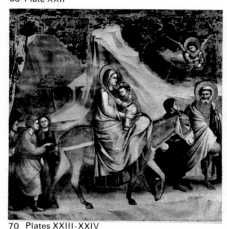

70  Plates XXIII-XXIV

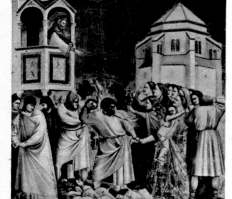

71  Plate XXV

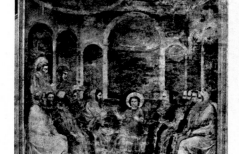

72

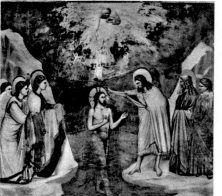

73

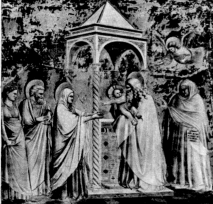

*Sketch illustrating painting procedure for no. 66. In this panel, as in nos. 65 B and C, the artist used buon fresco throughout. Here again, however, the plaster shows no signs of the joins which one would have expected to find, as in the case of the two bystanders on the left. We must therefore conclude that these were executed in a single 'day' together with the complex architectural background. Such speed of operation could well be interpreted as reliable proof that Giotto himself worked on this fresco. Indeed, such a conclusion would seem to be suggested not only by the quality of the fresco but also by its prominent position on the wall*

**69** ❖ ⊕ *200×185* *1304-06* 𝌆 ⦂

**Presentation in the Temple**
The handling of the figures in this fresco is held by some critics to be reminiscent of the iconography of the earlier frescoes featuring the life of the Virgin and of the 'Gothic' elegance of the *Wedding Cortège* (no. 64). Previtali (1965) attributes to Giotto himself this group of Simeon with the Child and also the female figure on the extreme right of the fresco.

**70** ⊞ ⊕ *200×185* *1304-06* 𝌆 ⦂

**Flight into Egypt**
The critics have rightly drawn attention to the fact that the figures of the Virgin and Child framed by the pyramid of rocks forming the background constitute both the ideal and the actual centre of the painting. A further feature worthy of note is the sense of drama conveyed by the fixed look in the eyes of the Madonna.

**71** ❖ ⊕ *200×185* *1304-06* 𝌆 ⦂

**Slaughter of the Innocents**
Gioseffi has likened the polygonal building on the right to the church of S. Francesco in Bologna on account of the circular disposition of the chapels and buttresses. Toesca (1951) felt that the dramatic effect was rather superficial and the sense of movement defective and both these considerations led him to conclude that the fresco was the work of an assistant. Later critics, however, express a much more favourable view (cf. Gnudi and others). The clothing of the woman on on the right is faded, as is also the lower part of the fresco.

**72** ❖ ⊕ *200×185* *1304-06* 𝌆 ⦂

**Christ among the Doctors**
Unfortunately, little of the fresco is now visible owing to its poor state of preservation. Even Selvatico (who nevertheless discounted absolutely Rumohr's pessimistic views concerning the possibility of preserving the Giotto cycle) admitted that 'this fresco has been so badly damaged by the salt in the walls that it would be both rash and imprudent to hazard an opinion'. A feature of this fresco is the return to a sense of greater spaciousness than in those preceeding it.

**73** ⊞ ⊕ *200×185* *1304-06* 𝌆 ⦂

**Baptism of Christ**
This fresco is the first of a series of fifteen in which the predominant figure is that of Christ (Gnudi). The handling of the figure of the Redeemer is evocative of Cavallini. The fresco is badly damaged towards the centre at the top, at the point at which a representation of the Almighty is surrounded by a halo of light.

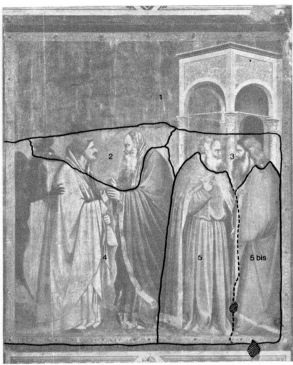

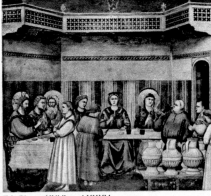

74 Plates XXVI and XXXV

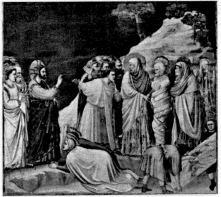

75 Plate XXVII

76 Plates XXVIII–XXIX

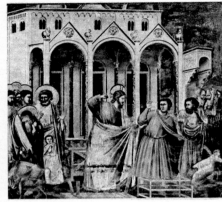

77 Plate XXX

*Sketch illustrating painting procedure for no. 78. Buon fresco seems to have been employed here with astonishing speed: more than two square metres covered in six days' work, though it is just possible that a seventh was required to complete the figure on the extreme right. One unusual feature in medieval painting is the execution of two 'principal' heads in a single 'day' (three, in fact, in the left-hand group which also includes the head of the devil). And this in spite of the fact that the panel occupies a prominent position and is well lit. It would be reasonable to see this very feature as a further indication that the panel was executed by Giotto*

## 74 ▦ ✠ *200×185* *1304–06*

### Marriage Feast at Cana
In his handling of the overall setting here, the artist was clearly feeling his way towards an entirely new spatial concept presaging the Sta Croce frescoes (Gnudi, Salvini and others). The detailed characterization of the figure drinking on the right suggests that it was drawn from life (Selvatico).

## 75 ▦ ✠ *200×185* *1304–06*

### Raising of Lazarus
Toesca (1951) points out that Giotto has here adopted the traditional composition, which has an iconographic history – in miniatures at least – going back to the sixth century. The figure of the young man in the centre, shown with his right hand raised, is held by Gnudi to be among the most natural and lifelike of the entire cycle, bearing comparison with corresponding figures executed by Giotto at the peak of his career, an appreciation which is based also on 'the luminous and transparent colouring'.
The emotional impact of the scene is considerable.

## 76 ▦ ✠ *200×185* *1304–06*

### Triumphal Entry into Jerusalem
This fresco was almost certainly executed in conjunction with other artists. The young boys shown in the trees in the background are similar to figures in the fresco *Poor Clares mourning the death of St Francis* in Assisi (no. 42). In discussing the figures on the right, Selvatico rather oddly saw 'the portrayal of one man with his head concealed beneath the cloak of another, who has prostrated himself before the Word Incarnate, as a skittish piece of vulgarity on the part of the artist'. The state of preservation is good.

## 77 ▦ ✠ *200×185* *1304–06*

### Cleansing of the Temple
Cellini (1948) was of the opinion that the temple architecture had been inspired by that of the original cathedral in Siena, though Gioseffi (1963) is rather more inclined to the view that it is reminiscent of the Basilica of S. Marco in Venice. Though the fresco is in good condition, the original design has been partly lost because some of the *fresco secco* sections have at some stage come away.

## 78 ▦ ✠ *150×140* 1306

### Judas' Betrayal
The fresco shows Judas receiving payment for his betrayal. Like the *Visitation* (no. 66), it was probably painted after much of the rest of the cycle had been completed, since it is located on the other side of the archway. The change of plan at this point has already been discussed (see p. 98 above) (cf. also Gnudi,

78

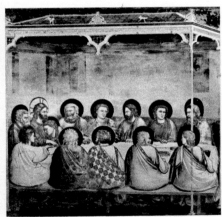

79

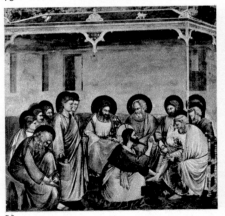

80

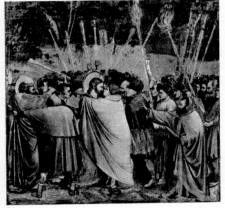

81

Salvini, etc.). The now barely visible halo above the head of Judas has turned black in the course of time as a result of chemical changes (as is also the case with the haloes of the apostles in the *Last Supper*); it has not therefore been deliberately shaded in, as some experts were inclined to think. There is a marked division horizontally between two sections. (cf. Tintori and Meiss)

## 79 ▦ ✠ *200×185* *1304–06*

### Last Supper
This fresco marks the beginning of the series devoted to scenes of the Passion; most commentators are agreed that Giotto was assisted in its execution (Salvini, etc.). As in the next fresco, the artist had introduced a sort of 'hierarchy' of haloes: that of Christ had been done in gilt (using fine gold) and in relief; those of the apostles had been executed using imitation gold, with rays but not in relief. Judas' halo had no rays (Tintori and Meiss). The apostles are depicted wearing the same clothes in this and in the following frescoes. The walls of the upper room, which are now bare, were once decorated with the *fresco secco* method.

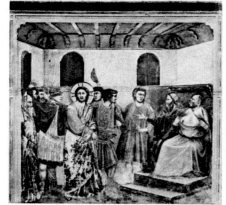

82

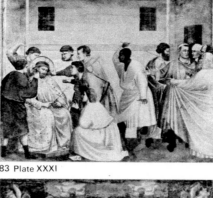

83 Plate XXXI

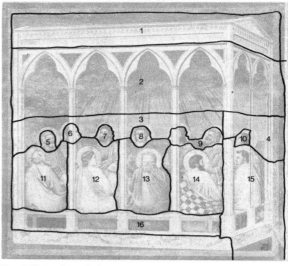

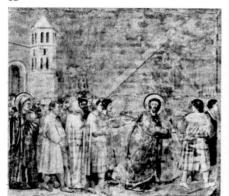

84

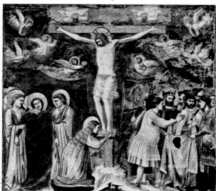

85 Plate XXXII

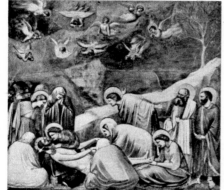

86 Plates XXXIII and XXXV

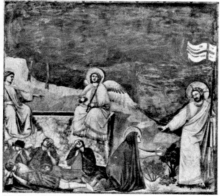

87 Plate XXXIV

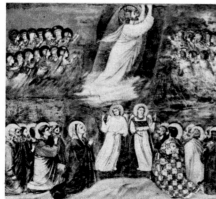

88

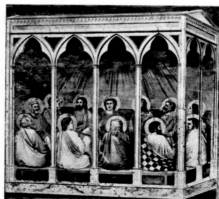

89

*Sketch illustrating painting procedure for no. 89 (for key see p. 90). Should further confirmation be required that speed of execution is a sure indication that the painting is Giotto's own work (cf. comments to panels 65 B, 65 C and, more especially, 78), it is provided here. A full day's work was devoted to each of the full-face heads; each of the side faces was painted at the same time as the rest of the figure, the criterion of 'difficulty' being the elementary and mechanical one of which way the figure was facing*

## 80 ⊞ ✛ *200×185* *1304-06* ▤ ⋮

### Washing of the Feet
The whole scene is closely linked with the preceding one ; in both, the setting is the same and both convey the same atmosphere of rapt attention. Most of the fresco is believed to have been executed by Giotto himself (Gnudi, etc.). See the notes on the previous fresco as regards the original treatment of the apostles' haloes.

## 81 ⊞ ✛ *200×185* *1304-06* ▤ ⋮

### Christ taken Prisoner
This is one of the best-known frescoes of the cycle ; its fame is mainly due to the great dramatic effect achieved by the contrast between the excitement of the guards and the motionless central group composed of Christ and Judas. Toesca (1951) has shown that, while respecting the traditional iconography of this scene, Giotto has imbued it with an entirely new figurative power. The central background is faded.

## 82 ⊞ ✛ *200×185* *1304-06* ▤ ⋮

### Jesus before Caiphas
This fresco, along with those that follow, is remarkable for the sense of drama which, as Gnudi has said, 'is here seen to have swept the traditional handling and iconography before it'. The fresco itself is in reasonably good condition, though some sections are somewhat faded, including the bottom of Christ's cloak, and the figure standing on the extreme left. There is a wealth of imaginative detail, and an uninhibited handling of the architectural detail.

## 83 ⊞ ✛ *200×185* *1304-06* ▤ ⋮

### The Flagellation
Scholars have commented on the complex nature of the iconographic treatment, as also on the inclusion of the Negro (Salvini), who is so strikingly depicted as to suggest comparison with such a work as Manet's *Olympia*.

## 84 ⊞ ✛ *200×185* *1304-06* ▤ ⋮

### Way of the Cross
Although much of this fresco was probably executed by assistants, most commentators agree that the design was Giotto's own work (Gnudi, etc.). The fresco is badly damaged.

## 85 ⊞ ✛ *200×185* *1304-06* ▤ ⋮

### Crucifixion
More than elsewhere in the cycle, this fresco betrays a marked affinity with traditional iconography. That this scene is closely linked in time with the earlier scenes of the Passion is confirmed by a number of identical details.

The excellence of the execution has been the subject of comment by many scholars and critics.

## 86 ⊞ ✛ *200×185* *1304-06* ▤ ⋮

### Mourning the dead Christ
This fresco, too, is among the more famous of the series and owes its reputation to the sense of almost 'cosmic' drama which characterizes it. Toesca's keen perception led him to write (1951) of this fresco, 'an all-pervading sense of unity is conveyed by means of a harmony of colour and yet there is a clear-cut change of tint from one figure to the next, achieved by subtle gradations and even by the handling of shadow effects'.

## 87 ⊞ ✛ *200×185* *1304-06* ▤ ⋮

### The Resurrection
In the left foreground are the soldiers asleep in front of the empty tomb, on which two angels are seated. On the right is the apparition of the Risen Christ to Mary Magdalen. Another title for this fresco is *Noli me tangere*. The rather abstract atmosphere and the figures of the sleeping soldiers have been seen by some to presage the work of Piero della Francesca. The upper part of the fresco has been painted over, with the result that we have lost the trees, though some trunks are still visible.

## 88 ⊞ ✛ *200×185* *1304-06* ▤ ⋮

### The Ascension
Both this and the next fresco are believed to be largely the work of Giotto's collaborators (Toesca, Gnudi, Salvini) : the head of the Virgin is by far the finest feature of the painting (Gnudi). Previtali (1965), however, dissociates himself from the traditional view, remarking that 'we are here faced with one of the most complex compositions of Giotto's maturity'.

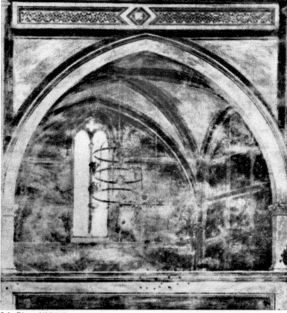

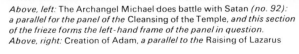

90

91 Plate XXXVI

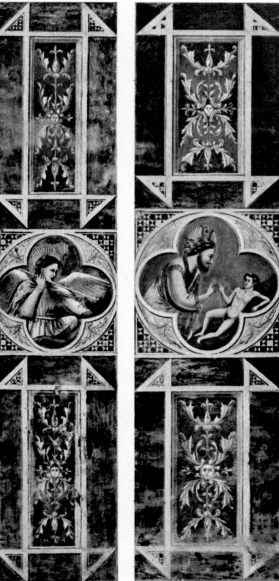

**89** 🔳 ✛ *200×185*
*1304 - 06* ▤ ⋮

**Pentecost**
This fresco, too, is believed to
be largely the work of
collaborators (Gnudi, Salvini,
etc.) and a far cry from the
inspired mood of the earlier
frescoes. Previtali (see no. 88)
maintains that the fresco
contains much of Giotto's own
work.

## 'Coretti' or Concealed Chapels

**90** 🔳 ✛ *150×140*
1306* ▤ ⋮

Nos. 90 and 91 illustrate the
interiors of a pair of
architectural structures
consisting of a ribbed vault and
mullioned window with two
lights. From the ceiling of each
hangs a lantern of a type
depicted by Giotto both here
and in Assisi. In both frescoes
the lines of perspective move

*Above, left:* The Archangel Michael does battle with Satan *(no. 92):*
*a parallel for the panel of the* Cleansing of the Temple, *and this section
of the frieze forms the left-hand frame of the panel in question.*
*Above, right:* Creation of Adam, *a parallel to the* Raising of Lazarus

*Centre page, top to bottom: Details of the frieze (no. 92):* St Joseph
with the Child Jesus ; Moses produces water from the rock ; *theme
unknown;* Elijah in the fiery chariot. *Above, left:* Moses receiving the
Commandments *(paralleling the* Pentecost *panel) and* Dog reared by
lioness

*105*

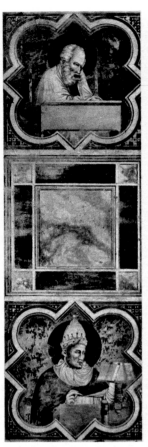

*Friezes probably featuring Evangelists and Doctors of the Church. The figures shown here may be: St Matthew and Pope St Gregory (left, top to bottom); St Luke and St Ambrose (right)*

*Friezes (no. 92) bordering on end wall, featuring female saints who cannot be identified, though they are depicted with their 'emblems'; it would seem reasonable to suppose that they are, in fact, prominent members of the Franciscan Order*

away from the centre of the chapel, in direct constrast to those of the Annunciation scenes (immediately above) which coverge on the central point. Some critics have attached a symbolic value to these structures (Cavalcaselle, Moschetti, etc.). In 1951, Toesca emphasized Giotto's great ability in handling perspective, but concluded that nothing more was involved than a 'straightforward exercise in perspective'. In the following year, Longhi drew attention to the architectural function fulfilled by these two frescoes. The latest commentators, including Gnudi, Battisti, Salvini and Gioseffi, hold that the frescoes are devoid of any allegorical or symbolic significance; in their view, these 'coretti' simply create an illusion of the transept that was never constructed.

**91** ⊞ ✛ *150×140* 1306* 📄 ⋮

see no. 90.

## Decorative Motifs

**92** ⊞ ✛ *200×40* 📄 ⋮

All the motifs here illustrated form part of the frames surrounding the individual fresco panels on the walls. Medallions of various shapes (quadrifoil and a combination of geometrical shapes) are used alternately to illustrate a series of 'potted' episodes from the Old Testament which foreshadow the corresponding events in the New Testament portrayed in the main frescoes. Other medallions contain the busts of saints, presumably arranged according to some kind of hierarchy (Salvini), and certainly not depicted at random. The almost miniature-like quality of some sections of this ornamentation has led a number of critics to draw some parallel between Giotto and the art of miniature in his day, and to speak of the influence of Gothic culture, also apparent in the 'principal' episodes (Gnudi). Owing to the repetition of the motifs and the fact that the work was executed by assistants, only a selection is illustrated on this page, where the master's design is least masked.

## Allegories of the Virtues and Vices

It is generally held that Giotto executed these frescoes, with a certain amount of assistance, as the decoration of the chapel reached completion. Opinions as to the quality vary from that expressed by Gnudi, who maintains that 'nearly all are masterpieces by Giotto himself,' to the conclusion reached by Salvini, who points to the 'essentially commonplace tone' of the series while

93

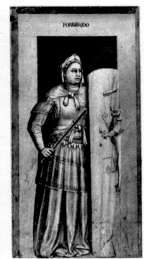

94

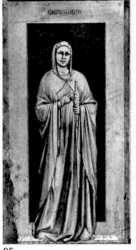

95

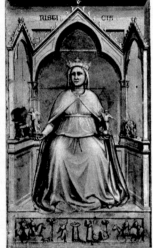

96 Plate XXXVII

recognizing the importance of the thought which dictated the choice of iconography. Toesca asserts that the figurative quality is somewhat lessened by the artist's decision to make use of symbols which were perhaps too abstract: he mentions *Injustice* and *Infidelity* in support of this contention. There was originally a Latin inscription beneath each of these monochrome frescoes, the purpose of which was almost certainly to explain the symbol selected (Selvatico). All that is now visible is the Latin name above each of the Virtues and Vices illustrated.

**93** ⊞ ✛ 120×60 1306* 📄 ⋮

### Prudence
The fresco portrays a three-quarter figure at a writing desk. It appears to be that of a woman but the faint outline of a second set of features, this time of a man, is believed by some to represent Socrates (Selvatico). The figure is holding a convex mirror, possibly symbolizing preconceived ideas which hinder a proper interpretation of events (ibid) or else representing an attribute of the occult sciences (Battisti). According to the detailed inconography advanced by

D'Hancarville and Selvatico, Prudence bears in the other hand a compass and is gazing on a book containing the history of the world, from which her teaching is derived. Even Gnudi agrees that the artistic quality is inferior to that of the rest of the series.

**94** ⊞ ✛ 120×55 1306* 📄 ⋮

### Fortitude
In this case, the artist has used the traditional iconographic pattern of a sturdy female figure resting on a shield with an iron bar in one hand. The shield bears the figure of a lion which may be taken to represent the powerful enemies in the path of Fortitude (D'Hancarville) or else a symbol of the generosity of heart implied by this Virtue (Selvatico). This is also of little artistic value.

**95** ⊞ ✛ 120×55 1306* 📄 ⋮

### Temperance
The female figure used to symbolize this Virtue is depicted carrying a sword bound tightly with knotted rope, as if to suggest that 'Temperance never uses weapons to win hearts nor force to secure good works' (Selvatico)

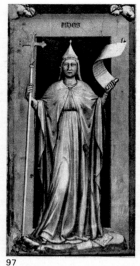

97

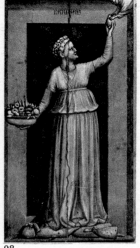

98

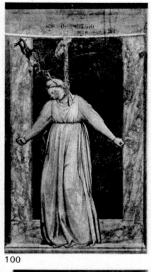

99

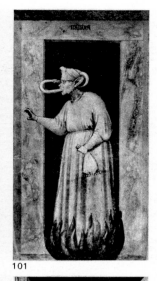

100

101

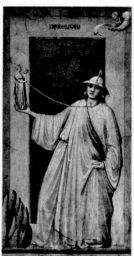

102

103 Plate XXXVII

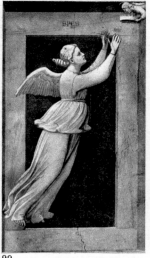

104

105

106

## 96 120×60 1306*

### Justice

This fresco is the central one of the series and is immediately opposite the corresponding central figure on the other wall, featuring Injustice (no. 103). It portrays a figure seated on a splendid Gothic throne bearing, in each hand, one of the dishes of a balance; the right-hand dish contains an angel in the act of crowning a wise man (this latter figure is now almost entirely lost) while the one on the left contains a second angel with drawn sword about to strike a malefactor, probably depicted alongside but now almost indecipherable. The frieze below the throne contains scenes of hunting, dancing and horse-riding, the intention almost certainly being to convey the idea that 'in those societies where justice holds sway, man can savour the joys and pleasures of life in peace' (Selvatico). Gnudi sees influence of Gothic and Latin culture.

## 97 120×55 1306*

### Faith

This Virtue is symbolized by a female figure carrying a cross in her right hand and a scroll in her left. A key hangs from the figure's belt and a broken idol is

crushed beneath the cross. The hieroglyphics on the tablets beneath her feet have been found to include signs of the occult and the 'judicial astrology which, in Giotto's day, was too often responsible for much error and aberration' (Selvatico). The figure's torn garments may well be an allusion to the poverty of early Christianity. The scroll is believed to contain the revealed truths.

## 98 120×55 1306*

### Charity

The iconography of this fresco owes nothing to the traditional treatment of the subject. A young maiden wearing a garland of flowers, symbolizes the happiness which she enjoys on earth. Her left hand is extended towards God, who is seen handing her a purse, symbol of providence, while in her right hand she bears a bowl of fruit and flowers. At her feet, we see bags of money for the needy (D'Hancarville, Selvatico). This figure is universally acclaimed as representing artistically the peak of the entire series. In particular, commentators have drawn attention to the bowl of fruit (Gnudi) and the poetic quality of the human figure (Salvini). The panel is defaced by a perpendicular crack.

## 99 120×60 1306*

### Hope

Here, too, the iconographic treatment represents a departure from tradition. The artist has depicted a winged girl rising from the earth and reaching out for a crown held out to her by an angel. Opinions concerning the quality of the fresco are more discordant here than elsewhere. Luzzatto (1928) praises its 'statuesque quality . . . drawing its inspiration from Greek sculpture' whereas Marangoni (1942) writes it off as being 'awkward, stiff and quite unfitted for flight with these two abortive wings'.

## 100 120×60 1306*

### Despair

The allegory is conveyed by a female figure hanging with hands contracted. The fact that the devil has her by the hair is a symbol of the religious condemnation of the person guilty of despair who becomes a 'prey of Satan' (Selvatico) for offending against Hope, seen as a theological virtue.

## 101 120×55 1306*

### Envy

Once again the iconographic treatment represents an innovation. The fresco portrays

some infernal creature with a serpent coming out of its mouth and turning back on it, an allusion to the poison of this Vice. The flames have been taken to symbolize the creature's place in hell, though they may represent 'the desire for what belongs to others which consumes the creature as with fire' (Selvatico). As early as 1312, Francesco da Barberino had spoken of this fresco in terms of praise : 'Giotto has depicted envy with great mastery in the Arena in Padua', and most critics agree.

## 102 120×55 1306*

### Infidelity (Idolatry)

As, with all the other allegories of the series, this fresco has religious significance. The infidel holds in his hand a female idol which has a cord about his own neck in such a way as to turn his head away from the truth, symbolized by the Eternal Father seen at the top of the panel. The flames underneath may well denote the infidel's condemnation to hell (Selvatico).

## 103 120×60 1306*

### Injustice

This is the central piece of the series and, like its counterpart

Justice on the opposite wall (no. 96), is a much more complex composition than the others and one which in all probability owes much to literary sources (Lumbroso, 1889). Beneath the imposing figure of an old man, against a backdrop of a ruined castle, the artist has depicted clumps of trees and bushes and, in the frieze at the foot of the fresco, the perpetration of a crime. Selvatico holds that the old man represents a magistrate presiding over a court and that the scene is intended to convey the 'sordid greed of one who, while officially responsible for ensuring public order, does not hesitate to turn all things to his own advantage'. Several commentators have drawn attention to the elegance of line and form and the Gothic character of the frieze (Gnudi, Salvini).

## 104 120×55 1306*

### Anger

The female figure is depicted rending her garments in a manner which shows some similarity to the corresponding gesture by Caiaphas as portrayed in fresco no. 82 (Marangoni, etc.). Salvini has rightly commented on the sense of vigour, which is more marked here than in any of the other allegorical frescoes on this wall.

*107*

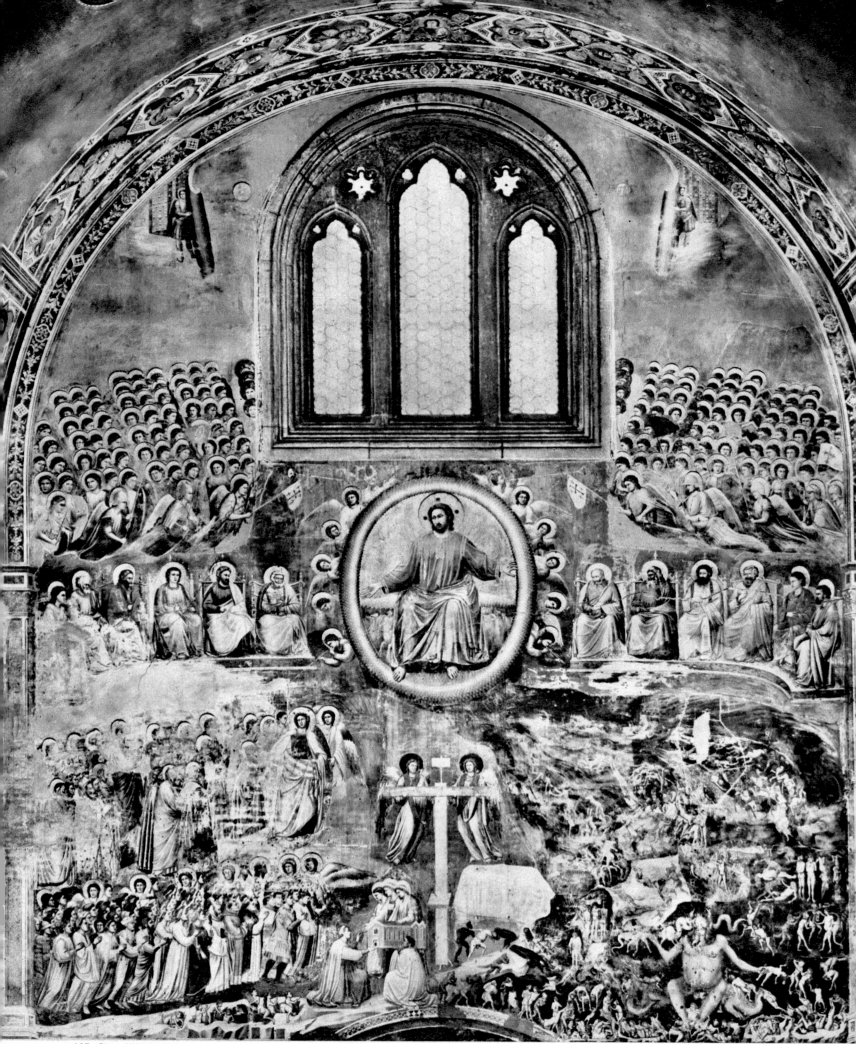

## 105  120×55 1306*

### Inconstancy

The figure is that of a young woman caught in the whirling of a wheel beneath her feet, 'a symbol of human fickleness'. However, as this fresco is immediately opposite Fortitude (no. 94), the wheel may have been intended as 'an image of weakness and fatuity in matters of religion' (Selvatico). This same scholar has postulated a connection between the symbol in question and the passage in Ecclesiasticus : 'The heart of a fool is like a cart wheel, and his thoughts like a turning axle' (Sirach, XXXIII, 5). The painting is believed to have been executed by a student possessing some ability (Gnudi, etc.), in spite of a rather harsh contrary judgement expressed by Marangoni : 'horrid . . . stiff and rigid . . . disjointed.'

## 106  120×55 1306*

### Folly

The artist has depicted a male figure 'wearing . . . a bizarre plumed headdress resembling that of the Indians' and carrying a huge club. Such is Selvatico's description and he has emphasized the religious significance with reference to the adjective 'foolish' as applied by St Paul to unbelievers and gentiles because they do not know the ways of the Lord. At one stage, the fresco had been whitewashed over, and was rediscovered later (Tolomei, 1881). It is believed to have been executed by a pupil.

*Medallions in the centre vault (no. 108). The one on the left features the Madonna with Child : the one on the right the Redeemer. They are marked 108 A – I and 108 B – I in the diagram on p. 98*

## The Last Judgement

### 107  *1000×840* 1306*

This fresco covers the whole of the west wall. Generally speaking, the overall design follows the traditional iconographic pattern. The upper part of the fresco is taken up with serried ranks of angels ; on either side of the central figure of Christ are seated the apostles and below, separated by a huge cross supported by two angels, are the saints and the elect on the right with the damned and demons on the left. At the very bottom, to the right of the cross, is what may be termed the 'dedication' group, comprising the figure of Enrico degli Scrovegni placing the chapel held by a friar in the hands of the Virgin, accompanied by a saint and an angel. The architecture of the chapel as here depicted differs from the structure as it now is ; in fact, the Gothic extension to the right of the apse was never built. Tradition has it that Giotto included his own portrait in the figure of one of the elect – fourth from the left, wearing a white cap (cf. page 83).

With the exception of Battisti (1960), who maintains that the *Last Judgement* was painted first, most critics and commentators are of the opinion that the fresco was executed in the latter stages of decoration of the chapel. Gnudi (1959) states (and in doing so reiterates the conclusion of many of his predecessors, particularly Toesca (1951) who adduced much evidence in support of his view) that Giotto very probably furnished the original general design for the fresco but left much of its actual execution to his *bottega*. Nevertheless, at a certain stage (possibly marked by his completion of the *Resurrection* episode – no. 87), he would appear to have worked on some sections of the great Judgement fresco himself, since part of it is believed by most of the critics to be his own work. This opinion holds good, in particular, for the figure of Christ (which bears a marked physical resemblance to the Christ of the *Resurrection* fresco), that of the Madonna and the portrait of Enrico degli Scrovegni in the 'dedication' group. Battisti holds that the fresco contains much of Giotto's own work and he has commented on the many figurative innovations, particularly from the point of view of the simplification and, to a certain extent, elimination of the traditional hierarchical barriers between this world and the next. Some sections of the fresco were rather heavily overpainted at the beginning of the last century (Selvatico, 1836). Gnudi points out that, for Giotto, both heaven and hell 'constitute another world, indefinable in its poetic reality, something fantastic, something unreal which persists in remaining unreal and can only be glimpsed in the occasional detail in flashes of poetic truth'.

## Vault

### 108  *1306

The ceiling vault is divided into two by means of three decorative strips, each 40 cm. wide. The first of these strips, that over the archway, contains alternate angels and saints in frames comprising a variety of geometrical shapes. The central strip, which again features similar frames, portrays crowned saints, who probably represent the precursors of Christ (Salvini). The third strip, above the *Last Judgement*, again features crowned saints. The two ceiling panels thus delineated contain the following figures : the one nearest the door, a medallion (diameter 100 cm. approx.) with a half figure of the Virgin and Child, together with four smaller medallions (diameter 80 cm. approx.) arranged symmetrically around it and each framing the half figure of a prophet. These are as follows (the numbers refer to the sketch on page 98) : Malachi – 108, A-II ; Isaiah – 108, A-III ; Daniel – 108, A-IV ; Baruch – 108, A-V. Similarly, in the second panel at the other end of the chapel there is a corresponding large medallion (diameter 100 cm. approx.) with the half figure of Christ the Redeemer imparting his blessing and this, too, is surrounded by four smaller medallions (diameter 80 cm. approx.) each with the half figure of a prophet, of which only that of St John the Baptist (108, B-IV) has been identified. Most critics hold that the decorative strips and the medallions are all the work of Giotto's pupils.

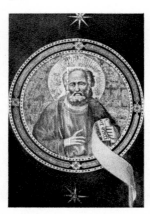

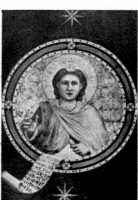

*Smaller medallions in the ceiling vault (no. 108). From top left: Malachi (no. 108 A – II in the diagram on page 98), Isaiah (no. 108 A – III), Daniel (no. 108 A – IV) and Baruch (no. 108 A – V)*

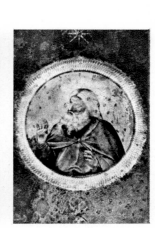

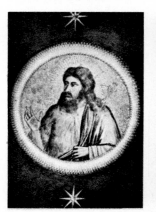

*Smaller medallions in the ceiling vault (no. 108). From top left: Prophet (108 B – II in the diagram on page 98), Prophet (108 B – III), St John the Baptist (108 B – IV) and Prophet (108 B – V)*

## 109

### Madonna in Majesty
Florence, Uffizi

The earliest reference to this work as having been executed by Giotto and mentioning its original location in the church of Ognissanti in Florence, occurs in a document of 1418 recording the leasing of the last altar on the right-hand side (where the panel was situated) to a certain Francesco di Benozzo. In the year 1810, the panel was transferred from the church to the Galleria dell'Accademia and in 1919 it was moved from there to the Uffizi. All the earliest sources, from Ghiberti onwards, attribute the work to Giotto and deem it among his unaided masterpieces. Some commentators (Thode, Toesca, Coletti) are of the opinion that it was executed before the Scrovegni Chapel cycle; others (A. Venturi, Rintelen, Weigelt, Offner, Brandi, Gnudi, Battisti, Salvini) are inclined to date it somewhat later, in the region of 1310. Brandi, in particular (1938), after studying the work with great care, opted for the latter opinion.

In spite of the diversity of opinion about dating this work, all the critics agree as to its excellence and its importance from the point of view of the development of Giotto's style and the evidence it affords of new trends in iconographic treatment. The sense of balance conveyed by the full and solid figures of the Madonna and Child with their marked air of

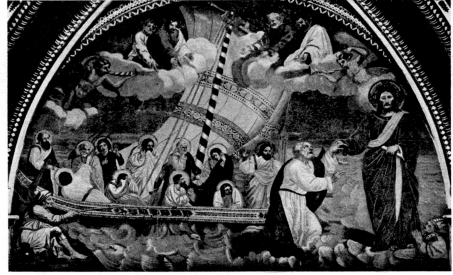

The Navicella (no. 110) as it now is, touched up in the sixteenth and seventeenth centuries

recollection has rightly been seen to constitute a basic feature of an entirely new language, conveying a deeply religious message which is no longer remote and hieratic but rather is open to human understanding.

## 110 ⊞ ⊗ *1310 🗒

### Navicella (Barque of Peter), formerly in the old Basilica of St Peter, Rome

For the attribution of this work to Giotto, our authorities are the obituary for Cardinal Jacopo Stefaneschi (1343), and the earliest sources from Ghiberti

Drawing by P. Spinelli from no. 110 (New York Metropolitan Museum of Art)

onwards. All that remains of the original mosaic overlooking the atrium of old St Peter's portraying Christ rescuing the Apostles from the fury of the tempest are two angels, one of

which is now at Boville Ernica (111) and the other at the Museo Petriano in Rome (112). The work as represented in the copy now in St Peter's (see reproduction above), has been completely altered in the course of extensive repainting carried out principally in the sixteenth and seventeenth centuries.

## 111 ⊞ ⊗ diam. 65 *1310 🗒

### Angel Boville Ernica (Frosinone), church of S. Pietro Ispano

The state of preservation is almost perfect. For further details, see no. 112.

## 112 ⊞ ⊗ diam. 65 *1310 🗒

### Angel Rome, Museo Petriano

As in the case of no. 111, this may well be a fragment of the original Navicella mosaic in the atrium of the old Basilica of St Peter in Rome (no. 110). The origin of the mosaic is recorded in an inscription dating from the early 1600s in the church of S. Pietro Ispano at Boville Ernica, where the first fragment was kept. It runs as follows: 'This image of an angel formed part of the picture of the Barque of St Peter (Naviculae S. Petri) which Iottus the great painter . . . in the atrium of the old Vatican Basilica . . .' – the remainder of the inscription is fragmentary. The second fragment was discovered in 1911 underneath a copy of 1728 which, according to the

111

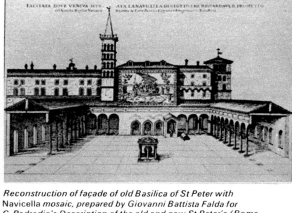

112

accompanying inscription, was the work of Giotto. It is no easy task to determine the exact location of the angels in the original mosaic, since this has come down to us much altered through repainting in the course of the centuries. However, an engraving done by Alessandro Specchi some time before 1600 would seem to indicate that they were incorporated in the decorative frieze around the mosaic itself. Nevertheless, Salvini (1962) is of the opinion that they were more likely to have been depicted alongside the inscription beneath the Navicella. All modern commentators agree that the mosaic was executed on the basis of a design furnished by Giotto; their views as to the date of execution vary from 1300, i.e. prior to the Arena cycle in Padua (Toesca, Battisti, 1960; Volpe, 1963, etc.) to 1310 (Paeseler, 1941; Gnudi, 1959; Salvini, 1962). There is documentary evidence of Giotto's having been in Rome shortly before 1313, while the Pope was in exile at Avignon and Cardinal Stefaneschi, who commissioned the work, was in charge of the basilica. Both Gnudi and Salvini maintain that the style of execution suggests

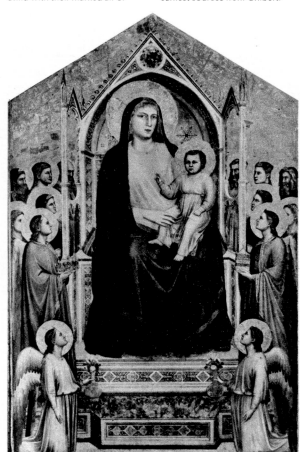

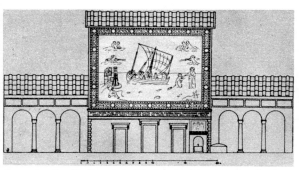

Reconstruction of façade of old Basilica of St Peter with Navicella mosaic, prepared by Giovanni Battista Falda for C. Padredio's Description of the old and new St Peter's (Rome, 1673)

Reconstruction (by Paeseler) of the façade of the old St Peter's with the Navicella mosaic and other Giotto works now lost. The Angels (nos. 111 and 112) are here incorporated in the decorative framework round the Navicella

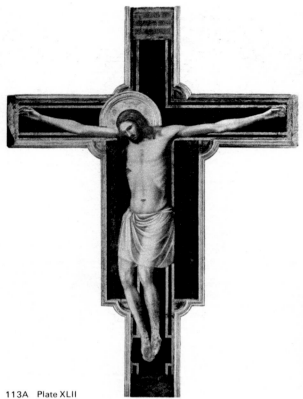

113A  Plate XLII

## 113 ⊞ ⊘ 430×303 *1310-17* 🗐

**A. Crucifix** – Rimini, Tempio Malatestiano

The early commentators and sources make no reference to this Crucifix, which is first mentioned by Tonini in his guide to Rimini (1864). It has come down to us shorn of the end panels and in a very poor condition. Although scholars and critics unanimously acknowledge its great worth, only Longhi actually attributed it to Giotto after an initial cleaning operation in 1934. The Crucifix was then exhibited at the Rimini Fair (1935) as the work of a local painter somewhere between 1310 and 1315 (Brandi, 1935) and, later, at the Giotto Exhibition in

Sketch showing original position of paintings nos. 113 B and 113 A

Florence (1937), when it attracted the attention of the critics. Beenken and Coletti (1936) endorsed the attribution to Giotto and their view was to some extent supported by Van Marle, Salmi and Suida (1935–7), who, however, also found in it traces of some collaboration on the part of a Rimini pupil. Sinibaldi (1941–2) attributed both this work and the Strasbourg Crucifixion (no. 155) to a 'Master of the Malatesta Crucifix' of Riminese origin. In 1957, Zeri identified in the *Redeemer* (no. 113 B), formerly in the Jekyll Collection, the original top end panel from this Crucifix and again endorsed the attribution to Giotto; he further suggested that the work was executed round about the year 1310. Gnudi (1959) pointed to this head panel as providing further evidence of Giotto's authorship, which Gnudi himself had, however, already postulated on the basis of the marked iconographic affinity between this and the Arena Crucifix (no. 114); he is, nevertheless, rather more inclined to favour 1317 as the date of execution. Salvini opened up the whole question of authorship again in 1962, making the point that 'the very delicate handling of light and shade' shows considerable affinity with the Rimini school but that other considerations are more suggestive of the panel's having been executed by Giotto. There remain only two tiny fragments of the original figures mourning the death of Christ. The actual figure of Christ had at one time been roughly covered with oil paint, but this was removed on the occasion of the Rimini Fair.

## 113 ⊞ ⊘ 81×86 *1310-17* 🗐

**B. Redeemer** Formerly in London, Jekyll Collection
This figure was first made known as Giotto's by Brockwell and Fry (1911) and later dated to fit in with his period in Padua (Fry, 1912 and 1919). However, Suida (1914) attributed it to the artist responsible for the *Stefaneschi Tryptych* (no. 152) and this opinion has been endorsed by Toesca (1951). In 1957, Zeri identified it as the head panel from the Rimini Crucifix (113 – A) and thus confirmed the opinion of all recent commentators. Both Gnudi and Salvini have commented on the superior artistic worth of this figure as compared with the Padua Crucifix (no. 114), which is similar in form. They

113B

further endorse the dating of the Rimini Crucifix as 1317. However, Zeri maintains that there is sufficient evidence to admit of its being dated between the execution of the Scrovegni Chapel and the artist's activities in Florence, i.e. round about 1310.

## 114 ⊞ ⊘ 223×164 *1317* 🗐

**Crucifix** Padua, Scrovegni Chapel

The outer frame of this panel features a variety of geometrical shapes and is done in relief and gilded. The head panel surmounting the upright portion of the cross contains the figure of the Redeemer; the panels at either end of the arms of the cross contain the figures of the Madonna and St John. On the reverse side of the Crucifix, there is a portrayal of the Mystical Lamb together with the symbols of the four Evangelists, but these are universally held to be *bottega* work. Though the Crucifix may originally have formed part of the iconostasis (Moschetti), there is no mention of it in the earliest sources. Cavalcaselle (1864) was the first to attribute it to Giotto, and he described it as hanging in the apse of the chapel. Later commentators have expressed a variety of opinions on the subject. Rintston (1912 and 1923) believes that it is merely a copy, done by a pupil, of the Crucifixion fresco in the Scrovegni Chapel (no. 85). Weigolt and Brandi discount the possibility of Giotto's authorship.

Gnudi endorses the theory, advanced by Longhi and originally formulated by Vavalà, that Giotto designed and partially executed the work while staying in Padua at some time subsequent to the period during which he executed the Padua frescoes. Nevertheless, most of the critics hold that the Crucifix is contemporary with the decoration of the walls of the chapel. Salvini (1962) has commented on the 'intense poetic quality' of the work and on its stylistic affinity with the Malatesta Crucifix (no. 113 – A). There is some pitting of the surface caused by the original colour having fallen away, particularly from the body of Christ; generally speaking, the surface is rubbed and somewhat

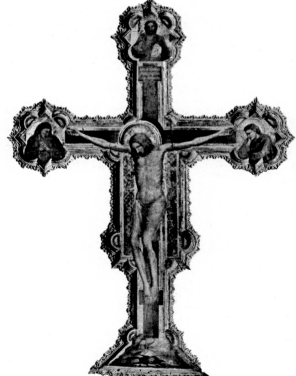

114  Plate XLIII

deteriorated. The cleaning operations carried out by M. Pellicioli (1955) have revealed that the artist used a number of colours (red ochre, lapis lazuli and lacquers) which were not in Giotto's usual repertoire (Crossato, 1957). The reverse of the panel is largely peeled.

## Magdalen Cycle

## 115 ⊞ ⊘ — 🗐

These frescoes are in the lower Basilica of S. Francesco in Assisi and cover the whole of the chapel dedicated to St Mary Magdalen, including the vault. Both side walls are marked off into three horizontal sections by means of decorative friezes incorporating imitation Cosmatesque work. The bays giving access to the chapels on either side divide the lower part of the wall into two. The space thus marked out on the left-hand wall is devoted to a portrayal of St Rufino in full prelate's regalia with his head inclined downwards in the direction of Bishop Teobaldo Pontano, who commissioned the chapel and is shown kneeling. The scene as described occupies the space to the left, while the corresponding space to the right features the penitent Magdalen. On the right-hand wall, the Magdalen, dressed in red, is seen offering her hand to Pontano, again depicted kneeling, but this time clad in the Franciscan habit (left panel). In the remaining fresco on the right of the wall are the head and shoulders of a saint peering out of a framelike structure. The curved triangular section of the wall bears a number of shields with the coat of arms of Bishop Pontano (white triple span bridge on a red field). The middle and upper horizontal sections of the walls are devoted to scenes from the life of St Mary Magdalen: *Supper in the House of the Pharisee* (left) and *Raising of Lazarus* (right) on the left-hand wall; the *Magdalen receives Communion* and *Her Soul is carried to Heaven* (both scenes depicted in the lunette on the same wall). The right-hand wall features the *'Noli me tangere'* scene (left) and *Arrival of the Saint's body in Marseilles* (right) with the *Magdalen and angels* in the lunette. The lunette on the wall over the doorway to the chapel contains the episode of the *Saint receiving a habit from the hands of Zosimo the Hermit*. On either side of the window are two smaller frescoes, one above the other, each of which contains a figure; on the left a saint as penitent with her long hair falling about her and clad in a white tunic (this may well be St Mary Magdalen herself), while underneath we have the figure of a second holy woman with a drum. The inscription 'MARIA SOROR MOYSIS' identifies her as Miriam, the sister of Moses. On the upper right-hand side is the figure of St Helen ('S. ELENA, MATER CONSTANTINI') bearing a

*III*

a date subsequent to the Padua cycle and is in any case indicative of a more mature stage in Giotto's careers.

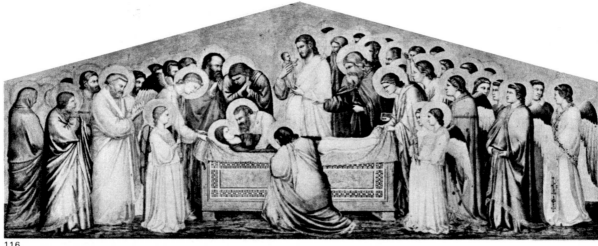

116

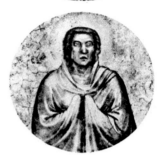

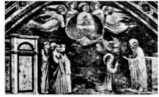

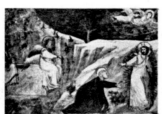

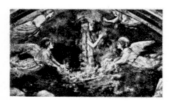

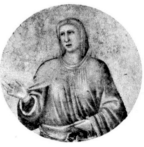

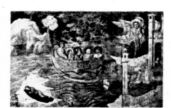

*Dedicatory panels (no. 115) depicting Bishop Pontano kneeling before St Rufino and Mary Magdalen*

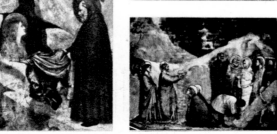

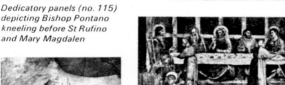

*Other features of the cycle here covered by no. 115. Above, left: The saint clothed by Zosimo. Above, right – from the top: The Magdalen receives Communion and Her Soul is carried to Heaven; 'Noli me tangere'; Magdalen and angels; Arrival of the Saint's body in Marseilles; Supper in the House of the Pharisee; Raising of Lazarus.*

cross, and below this a female martyr bearing a palm, to whose identity there is no clue. The intrados of the main archway leading to the chapel includes a series of twelve rectangular panels arranged in pairs and each containing the figure of a saint. These are as follows: on the left (reckoning from the top) Peter ('S. PETRVS') and Matthew ('S. MATHEVS') both carrying a scroll; a young man dressed in white embracing a cross and another clad in armour with a blue cloak; two female saints with no distinguishing features; on the right, Paul with a scroll and David ('DAVID REX') clad in a curious peaked hood and carrying a lyre; an old bearded figure with a globe in his left hand and Augustine ('S. AVGUSTINVS') as a monk; two female saints, one of whom has a flower in her hand and may be St Rose. Finally, set against the ultramarine background of each cell of the groin vault there is a round shield framing a half figure: Christ the Redeemer; Mary Magdalen; Lazarus and St Martha.

The earliest critics were inclined to attribute authorship to Taddeo Gaddi (Fratini, Guardabassi, etc.). Later, however, a passage in Vasari's *Lives* was interpreted as meaning that Puccio Capanna was the artist concerned (Cavalcaselle, Forster, Burckhardt, etc.). Endorsement of this theory was tantamount to ascribing the cycle to the circle of Giotto's closest and more immediate imitators, a theory which is even more tenable if it is also admitted that the cycle may have been executed by a team of artists working together (Zimmermann, Wulff, Rintelen, Sirén, Toesca, Supino, Kleinschmidt, Zocca, etc.), or alternatively under the direction of a gifted Giottesque artist (Salvini, etc.). In any case, the very high quality of sections of the cycle soon led certain critics to attribute some share in its execution to Giotto himself. Thus A. Venturi maintains that he had a hand in the *Raising of Lazarus* (Van Marle is of the same opinion), in the *Arrival of the Saint's body in Marseilles* and in the *Magdalen with Zosimo*. To the first of these three, Berenson adds the *Supper in the House of the*

*Pharisee,* while both Van Marle and Coletti (1949) see his hand also in the shield-framed figures on the ceiling. Some commentators, including Perkins, Ryss and others, are inclined to endorse Thode's view that the whole cycle is to be attributed to Giotto — though he did not necessarily execute it in its entirety. Indeed, this latter view is coming to be widely held among the most recent scholars and critics, such as Gnudi, Volpe, Previtali and others. The paintings are in a very mediocre condition. When they were cleaned by C. Fea at the end of the eighteenth century, they had been almost entirely obscured by a constitution of damp and candle smoke. In 1850 they were considerably damaged by a flash of lightning which struck this particular chapel. D. Brizi restored them in 1912 and successfully removed at least some of the over-laying dirt; the colour is still somewhat faded and corroded (Zocca, 1936).

**116** ▦ ◉ 75×178 / 1320* ▤ ⦙
**Dormition of the Virgin**
Berlin, Staatliche Museen, Gemäldegalerie
This is one of the works mentioned by Ghiberti ('the death of Our Lady with angels and twelve apostles and Our Lord') as being in the church of Ognissanti in Florence together with the *Madonna in Majesty* now at the Uffizi (no. 109). It was removed from the church towards the middle of the sixteenth century and all trace

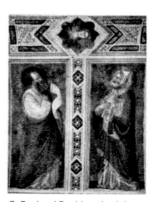

*St Paul and David on the right intrados of the main archway (no. 115)*

*The medallions in the ceiling vault (no. 115) featuring Christ the Redeemer, Mary Magdalen, Lazarus and St Martha*

of it was then lost until it reappeared as part of the Cardinal Fesch Collection at some time prior to 1841 (though there is no documentary evidence, most critics are agreed as to its identification). Some critics believe it to be a product of Giotto's *bottega,* or of an unknown Giottesque (Brandi, 1939, etc.). Later commentators incline to the view that it is Giotto's own (though not unaided) work and, on the basis of marked affinities of style, they hold that it was executed about the same time as the frescoes in the Peruzzi Chapel in Sta Croce in Florence. The fact that the artistic quality varies considerably, though there are sections of great beauty (central group and angels to right), would seem to endorse the view that the whole was not executed by Giotto (Gnudi, Salvini). Although it is defaced by some peeling, the general state of preservation is good.

# The Peruzzi Chapel

This cycle of frescoes is located in the church of Sta Croce in Florence. Critics and commentators from Ghiberti onwards have always attributed to Giotto the decoration of four chapels described by a number of sixteenth-century writers as the Bardi, Tosinghi-Spinelli, Giugni and Peruzzi chapels ('Billi', the 'Anonimo Gaddiano', Vasari). During the most recent restoration carried out by L. Tintori under the direction of U. Procacci over the period 1958–61, steps were taken, among other things, to eliminate the 'finishing touches' which had been added in the nineteenth century by Antonio Marini and his pupil P. Pezzati, who saw fit not only to fill in the missing sections but to overpaint much of the original fresco, thus obscuring almost entirely what was left of the work of Giotto. The recent restoration has enabled us to assess the quality of the original design rather than the intrinsic worth of the actual execution. While the restoration was in progress, it proved possible to establish that, presumably on account of the many works commissioned from him in his maturity and when he was at the peak of his career, Giotto executed almost the entire cycle by the *fresco secco* method and this has been a contributory factor to the present poor state of the work.

On the left-hand side of the chapel, the artist has depicted three scenes from the life of St John the Baptist. On the opposite wall, there are three companion scenes from the life of St John the Evangelist. In each case, the paintings are arranged in a lunette at the top and two rectangular scenes side by side underneath. The groin vault had originally featured the symbols of the four evangelists (now almost lost), with a series of figures of prophets in the archway giving access to the chapel. Of the frescoes executed on the end wall incorporating the window, we now have only the mutilated figure of the Mystical Lamb of

the Apocalypse. Miss Borsook's research (1961 and 1965) would seem to indicate that the 'parallel' iconographic treatment of the two St Johns was suggested both by the name of the man who commissioned the chapel, Giovanni di Rinieri Peruzzi, and by the great devotion of the Florentines to St John the Baptist, and possibly also by the fact that many of the events connected with the two saints (at least as narrated in the *Leggenda aurea* by Jacopo da Varagine, which would seem to have provided the inspiration for the frescoes) are closely linked by date. Indeed, both the coming of the Evangelist to heaven and the birth of the Baptist are commemorated on the same day, 24 June, in the Florentine calendar.

The problem of dating these frescoes is closely bound up with that of the further cycle in the Bardi Chapel in the same church. Most critics (with the exception, in recent times, of Miss Borsook) are of the opinion that the latter cycle was executed only shortly after those in the Peruzzi Chapel. On the basis of stylistic and figurative considerations, Gnudi (1959) has suggested a date somewhere between 1318–20 and the beginning of 1322 for the execution of the Peruzzi Chapel frescoes. He argues that, with more than a decade of experience behind him in the execution of the Padua frescoes, Giotto brought to this cycle and to the subsequent cycle in the Bardi Chapel a new peak of uniform grandeur and a 'broader, more conscious humanistic spirit'. He goes on to say that the affinity between this and the Bardi Chapel is so marked that there are good grounds for believing that the latter cycle was begun in 1325. Further, and in this Gnudi's view is endorsed by Battisti and Salvini, the point of transition from one cycle to the other is marked by the frescoes in the Bardi Chapel lunettes, even allowing for the contribution made by collaborators. This

order of events, however, differs from that proposed by Peter (1940) who recognized the affinities in style between the two chapels and the closeness of their execution in time but felt that the Bardi Chapel came first, though both were completed before 1323. Recently, this theory has again been propounded in the work by Tintori and Miss Borsook. These scholars hold that there are considerable differences in style between the Peruzzi and Bardi chapels and that, moreover, the quality of both design and execution varies much even within each individual cycle. They therefore conclude that, though the Baptist cycle was almost certainly completed before 1328, the Evangelist cycle could well have been executed some time later and therefore furnishes an example of Giotto's style as it had evolved following his trip to Naples. While all critics are agreed that Giotto was assisted by his *bottega* in executing the cycle, it is universally recognized that the frescoes are largely his work.

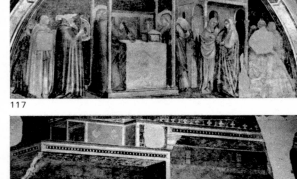

117

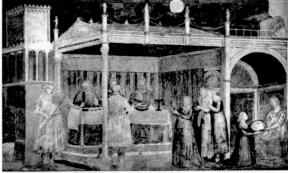

118   Plate XLVI

## John the Baptist Cycle

### 117 🔲 ⊕ *280×450* 1320* 🔳 ⫶

**Annunciation to Zachary**
The fresco illustrates the gospel story of the apparition of the Archangel Gabriel to Zachary, offering sacrifice in the temple, to announce the birth of a son, the future St John the Baptist. During recent restoration, the subsequent decoration of the temple was removed. The female figures on the right of the picture are most clearly distinguishable.

### 118 🔲 ⊕ *280×450* 1320* 🔳 ⫶

**Birth of John the Baptist**
An architectural structure divides the fresco into two. On the right is the birth of the saint with, on the left, the naming of John the Baptist by Zachary who, having been struck dumb by the angel, is writing the name on a tablet. The painting is entirely Giotto's work but is much damaged and several portions are missing. The half figure of St Elizabeth, executed by Pezzati, has now been completely eliminated.

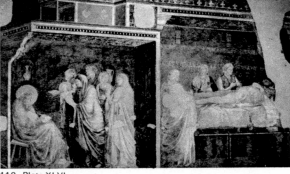

119   Plates XLVII-XLVIII

### 119 🔲 ⊕ *280×450* 1320* 🔳 ⫶

**Herod's Feast**
Again, the painting portrays two separate incidents which took place on the same occasion. The dance of Salome occupies most of the fresco, with the scene of the girl offering the head of the Baptist to her mother depicted on the extreme right. It is much worn but almost complete, at least as far as the overall composition is concerned. Giotto's treatment of the figures here became immensely popular at once, and was probably his most widely copied work throughout the

fourteenth century (Tintori and Miss Borsook). The group of two women seen watching Salome on the right was featured by A. Lorenzetti in his frescoes in the church of S. Francesco in Siena executed in the year 1328 or thereabouts. During the recent cleaning operations, it was found that, in all probability, this particular fresco, and possibly others, had already been subjected to some restoration in the 1400s or 1500s, at which stage many of the heads of the guests at the banquet and the lyre carried by Salome would appear to have been retouched.

## John the Evangelist Cycle

### 120 🔲 ⊕ *280×450* 1320* 🔳 ⫶

**St John on Patmos**
The lunette depicts the banishment of St John the Evangelist to the island of Patmos during the reign of Diocletian. The saint is shown surrounded by the symbols of his apocalyptic vision about which he wrote to the seven churches in Asia. Recent restorations have rendered the overall design of the architectural structure visible, though unfortunately the execution is impaired. The

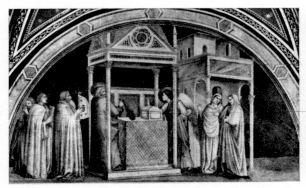

*Condition of no. 117 before restoration. The nineteenth-century retouching had obscured the figures on the extreme right and almost destroyed the composition*

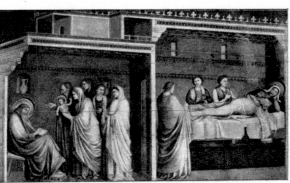

*Condition of no. 118 before restoration. The nineteenth-century retoucher not only altered the setting, but put in the head of the woman in labour which, in fact, is missing*

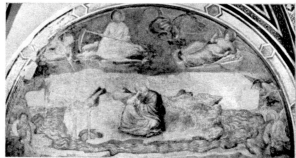

120 Plate IL

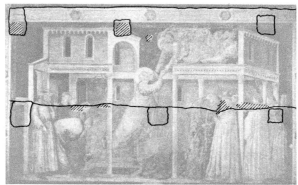

Sketch illustrating painting procedure for no. 122. The horizontal lines mark the joins between the areas painted at each scaffolding level, a procedure made possible by the use of the dry fresco rather than of the buon fresco method. The squarish marks show the points at which the scaffolding was let into the wall

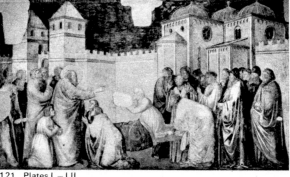

121 Plates L – LII

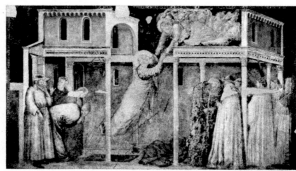

122

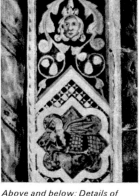

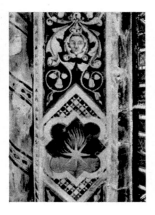

Above and below: Details of decorative frieze featuring grotesques and symbolic figures in window embrasure (end wall, no. 125) to left (see also Plate LIII)

second figure from the left is almost invisible and a portion of the plaster on the right-hand side is missing.

**121** ⊞ ⊗ *280×450* 1320* ▤ ⋮

**The Raising of Drusiana**
On his return from Ephesus, St John the Evangelist encounters the funeral procession of Drusiana who has died before

her time from her longing to see him again. Greatly moved, the saint performs a miracle and brings her back to life. The earlier attempts at retouching this fresco had tended largely to emphasize the figures. The recent work of restoration had to be executed with the greatest care as there was considerable danger of losing the original surface almost completely. As

in the other frescoes, portions of the plasters are missing at the points corresponding to the holes which were driven in the wall for the old scaffolding.

**122** ⊞ ⊗ *280×450* 1320* ▤ ⋮

**The Assumption**
Feeling the approach of the death prophesied by Christ, St John the Evangelist lets himself down into a pit in the presence of the citizens of Ephesus. There appears a light from heaven in which the saint disappears, to be clasped in the arms of God. As with the other frescoes in this cycle, restoration has revealed the original design and shown up the many gaps now left in the execution. Some details added subsequently, including the bearded head of an old man to the right, have been removed. Marini rediscovered the work in 1849 (Guasti; Cavalcaselle). A drawing by Michelangelo dating from between 1489 and 1492 featuring the two figures on the left (Berenson, 1938; Tolnay, 1947; Tintori and Miss Borsook, 1965) is now at the Louvre.

general composition is still discernible, but the details are so worn as to make assessment impossible.

**End Wall**

**125** ⊞ ⊗ 1320* ▤ ⋮

Most of the fresco in the lunette above the window has been lost. There remains, at the very top, the head and forelegs of the Mystical Lamb; in addition, the window embrasure retains traces of decorative motifs comprising heads and symbolic figures in a stylized framework of foliage.

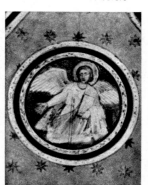

Above, left: Actual condition of medallion – with angel symbolizing the evangelist Matthew – best preserved feature of vault decoration (no. 123). Above, right: One of a series of prophets in embrasure of main archway (no. 124) (left-hand side) in present condition following restoration

Three heads (believed to be self-portraits) in the frieze around painting no. 122 (following recent restoration)

Above, left: Prophet (one of the more decipherable) in embrasure to right of main archway (no. 124) in present condition following restoration. Above, right: Remains, as now visible, of Mystical Lamb on end wall (no. 125)

**The Vault**

**123** ⊞ ⊗ 1320* ▤ ⋮

The four symbols of the Evangelists originally in the cells of the vault have been lost, except for the one adjoining the archway giving access to the chapel.

**Main Archway**

**124** ⊞ ⊗ 1320* ▤ ⋮

This archway features the half figures of eight prophets. The

**The Peruzzi Polyptych**

**126** ⊞ ⊗ 667×217 ▤ ⋮

This polyptych is composed of five panels portraying St John the Evangelist, the Madonna, Christ the Judge, St John the Baptist and St Francis. The original altarpiece had been broken up but was reassembled at the National Gallery of Art in Washington (Kress) before being moved (1960) to the North Carolina Museum of Art in Raleigh, where it is now housed. Sirén was the first to

114

make the four side panels known to the public in 1923. He attributed them to a pupil of Giotto's, suggesting that this might well have been Stefano. Later, Suida (1931) realized that all five panels formed part of a single whole and identified them (largely on account of the two St Johns) with the panel from the high altar in the Peruzzi Chapel in Sta Croce in Florence; he further attributed the figures of Christ and St Francis and the head of John the Baptist to Giotto himself. Most later commentators hold that the work was executed by Giotto's workshop, but vary in their opinions concerning Giotto's own contribution. In a private memorandum, Zeri maintained that much of the polyptych was to be attributed to Giotto, but Shaffran (1953) and Berenson (1963) attributed it to a pupil, whom they identified as Maso. Gnudi (1959) endorsed this view and added that both treatment and style were far removed from those manifested

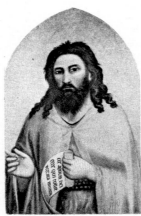

126 A

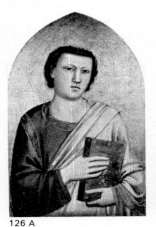

126 B

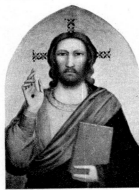

126 C

in the wall frescoes in the same chapel.

**A. St John the Evangelist**
Universally held to be the work of a pupil.

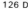

126 D

126 E

**B. Madonna**
See above (no. 126 A).

**C. Christ the Judge**
Some believe this figure to have been executed by Giotto. In any case, it most closely resembles the Master's known style.

**D. St John the Baptist**
Suida believes the saint's head to be the work of Giotto; for the rest, experts agree that the work is that of a pupil.

**E. St Francis**
Some believe this to be the work of Giotto.

**127** ⊞ ◔ 84×54 *1320 - 25* 目 ⋮

**St Stephen** Florence, Horne Museum
The critics unanimously agree that this work forms part of a dismembered polyptych which originally included the *Madonna with Child* now in the National Gallery in Washington (no. 128) (Offner, 1924; Mather, 1925), the *St John the Evangelist* and the *St Laurence* now at the Jacquemart-André Museum in Châalis (nos. 129 and 130) — both of which were first brought to the notice of the public by

Longhi in 1930. There must originally have been a fifth panel, which may have been a St Bernard of which, however, we still know nothing (cf. the reconstruction proposed by Longhi). Many critics concede that the work was executed by Giotto, with assistance from his *bottega*, in his later years. Others, including Sirén, Supino, Berenson, Toesca and Brandi, merely attribute it to a Giottesque. The St Stephen panel is sufficiently well preserved to allow an assessment of the overall design and the rich colouring; it is certainly a fine example of Giotto's own work and is stylistically very close to the frescoes in Sta Croce (Gnudi, Salvini).

**128** ⊞ ◔ 85,5×62 *1320 - 25* 目 ⋮

**Madonna with Child** —
Washington, National Gallery of Art (Kress Collection)
This panel was part of the dismembered polyptych which included the *St Stephen* (see no. 127). The execution has been impaired by touching up and restoration, but the latest critics attribute the work to Giotto. The affinity between this Virgin and equivalent portrayals in the Bardi Chapel (Sta Croce) has been emphasized by Gnudi, who further comments on the artist's novel handling of a traditional theme.

**129** ⊞ ◔ 81×55 *1320 - 25* 目 ⋮

**St John the Evangelist**
Châalis, Jacquemart-André Museum
This, too, formed part of the dismembered polyptych under discussion (no. 127), together with the *St Laurence* in the same museum (no. 130). The saint is surmounted by a cusp framing an angel. Both features and raiment closely resemble those of the John the Evangelist in the Peruzzi Chapel (Sta Croce) (Gnudi). The panel has suffered at the hands of would-be restorers, but is nevertheless believed by Gnudi, Salvini and others to be the work of Giotto.

**130** ⊞ ◔ 81×55 *1320 - 25* 目 ⋮

**St Laurence** Châalis, Jacquemart-André Museum
Like the *St John the Evangelist* (see no. 129), this panel retains its triangular cusp with an angel. Salvini and others hold that it is

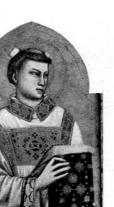

127 Plate LXIV

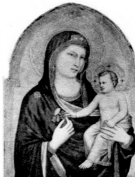

128

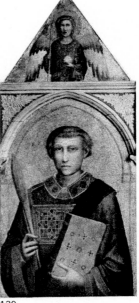

129

130

the work of an assistant of Giotto. Unfortunately it has been seriously impaired both by restoration and by retouching at one time or another.

*Proposed reconstruction of polyptych which may have comprised nos. 127, 128, 129, 130 and one other unknown panel (cf. no. 127)*

**131** ⊞ ◔ 44×45 *1320 - 25* 目 ⋮

**Adoration of the Magi** New York, Metropolitan Museum
This work is usually considered in conjunction with the six panels discussed below (nos. 132–7), with which it bears marked affinities of style. Attribution of the work to Giotto is by no means unanimous. Some critics (ranging from Rumohr to Longhi and Gnudi) maintain that all seven panels constitute fine examples of Giotto's mature work, and were probably executed only shortly before he undertook the frescoes in Sta Croce in Florence. Longhi goes even further and suggests that the seven panels may well have originally formed one of the four polyptychs which are known to have been executed by Giotto for the two chapels in Sta Croce (but cf. p. 113) (Ghiberti). He further postulates their forming part of the dismembered work to which the various panels housed in Florence (Horne Museum, no. 127), Washington (no. 128) and Châalis (nos. 129 and 130) have been ascribed. Gnudi (1959) endorsed Longhi's view that such an ideal reconstruction of the polyptych provides an undoubted representational link between

the two fresco cycles in the Peruzzi and Bardi chapels. Nevertheless, Gnudi recognizes that Longhi's reconstruction would result in a complete panel too large for the chapels in question. Other critics (ranging from Cavalcaselle to Toesca and from Brandi to Salmi and Salvini) prefer to believe that the *Adoration* and the other seven panels are fine examples of the work of artists of the Giotto school, and that they merely reflect the Master's maturing style. The *Adoration* panel with which we are here concerned shows visible signs of retouching; the modelling seems to be somewhat flattened.

115

131

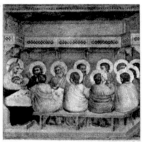

132

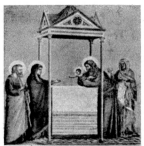

133

## 132 ⊞ ⊘ 44×43 *1320-25* 🗏⁞

**Presentation of the Child Jesus in the Temple** Boston, Gardner Museum

All are agreed that this is one of the finest works in the series (cf. no. 131). Iconographically and otherwise (e.g. figure of Child Jesus, baldacchino, etc.), it betrays close affinities with the frescoes in the Peruzzi Chapel in Sta Croce (Gnudi).

## 133 ⊞ ⊘ 42,5×43 *1320-25* 🗏⁞

**Last Supper** Munich, Alte Pinakothek

In 1813, Maximilian I acquired this and nos. 134 and 136 from an Italian collection.

Thode believes it to be a study by Giotto himself in preparation for the fresco featuring the same theme in the Scrovegni Chapel (but see also no. 131).

The panel is unfortunately somewhat damaged.

## 134 ⊞ ⊘ 45×43,5 *1820-25* 🗏⁞

**Crucifixion** Munich, Alte Pinakothek

Critics generally agree that Giotto's *bottega* was largely responsible for this work. The inclusion of St Francis at the foot of the cross with the figures of the donors was regarded by Longhi (1930) as proof that it had been part of one of the four altarpieces executed by Giotto (cf. Ghiberti) for the Franciscan church of Sta Croce in Florence (but see also the notes to no. 131 above).

116

## 135 ⊞ ⊘ 44,5×43 *1320-25* 🗏⁞

**Deposition** Settignano (Florence), Berenson Collection (Harvard University)

Even Gnudi entertains some doubts as to Giotto's authorship, though he recognizes the fine quality of the group comprising the Madonna supported by the other Mary (cf. no. 131). The panel is in a good state of preservation.

## 136 ⊞ ⊘ 45×44 *1320-25* 🗏⁞

**Descent to Limbo** Munich, Alte Pinakothek

The painting is somewhat damaged (cf. no. 131).

## 137 ⊞ ⊘ 45×44 *1320-25* 🗏⁞

**Pentecost** London, National Gallery

This is regarded as one of the finest panels of the entire series here under review (cf. no. 131), particularly from the point of view of the architectural and spatial treatment (Gnudi).

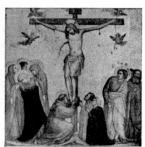

134

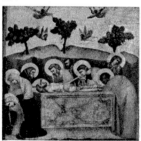

135

136

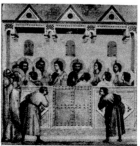

137

# The Bardi Chapel

This cycle of wall paintings is to be found in the Florentine church of Sta Croce. First mentioned by Ghiberti and thereafter by 'Billi', the 'Anonimo Gaddiano' and Vasari (cf. page 113), it is universally held to be the work of Giotto, though with some assistance. Oertel, however (1949 and 1953), dissociates himself from this view and adduces stylistic grounds in support of his attribution of the cycle to a pupil, who might have been either Maso di Banco or the so-called 'Maestro di Figline'. The cycle comprises a series of seven frescoes executed on the side walls (one lunette and two rectangular paintings on each wall) and on the main archway giving access to the chapel. All are devoted to scenes from the life of St Francis: on the end wall, on either side of the window, there appear the figures of four saints, though only those of St Clare and St Louis of Toulouse are now decipherable. Elizabeth of Hungary (bottom right) is much damaged and the figure above her has disappeared completely. The entire cycle was whitewashed over in the eighteenth century (there was no trace of it already by 1730) and was not rediscovered until 1852. Moreover, it suffered more or less the same vicissitudes as the Peruzzi Chapel (cf. page 113), culminating in the same 'finishing touches' added in the nineteenth century. In 1937, it proved possible to restore the fresco featuring the *Stigmata of St Francis* on the archway almost to its original condition. A series of analyses of the other frescoes (Procacci, 1937) seemed to indicate that it would be possible to recover much of the original ornamentation, which had been much impaired by the arbitrary finishing touches added by the earlier restorer, Gaetano Bianchi. In fact, the cleaning operations carried out in 1958 and 1959 by L. Tintori under the supervision of U. Procacci effectively revealed the artist's original design and treatment, though there were irremediable lacunae occasioned by past treatment (erection of memorial tablets and tombstones). Moreover, Giotto had used the *fresco secco* technique to a very considerable extent. As for the date of execution, most critics incline to the view that these frescoes were completed shortly after those in the Peruzzi Chapel and display the same stylistic treatment. The fact that St Louis of Toulouse was canonized in 1317 would seem to set a limit before which the cycle cannot have been executed, since it includes the figure of St Louis. Some scholars have opted for 1325 or thereabouts (Gnudi, 1959; Salvini, 1962), but the 1325 dating has been rejected by Peter (1940) who favours the year 1323; Miss Borsook,

too, has recently (1965) questioned the accepted 1325 dating since, in her view, the Bardi frescoes are much closer than had been thought to the inspiration apparent in Padua. Moreover, she again raises the question of the date of execution by querying the earlier limit traditionally regarded as having been set by the canonization of St Louis (i.e. 1317), and pointing out that a number of persons who had died in the odour of sanctity have been known to figure in

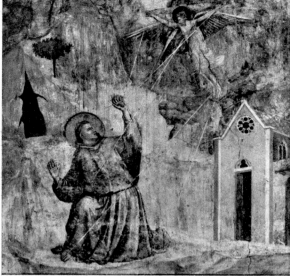

138

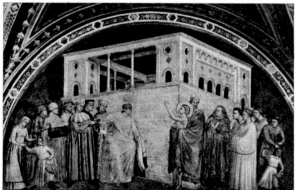

139   Plates LIV-LV

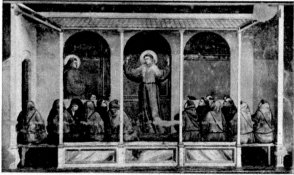

140   Plate LVI

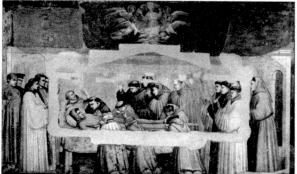

141   Plates LVII-LIX

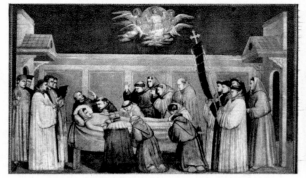

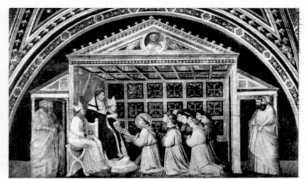

In our own view, these two
cycles in Sta Croce are the fruit
of one and the same period of
lyrical and representational skill
attained by Giotto in his
maturity. We have seen that he
moved steadily throughout his
career towards the expression of
a broader and more tranquil
dramatic quality, a development
which is apparent in the Arena
frescoes, as compared with
those executed earlier in Assisi,
and increasingly so in those of
his works which followed the
Scrovegni period. Thus, he now
achieves a breadth and unity in
his treatment of space which
would certainly seem to justify
the view that Giotto's art, at this
point, mirrors the parallel
development of culture at this
very time towards a consciously
'humanistic' attitude, and this
precisely in those centres where
the artist was most frequently at
work, namely Florence and
Padua (Gnudi). Some of the
frescoes evoke themes already
handled in Assisi (for obvious
reasons, this will show more
clearly the development we are
trying to demonstrate) and all
convey an atmosphere of depth

*Condition of no. 141 before restoration. The gaps caused by the insertion of a tombstone and other damage had been made good by the 'invention' of the head of St Francis in the centre and the processional cross and banner on the right*

*Condition of no. 142 before restoration. The nineteenth-century 'restorer' had added the decoration on the rear wall of the edifice, as well as the faces of the two figures to the left and much of the Pope's head*

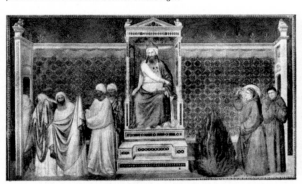

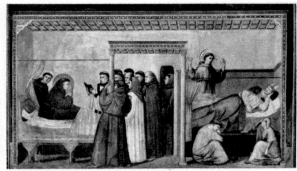

*Condition of no. 143 before restoration. Again, the nineteenth-century 'restorer' had bestowed an 'original' decoration on the rear wall in addition to a 'reconstruction' of most of the foreshortened wall on the left of the panel*

*Condition of no. 144 before restoration. The retouchers almost let their imagination run away with them: much of the figure of Fra Agostino and of the friar in the doorway and the whole of the figure of St Francis were added gratuitously*

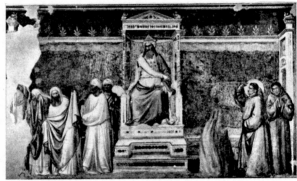

142  Plate LXI

143

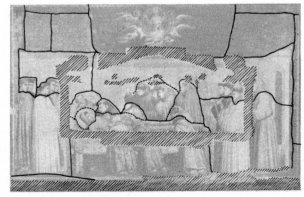

144  Plate LXII

and grandeur characteristic of
Giotto's mature style.

The frescoes are here
reviewed in the order in which
they are depicted, going from
left to right and top to bottom.

## Life of St Francis

### 138 ⊞ ⊕ *390×370* *1325* 🗏 ⋮
**The Stigmata**
The subject would seem to have
been handled somewhat after
the manner of the corresponding
episode in the Franciscan cycle
in Assisi (no. 38); here,
however, the unity of
composition is both greater and
more complex.

### 139 ⊞ ⊕ *280×450* *1325* 🗏 ⋮
**St Francis renounces his
possessions**
The theme is the same as that in
one of the Assisi frescoes (no.
24); indeed, many of the
*dramatis personae* appear in
both. The group of figures to the
right of the picture (certainly
executed by Giotto himself) is
close in style to the paintings in
the Peruzzi Chapel; there are
unmistakable indications that
the artist's assistants had a hand
in the execution of the left-hand
group (Gnudi, Salvini).

### 140 ⊞ ⊕ *280×450* *1325* 🗏 ⋮
**Apparition to the Chapter
at Arles**
Once again, the artist had
already illustrated this theme in
the Upper Basilica in Assisi (no.
37). However, his quite novel
approach is here apparent in the
disposition of the figures and in
the manner in which the scene
is set 'with an entirely new
concept of depth conveyed by
the three arches' (Salvini).
Except for incidental details
executed by others (discernible

from the over-emphasis of facial
contours and expression), the
entire fresco would appear to be
Giotto's own work.

### 141 ⊞ ⊕ *280×450* *1325* 🗏 ⋮
**Confirmation of the
Stigmata**
This fresco combines the
themes which had inspired two
separate frescoes in the Upper
Basilica in Assisi (*Death of St
Francis*, no. 39 and
*Confirmation of the Stigmata*,
no. 41), and, once again, it
would appear to be entirely the
work of Giotto. The latest
restorations have successfully
freed the work of all the
gratuitous 'improvements'
of the nineteenth century.

### 142 ⊞ ⊕ *280×450* *1325* 🗏 ⋮
**Confirmation of the Rule**
A similar scene appears in the
Upper Basilica in Assisi (no.
26), though here the disposition
of the figures has been reversed
and the setting is different.

Gnudi maintains (and Salvini
supports him) that most of the
fresco was executed by a fairly
gifted pupil who had in mind in
particular the Master's style as it
had been manifested in the
Peruzzi Chapel.

### 143 ⊞ ⊕ *280×450* *1325* 🗏 ⋮
**Trial by Fire**
Already portrayed in the Upper
Basilica in Assisi (no. 30), the
overall perspective here differs
considerably and the figures
(which also differ widely from
those depicted in the earlier
Assisi fresco) are brought into
the foreground and thrown into
sharp relief. The entire fresco is
considered to be Giotto's
unaided work. Salvini has
commented on the intensity of
colour, which 'so perfectly
matches the relaxed and
harmonious movement of the
figures'. During the recent
restoration, much of the
nineteenth-century retouching
was removed.

*Sketch illustrating the painting procedure for no. 141. The area covered in a day's work is larger than at Assisi or Padua – seven heads were completed in a 'day' – because the artist here used fresco secco in order to finish work started in buon fresco*

## 144 *280×450* *1325*

**Apparition to Fra Agostino and the Bishop**
Though the iconography differs, the fresco contains yet another episode depicted in Assisi (no. 40). When the nineteenth-

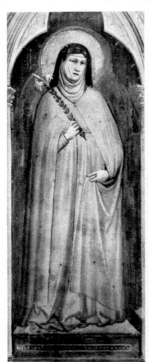

145 Plate LX

148

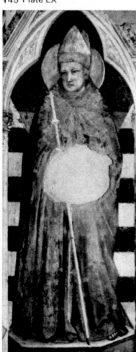

146

147 Plate LXIII

century accretions had been removed, this was found to be the most extensively damaged painting of the entire cycle. However, the quality of what is left leaves no doubt that Giotto himself was largely responsible for the execution of it (Gnudi, Salvini, etc.).

## Franciscan Saints

### 145 *230×70* *1325*

**St Clare**
The saint is depicted (on the end wall, to the left of the window and below the figure of *St Louis of Toulouse*) according to traditional iconography. The excellence of the painting clearly indicates that it is Giotto's own work (Gnudi, Salvini). The other two figures to the right are too far gone to admit of any assessment.

### 146 *230×70* *1325*

**St Louis of Toulouse**
This painting is situated immediately above no. 145 (*St Clare*) and is so badly damaged as to invalidate any definite appraisal. Nonetheless, it would certainly seem to be inferior to *St Clare* (Salvini).

## The Vault

### 147 *1325*

The vault is divided into four triangular cells by diagonal ribs incorporating simulated

Cosmatesque work. Each cell contains the half figure of a saint in a lobed frame. Over the left-hand wall, there are traces of a Franciscan saint with the index finger of his right hand to his lips, thus reminding the onlooker of the need for silence. In the corresponding position over the entrance is the *Allegory of Chastity* reproduced here; only indecipherable fragments of the frescoes in the other two cells now remain.

## Ornamental Friezes

### 148 *1325*

In addition to the decorative motifs, of which one of the few decipherable portions is illustrated here, the incidental ornamentation includes two imitation polychrome marble panels underneath the figures of the saints on either side of the window; a painted column in each corner of the chapel; eight busts of saints arranged in fours on either side of the entrance. However, the paint is so worn as to render them indecipherable.

## Baroncelli Polyptych

### 149 185×323

The original work, consisting of five panels and a predella, has been housed, since its completion, in the chapel of the Baroncelli family in Sta Croce in Florence. It is signed: '*Opus magistri Jocti*'. It was probably to this work that Ghiberti referred, though in terms which were not at all clear (Salvini, 1962). Vasari records a description of it, in the course of which he states specifically that the frame and the cherubs featured in the insets between the arching of the five major panels were added in the fifteenth century. It may well be that the actual disposition of the panels was altered at the same time. Some critics are of the opinion that the entire work is that of Giotto. Others, however (A. Venturi, Toesca, Salvini, etc.), are more inclined to the view that it was commissioned from Giotto but that he entrusted its execution (on the basis of his own design and possibly also with some assistance from himself) to Taddeo Gaddi and others. It is worth mentioning that Gaddi was in any case the artist responsible for the frescoes in the Baroncelli Chapel. Longhi (1957) nevertheless holds that Giotto's own hand is discernible in much of the actual execution of the polyptych. This same view has again been expressed by the latest commentators, including Zeri (1957), who was responsible for identifying the small panel portraying God the Father (no. 149 G) now at San Diego as having originally surmounted the work.

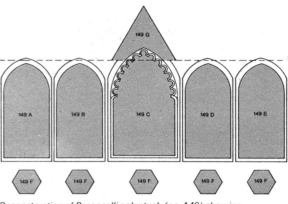

*Reconstruction of Baroncelli polyptych (no. 149) showing original position of head panel portraying God the Father and Angels, now in San Diego (no. 149 G)*

Opinions as to dating vary from before the year 1328 (Zeri, etc.), in which Giotto left for Naples, to after the year 1332 (Salvini, etc.), when Gaddi started work on the wall frescoes in the Baroncelli Chapel. On the whole, the work, which was restored in the last century, is fortunately in reasonably good condition.

**A. Saints, Prophets, Blessed and Angels**
St Francis and St Clare are recognizable among the ranks of prophets, blessed and angels with instruments.

**B. Saints, Blessed and Angels**
Behind the angels we may distinguish the figures of St Peter, Adam, and Eve (behind Adam); further back may be seen Moses in the midst of a group of blessed.

**C. Coronation of the Virgin**
Four angels kneel at the feet of the Virgin and of Christ, who is placing the crown on her head. Most commentators hold that this panel is most closely akin to Giotto's known work, while some believe that it was executed either entirely or at least in part by the Master himself (Longhi, Zeri, etc.).

**D. Saints, Blessed, Angels**
St Paul, Abraham and St John the Baptist may be identified.

**E. Saints and Angels**
The hand of Taddeo Gaddi is more clearly discernible here, perhaps, than in the rest of the polyptych.

**F. Christ and Saints**
The divisions in the predella do not exactly match the main panels, though it, too, is divided into five sections which depict respectively a bishop saint, St John the Baptist, the Dead Christ, St Francis and St Onofrio.

**G. God the Father and Angels** San Diego (California), Fine Arts Gallery
This panel was at one time in the Arthur Berenson Collection in

New York. It had been ascribed to Giotto by Berenson (1932), L. Venturi (1933) and later by Toesca (1951). In 1957, Zeri recognized it as being the panel which had originally surmounted the *Baroncelli Polyptych* in Sta Croce, and maintained that the figure of God the Father had been executed by Giotto, though the angels were the work of Taddeo Gaddi. He amplified his remarks by stating that the quality of the composition is strongly indicative of its having been destined for a major work such as the polyptych in the Baroncelli Chapel. As we have already pointed out, Zeri dated it prior to Giotto's sojourn in Naples (1329). With the exception of the extreme right, where there has been some peeling, the panel is in reasonably good condition; however, the quality of the restoration, including the addition of a frame, is somewhat questionable.

## Bologna Polyptych

### 150 91×340

This polyptych, comprising five panels and a predella, is signed '*opus magistri Jocti de Florentia*'. It is now housed at the Art Gallery in Bologna, and comes originally from the church of Sta Maria degli Angeli in Florence, known to have been built (Frati, 1910; Gnudi, 1959) after the year 1328. All the critics agree that this is a work dating from Giotto's later years and that it was to a large extent executed in his *bottega*, though Giotto himself probably took a hand. The polyptych was broken up during the

149 G

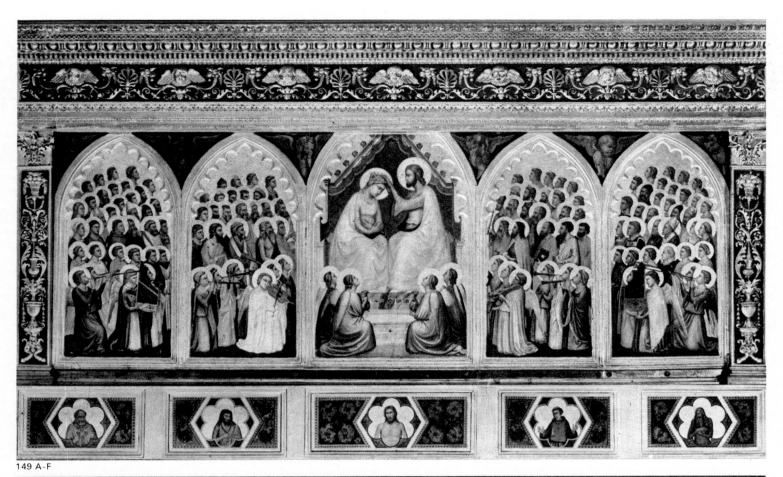

149 A-F

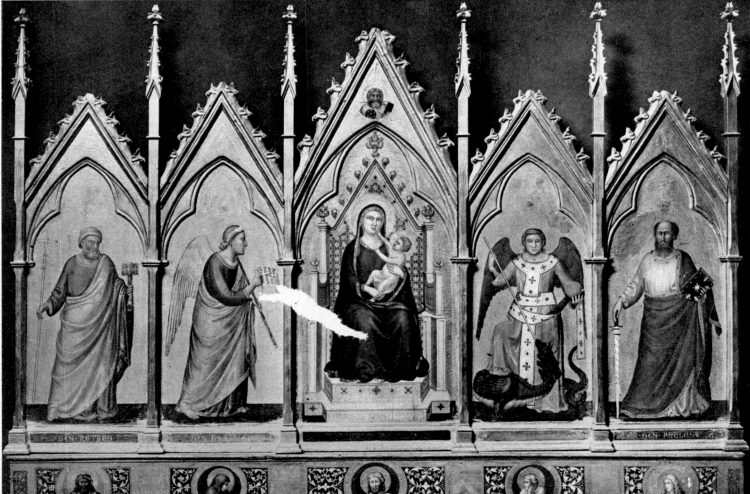

150 A-F

*The Christ (no. 150 F) in the predella of the Bologna polyptych*

Napoleonic wars (1808) and reassembled in 1894. On the whole, it is in good condition.

**A. St Peter**
Generally regarded as a *bottega* work, though Toesca felt it bore some affinity to Giotto's own style.

**B. Archangel Gabriel**
Universally held to be a *bottega* work.

**C. Madonna with Child**
Most of the critics (Toesca, Coletti, Longhi, Salvini) consider that this centre panel may well have been executed by Giotto himself, in view of the great delicacy of treatment in both outline and colour, this being a marked characteristic of the Master's later work.

**D. Archangel Michael**
Universally held to be a *bottega* work. There has been some retouching.

**E. St Paul**
All critics ascribe this to a Giottesque painter.

**F. Christ and Saints**
The predella includes five figures set in round frames. From left to right : St John the Baptist ; the Virgin ; Christ ; St John the Evangelist ; St Mary Magdalen. The *Christ* is believed to be the work of Giotto, and Toesca thinks he may have been responsible for the *Virgin*. The paintings have been touched up, particularly the first one on the left and that of *Christ*.

## Stefaneschi Polyptych

**151** ▦ ⊕ 220×245 ▤ ⋮

This work, now at the Vatican Gallery in Rome, comprises three main panels and a predella, with paintings on both sides. On the reverse side, a prelate (under the patronage of St George) is shown at the feet of St Peter offering the polyptych (see no. 151 H). This is almost certainly intended to be Jacopo Caetani Stefaneschi, Cardinal Deacon of S.Giorgio al Velabro (Toesca, 1941). In the necrology, under the cardinal's death in the year 1343, it is recorded that he

151 A

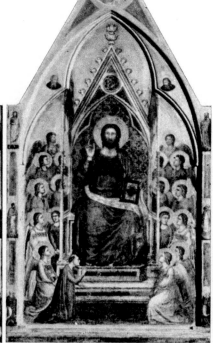

151 B

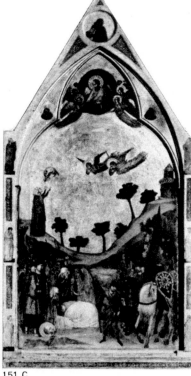

151 C

151 D

151 E

151 F

commissioned this work from Giotto for the high altar of the old Basilica of St Peter. This statement is repeated by Ghiberti and others writing soon afterwards. Most commentators are now agreed that Giotto entrusted its execution to his *bottega*. However, Supino and, more recently, Gosebruch (1958) maintain that he himself was responsible for its execution. As for dating, there would seem to be considerable substantiation for the view that it was produced in the third decade of the fourteenth century ; round about 1320, according to some (A. Venturi ; L. Venturi ; Toesca ; Cecchi, 1937, etc.), or, more probably, somewhere in the region of 1330, in view of the marked affinities of style

between it and the later works of Giotto who, maintains Gnudi, was certainly responsible for the design. The side panels from the predella on the reverse of the polyptych are now missing.

**A. Crucifixion of St Peter**
This is attributed to one of the most gifted of Giotto's assistants (assuming it was not the work of Giotto himself). Toesca states that the same artist was not responsible for the other lateral panel on the same side of the polyptych.

**B. Christ Enthroned and Angels**
Some commentators think that this panel may have been the work of Giotto himself. Toesca holds that he painted the figure

of Christ. Gnudi ascribes to him the overall design, in particular the expert handling of the throne, which fits perfectly into the composition.

**C. Beheading of St Paul**
Though believed to be a *bottega* work, the quality of this panel is duly recognized by the critics. Specifically, Toesca is inclined to attribute it to Taddeo Gaddi.

**D. Saints**
These may well be apostles and evangelists. Certainly St Paul is one of the three central figures.

**E. Madonna with Saints and Angels**
The first figure on the left is that of St Peter.

**F. Saints**
There is no means of identifying these figures with any certainty.

**G. Saints**
There is no means of identifying the saint with a scroll in the medallion at the top of the panel. The lettering beneath their feet confirms that the other two saints are James and Paul.

**H. St Peter with Saints and Angels**
The first Pope is shown with the commissioner of the work, Cardinal Stefaneschi, at his feet.
The work is universally attributed to Giotto's *bottega*, and not the master himself.

**I. Saints**
There is no means of identifying the figure at the top bearing a scroll. The lower figures represent St Andrew and St John the Evangelist.

**J. Saints**
The first of these is Stephen ; the others cannot be identified with any accuracy.

## Life of Christ
(Rome)

**152** ▦ ⊕ — ▤ ⋮

The necrology entry for Cardinal Stefaneschi (1343) states that, in addition to the altarpiece for the high altar (no. 151), the prelate commissioned the decoration of the tribune in the Constantine Basilica of St Peter. The attribution to Giotto was first made by Ghiberti and then by Vasari, who stated that the cycle consisted of 'five scenes from the life of Christ'. This cycle was destroyed, possibly at a relatively recent date (cf. no. 153). Some authorities hold that the fragment in the Fiumi Heirs Collection in Assisi (no. 153) originated from it.

**153** ▦ ⊕ — ▤ ⋮

**Apostles** Assisi, Fiumi Heirs Collection
An inscription added in 1625 on the reverse side of this fragment identifies the two figures as Peter and Paul and records that they had been removed a few

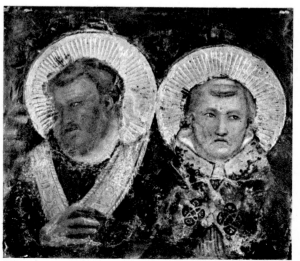

153

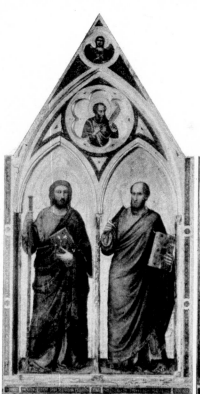

151 G

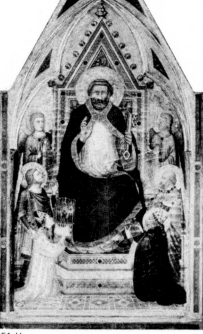

151 H

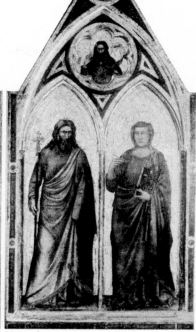

151 I

158

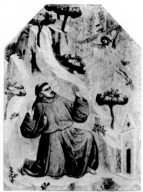

159

151 J

years earlier (1616) from the interior of the old Basilica of St Peter in Rome. This explains how they came to be connected with the decoration of the tribune commissioned by Cardinal Stefaneschi from Giotto (cf. no. 152). The earliest mention of this fresco fragment is made by A. Venturi (*Storia*, 1907), and it was first presented to the public by L. Venturi in 1919 as the work of a Giottesque. In recent times, Battisti (1960) has again suggested that it might be the

work of Giotto himself, and he has compared it with the Badia Polyptych (no. 52).

**154** ⊞ ⊘ 58×33 ☰ ⦂

**Crucifixion** Berlin - Dahlem, State Museum, Gemäldegalerie
The work was first attributed to Giotto by Bode; though initially discounted, this opinion has in recent years been reformulated by Longhi (1948) and Gnudi (1959). Suida, Toesca, Offner and others had earlier ascribed it to the so-called Master of the Strasbourg Crucifixion. Salvini believes that it is the work of an artist of the Giotto school, adding that it closely resembles the style of the painter responsible for the Stefaneschi Polyptych (cf. no. 151). There has been some peeling of the paintwork.

**155** ⊞ ⊘ 39×26 ☰ ⦂

**Crucifixion** Strasbourg, Municipal Museum
This Crucifixion is generally ascribed to the Giotto school. However, in 1948, Longhi suggested that it might be Giotto's own work and, in 1952, claimed to identify it as having formed part of a diptych, the companion panel being – according to him – the *Madonna with Child* in the Wildenstein Collection (no. 156). Parts of it are much damaged.

**156** ⊞ ⊘ 34,5×25,5 ☰ ⦂

**Madonna with Child Enthroned surrounded by Saints and Virtues** formerly in New York, Wildenstein Collection
Details were first made public by Meiss (1951), who attributed it to the painter of the Stefaneschi Polyptych. Longhi (1952) believes it to be part of a diptych, the companion panel being the Strasbourg Crucifixion (no. 155). Salvini (1962) considers the style much closer to that of the 'Maestro delle Vele' in Assisi (cf. no. 163), and other commentators will at most concede that the painting may have been executed by Giotto's *bottega*.

**157** ⊞ ⊘ 343×432 ☰ ⦂

**Crucifix** Florence, Church of S. Felice
The traditional opinion that it had been executed by Giotto is

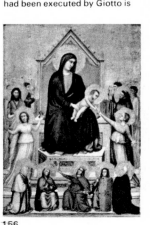

156

now universally discounted. Cecchi (1937) pointed to its affinity with the Scrovegni Crucifix (no. 114), adding, however, that there was a considerable time lag between the two. Salvini (1962) also maintained that it is by an artist of the Giotto school. The painting is both dirty and stained; the face of Christ has been redone.

**158** ⊞ ⊘ ── ☰ ⦂

**St Benedict** Florence, Bardini Collection
Suida (1931) first ascribed this work to Giotto and suggested that it may have originated from a polyptych. Coletti rejects this theory, preferring to regard it as one of the early works of Bernardo Daddi.

**159** ⊞ ⊘ 229×168 ☰ ⦂

**Stigmata of St Francis** Cambridge (Massachusetts), Fogg Art Museum
Attributed to Giotto by Mahler, jr. (1931), though most commentators hold that it is a product of his *bottega*. Even the Fogg Museum catalogue (1964) questions the validity of the attribution to Giotto himself.

**160** ⊞ ⊘ ── ☰ ⦂

**St Francis** Amsterdam, Goudstikker Collection
Suida, whose opinion was endorsed by Van Marle, suggested in 1931 that Giotto might have been the artist of this work, along with no. 161. In fact, however, the entire work

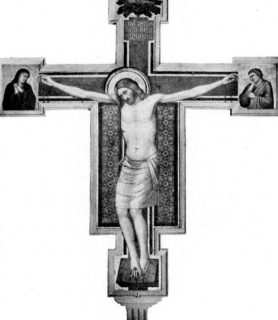

157

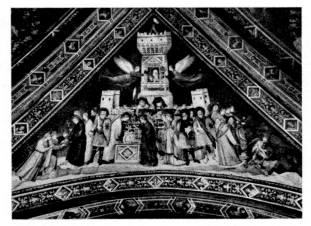

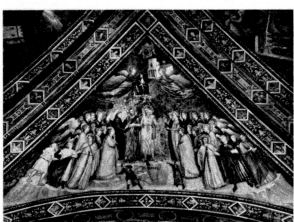

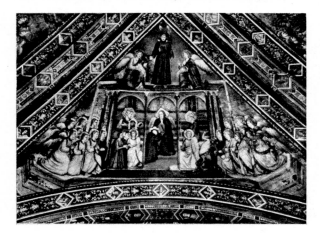

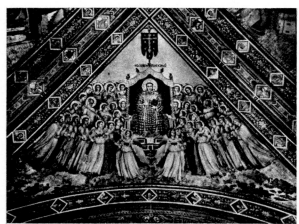

*The four cells in the vault comprising fresco cycle no. 163: (from the top to bottom) Chastity ; Poverty ; Obedience and the Triumph of St Francis. The surrounding frames feature either angels or symbolic compositions in rhombuses linked together by stylised greenery motifs interspersed with heads of cupids*

would appear to be that of an imitator (Salvini, 1962, etc.), though there are some grounds for accepting Sirén's identification of the artist (1917) as a certain Maestro Stefano, about whom we still know very little. This may, at one time, have formed part of a now dismembered polyptych, along with no. 161, 162 and a *Madonna* not illustrated here.

## 161 ⊞⊘ ── 🗎⦂

**St John the Baptist** Amsterdam, Goudstikker Collection See notes on previous entry.

## 162 ⊞⊘ ── 🗎⦂

**Christ imparts His Blessing** Florence ( ?), Private Collection The attribution of this work to Giotto was first proposed by Suida (1931) in connection with the Goudstikker paintings.

## Franciscan Allegories (Assisi)

## 163 ⊞⊘ *1334* 🗎⦂

These frescoes, which portray the three Franciscan virtues of *Chastity, Poverty* and *Obedience,* together with the *Triumph of St Francis,* adorn the four cells of the groin vault formed by the intersection of the nave and transept of the Lower Basilica of S. Francesco in Assisi. The paintings were first attributed to Giotto by Vasari, who described each of them in detail. However, all critics from A.Venturi (1905) onwards have rejected this view, which, in effect, is today held only by Franciscan writers. An attempt to reinstate Giotto as the artist both of these frescoes and of the Stefaneschi altarpiece (no. 151) was made by M. Gosebruch (1958). In the light of the undeniable affinities of style between the two works, Gnudi (1959) is at least inclined to endorse Gosebruch's view that both were commissioned by the same Cardinal Stefaneschi, who was appointed protector of the Franciscan Order in 1334 ; also that, in the same year or shortly afterwards, the actual execution was entrusted to a pupil of Giotto's, to wit the 'Maestro delle Vele' (Master of the Vault Compartments.

## Last Judgement and Magdalen Cycle (Florence)

## 164 ⊞⊕ ── 🗎⦂

The attribution to Giotto of the frescoes featuring the *Last Judgement* and the *Lives of St*

*Mary of Egypt* and *St Mary Magdalen* in the chapel known as the Madgalen Chapel in the Bargello in Florence, may have arisen from a mistranslation in the Italian rendering by A. Manetti of a Latin passage from Villani round about 1400. Villani had attributed to Giotto the self-portrait beside the figure of Dante *'in tabula altaris'* in this chapel. However, the Italian version renders *'in tabula altaris'* as 'on the wall' – hence the attribution to Giotto of the frescoes which an extant inscription records as having been executed (though the date may well refer merely to the placing of the commission) between July and December, 1337, i.e. after Giotto's death. Having at some stage been whitewashed over, the frescoes were brought to light again and restored in 1841. Of the cycle, there remain – though in poor condition – *Hell,* the *Lives of St Mary of Egypt* and *St Mary Magdalen,* a *St Venantius* on the left-hand wall and a *Paradise* on

the end wall, featuring a number of historical personages including Dante, though much retouched. All the critics discount the possibility of their having been executed by Giotto, though they may well be the work of one of his pupils. In any case, they are virtually indecipherable on account of their poor state of preservation.

## 165 ⊞⊘ 234×89 🗎⦂
1333 (?)

**St Paul and Twelve People in Prayer** Washington, National Gallery of Art (Mellon Collection) The theory is that the panel came from the Florentine Monastery of S. Felice, which still possesses a Crucifix believed by some commentators to be connected with Giotto (no. 157). However, there is nothing to show that even if it did originate from this monastery (in recent times, it has been in a private collection in Paris, though later acquired by the House of Duveen in New York),

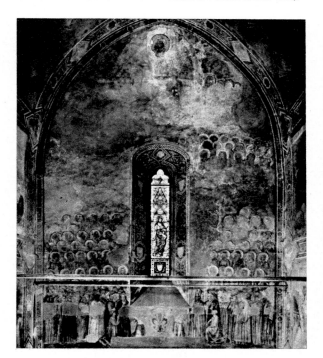

*Portions of cycle no. 164 Above: the end wall, showing Paradise (the well-known figure of Dante appears in the bottom row, to the right of the window). Lower picture: lower half of Hell (only decipherable portion of fresco), with Satan seated at the centre and two ape-like figures between his legs*

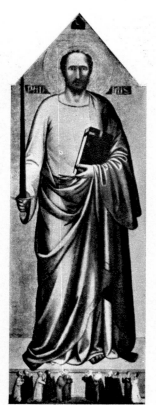

165

166

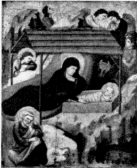

167

### 166

**Crucifixion** Settignano (Florence), Berenson Collection (Harvard University)
Fry (1930) first mooted the possibility of Giotto's authorship and that the work may have formed a diptych together with the *Nativity* (no. 167). The diptych theory – though not the attribution to Giotto – is accepted by many critics (Cecchi, etc.). Offner (1939) argues from the affinity with the Brussels painting that the artist was one possessing a rather archaic style who was influenced by the very un-Giotto-like approach of the 'Master of St Cecilia'. A number of commentators, including Sinibaldi (1943), Salvini and, at one time, Berenson, are inclined to support this view. However, though continuing to endorse Offner's main contention, Berenson subsequently postulated the possibility of this *Crucifixion*, together with the Brussels *Nativity*, the above-mentioned *Madonna*, the *Annunciation* and the *Mourning the Dead Christ* listed below (nos. 168 and 169), having constituted a single work by one of Giotto's immediate followers. In a good state of preservation.

### 167

**Nativity** Brussels, Feron-Stoclet Collection
For this work see notes to no. 166 above.

### 168

**Annunciation** Whereabouts unknown
For this work see notes to no. 166 above.

### 169

**Mourning the Dead Christ** Whereabouts unknown
For this work see notes to no. 166 above.

### 170

**Coronation of the Virgin** Budapest, Fine Arts Museum
Ascribed to Giotto by Konody (1932), a theory supported by Borenius and others. According to Berenson (1936), Salmi, though with reservations (1937), Brandi, Longhi and others, it is the work of Maso di Banco. Later commentators, including Suida (1937), Offner (1937), Vavalà and Sinibaldi were more inclined to attribute it to an unknown Giottesque whose other works may have included a *Dormition of the Virgin* at the Condé Museum in Chantilly, and the *Madonna della Cintola* in the Berlin State Museum (Berenson, 1963, figs. 133 and 137). Both of these works had at one time been linked by Longhi with the *Coronation* now under review; indeed, he suggested that they might have formed part of the so-called Shrine of the Virgin's Girdle in Prato Cathedral. If Berenson (1936) is right and the works he lists were executed by Giovanni di Bartolomeo Cristiani of Pistoia, it would seem reasonable to add this *Coronation* to those he enumerates; this would rank it with such works as the *Madonna Enthroned with two Saints* in S. Ambrogio in Florence

### 171  391×478

**Crucifix** Florence, Church of Ognissanti
The panels terminating each arm of the cross portray the Mater Dolorosa and St John, the head panel the Redeemer in the act of blessing. The attribution to Giotto dates back to Ghiberti, followed by the 'Anonimo Magliabechiano' and Gelli. Few modern commentators accept this view.

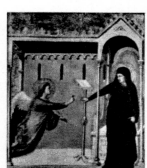

168

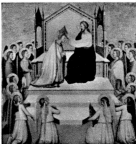

169

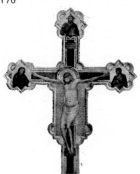

170

173

174

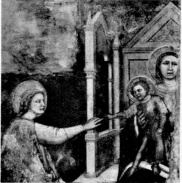 

175                                         175

Salvini has commented on the inferior quality of the work as compared with the somewhat similar Crucifix at S. Felice in Florence (no. 157). The upper part of the figure of Christ is marred by a number of cracks, clearly corresponding to divisions of the panels forming the wooden support.

### 172  405×595

**Crucifix** Florence, Church of S. Marco
The Mater Dolorosa and St John are depicted, at the end of each arm of the cross, on a gold ground against which Christ is also painted. The head panel portrays the symbolic figure of the pelican feeding its young with its own blood, while beneath the cross there are two donors kneeling on either side of Calvary, shown with a skull. Vasari first attributed the work to Giotto and this opinion was reformulated by Cavalcaselle, Fry and, more recently, by Hausenstein (1963). Most modern critics are, however, of the opinion that it is by an imitator, believed to have been influenced by the Master's style and activity in Padua. Several splits are evident.

### 173  60×80

**Angel** Formerly in Paris, E. Stern Collection
Both this and the next painting were presumed by Cecchi (1937) to have formed part of a *Crucifixion* fresco similar to the one in Padua (no. 114). Though recognizing the affinities between these angels and the corresponding figures in the Paduan painting, he nevertheless came to the conclusion that the work belonged to the period during which Giotto was engaged in the decoration of Sta Croce. No other prominent scholars have endorsed this view. Moreover, there has been a suggestion that the figures may in fact have originated from quite another

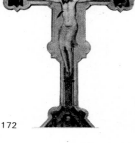

172

source, namely the *Mystical Marriage of St Catherine of Alexandria* (no. 175).

### 174  60×80

**Angel** Formerly in Paris, E. Stern Collection
For this work see notes to no. 173 above

### 175  140×133

**Mystical Marriage of St Catherine of Alexandria** Florence, Niny Bellini Collection
Having been privately attributed to Giotto, it was exhibited as such at antique fairs in Florence (Palazzo Strozzi, 1953) and Venice (Palazzo Grassi, 1962). Those responsible for the attribution propounded the theory that the *Angels* formerly in the Stern collection (nos. 173 and 174) had formed part of the fresco – or, rather, that they had featured in a *Crucifixion* forming part of the fresco cycle – from which the present fragment has been taken. It may well be that the figure of *St Laurence* shown above, and brought to our attention by the owner of the *Mystical Marriage*, also formed part of the same composition at one time.

If so, he undoubtedly appeared on the right side of the picture, beside the Madonna enthroned.

it was in fact expressly executed for it. Sirén (1919 and 1920), followed by Van Marle, attributed it to the 'Master of St Cecilia'. On the basis of the Sienese influence which he believed he could detect in this *St Paul*, L. Venturi (1931) ascribed it to Maso di Banco; Cecchi opted for Giotto – in his later years – while recognizing that his *bottega* had had a considerable hand in its execution. Salvini discounts all these theories and declares that the work is 'far removed from Giotto'.

The painting is in a reasonably good state of preservation.

171

# Other Works Mentioned by the Early Commentators

*We list here the other works attributed to Giotto by early sources [Ghiberti – 1452–5; the 'Anonimo Magliabechiano' – early 1500s; Gelli – 1540ca; Vasari – 1550 and 1568, etc.; the compilers of the 'Ottimo' commentary (1333–4ca) and of the anonymous Florentine commentary on the Divine Comedy (1395–1400ca)], for which there now exists no means of assessing the validity, in alphabetical order of geographical location and chronological order given by the sources, unless otherwise stated.*

### ARREZZO

According to Vasari – who constitutes our earliest source – Giotto worked in Arezzo on two separate occasions: the first during a trip from Florence to Assisi to paint the frescoes in S. Francesco and the second, or so the biographer implies, round about the year 1320.

**Pieve or parish church** Vasari states that Giotto here painted St Francis (to whom the church is dedicated) and St Dominic. Cavalcaselle attributed them to Jacopo del Casentino, and Procacci (1929) to an unknown fourteenth-century artist. There is evidence to show that on 16 September 1375, the decoration of the chapel in question was entrusted to Spinello Aretino, and this would seem to indicate that the paintings are the earliest examples of his work.

**Duomo** Again we quote Vasari to the effect that, during his first visit to Arezzo, Giotto painted a 'fine' *Stoning of St Stephen* in a 'little chapel', demolished 1561.

**Bishop's Palace** Giotto is reported (Vasari) to have executed a fresco of *St Martin gives away his cloak* in the 'main chapel'; however, this work had already been lost when Milanesi was writing.

**Badia** Vasari mentions a 'large crucifix done in tempera . . .' which may have been executed in 1319, is still extant and was again attributed to Giotto by Milanesi. It is, in fact, the work of the Sienese artist, Segna di Bonaventura.

### AVIGNON

There is a reference to Giotto's working in Avignon in the 'Ottimo' commentary on the *Divine Comedy* (1333–4). In the second edition of his *Lives*, Vasari sets this period in the artist's career between 1305 and 1315, although Giotto was summoned to France by Benedict XII (but did not go) some time after 1334.

**Papal Palace** (?) With no details other than the statement that Giotto worked in Avignon in the service of the Pope, Vasari refers to 'a number of works' of which there is now no trace. He is further credited with a portrait of Clement V which he took with him to Florence – in 1316, according to Vasari – and gave to Taddeo Gaddi.

### BOLOGNA

The anonymous Dante commentator of 1395–1400 (ed. Fanfani, Bologna 1868), attributed to Giotto the decoration of a 'chapel' – but without further details. In addition, R. Ronco (*Compendium of the History of Bologna from the year 610 to the year 1400* – manuscript dating from round about 1400 at University of Bologna) records a number of works in the 'castle at the Galiera Gate', and in particular in the 'chapel', which he dates in 1329. No other sources refer to Giotto's having worked in Bologna.

### FERRARA

According to Vasari Giotto went to Ferrara at the behest of the d'Este family, for whose palace (and the church of S. Agostino) he painted 'a number of items,' which were extant when Vasari was writing, but are now lost.

### FLORENCE

Vasari's *Lives* is the richest source of information for works of Giotto in Florence. However, the chronology (whether specific or implied) is at times so unreliable that we prefer to consider the works in alphabetical order of location.

**Carmine** Vasari attributes to Giotto a cycle featuring the life of St John the Baptist, which was destroyed during the restoration of the church following a fire in 1771. However, some fragments of the frescoes were preserved and are now in the Ammannati Chapel in the Camposanto, Pisa (the largest selection, comprising six pieces), the Roscoe Collection, Liverpool (two pieces), the National Gallery, London (one piece), the Boymans-van Beuningen Museum, Rotterdam (one piece), etc. All were at one time believed to be Giotto's work (Waagen, 1837–8; Grassi, 1874, etc.), but this is not so (Cavalcaselle 1864).

**Monastero degli Angeli** In 1568, Vasari wrote that this monastery had acquired a 'small crucifix on a gold background with Giotto's name written in his own hand, and very beautiful', adding that it had been executed about 1327 for the Camaldolese hermits.

**Monastero delle Donne di Faenza** Vasari first mentioned 'a number of fresco and tempera paintings by Giotto which are now lost, owing to the destruction of the monastery in question'. He dates them 1332.

**Palazzo Gondi** Vasari (1568) first mentions 'a panel by Giotto featuring small figures', which had been at Sansepolcro but was moved to Arezzo by Pietro Tarlati (who died in 1356) and later '. . . broken to pieces'. Some of these were recovered by Baccio Gondi and taken to Florence. Ragghianti suggested that the reference might be to the dismembered polyptych of which the Horne *St Stephen* (no. 127) formed part. However, since Vasari specified 'small figures', Previtali feels it is more likely to have been the other dismembered polyptych, the various parts of which are now in Munich (nos. 133, 134, 136), New York (no. 131), Boston (no. 132), Settignano (no. 135) and London (no. 137), though it should be borne in mind that this has also been identified with the Peruzzi Chapel altarpiece.

**Palazzo di Parte Guelfa** 'Billi' and the 'Anonimo Magliabechiano', followed by Gelli and Vasari, attribute to Giotto 'a cycle of frescoes illustrating the Christian faith, painted perfectly, and incorporating a portrait of Pope Clement the Fourth . . .' (Vasari). The work is no longer in its original location. It is likely that such a series of frescoes by Giotto never existed (Brizio, 1948), since the reference almost certainly arises out of a misinterpretation of a passage in Ghiberti relating to the Palazzo della Ragione in Padua.

**Palazzo della Podestà** Ghiberti, 'Anonimo Magliabechiano' and Vasari, attribute to Giotto a painting which Vasari describes as portraying 'the Commune despoiled by many, the figure symbolizing the Commune being depicted as a judge, seated, with a sceptre in one hand and, above his head, a scales evenly balanced, denoting the justice he dispenses. The judge is assisted by the four Virtues: Fortitude with a heart, Prudence with the laws, Justice with weapons and Temperance with words; the painting is beautiful and the design original and true to life'. Vasari suggests a date in 1334. A reliable reconstruction of the painting was attempted by Morpurgo (1897 and 1933).

**Piazzuola de' Gianfigliazzi** Gelli alone of the early sources attributes to Giotto a number of small figures of the Virgin and other saints, though Vasari (1550) states that they are the work of Maestro Stefano.

**Sta Croce – Giugni Chapel** Ghiberti and, indirectly, 'Billi', the 'Anonimo Magliabechiano' and Gelli, all mention the decoration of this chapel with reference to Giotto. Vasari ties it in with the early stages of Giotto's career whereas, if the attribution does in fact carry any weight, it is more likely to have been a mature work; according to Vasari, the subject matter was 'the martyrdom of many (of the Apostles)'. When Richa wrote in 1754, the paintings were still extant though there is now nothing to be seen.

**Sta Croce – Tosinghi-Spinelli Chapel** Though not explicit, even the sources prior to Vasari (Ghiberti, 'Billi' and Gelli) mention the decoration of this chapel which, Vasari declares, was dedicated to the Assumption of the Virgin, adding that it was one of the artist's early works. If Giotto was responsible he is more likely to have executed it at a much later stage. Only the Assumption scene now remains. Graziani (1943) and many later critics attribute it to the fourteenth-century Florentine Master of Figline.

**Sta Croce – Refectory** The 'Anonimo Magliabechiano' and Vasari recall 'a tree of the Cross with episodes from the life of St Louis and a Last Supper by the same (Giotto)'. The works are in the Sta Croce museum (the old refectory), though attributed to Taddeo Gaddi.

**Sta Croce – Sacristy** The 'Anonimo Magliabechiano', Gelli and Vasari all mention, 'in the cupboards', where the sacred vestments are kept, a number of 'small panel cycles featuring the lives of Christ and of St Francis'. Twenty eight of them have survived. All are held to be the work of Taddeo Gaddi. Marcucci (1960) attempted a reconstruction of the original distribution of the panels.

**Sta Croce – Tomb of Carlo Marsuppini** Vasari mentions, as by Giotto, 'a Crucifix, a Madonna, a St John and Magdalen at the foot of the Cross' above this tomb, but Milanesi states that the paintings had been 'whitewashed over'.

**Sta Croce – Tomb of Lionardo Aretino** This tomb is immediately opposite the one mentioned above and again Vasari attributes to Giotto 'an Annunciation towards the high altar'. Nothing survives.

**Sta Croce – on the walls** Round about 1450 Manetti attributes to Giotto a fresco featuring Dante *in parietibus*. It may have been in a chapel now destroyed or the writer was referring to the Bargello paintings (cf. no. 164).

**Sta Maria Novella** 'Billi', the 'Anonimo Magliabechiano', Gelli and, later, Vasari mention as being by Giotto a *St Louis with two donors in prayer* painted on the rood screen. Milanesi says the work was lost.

**FRANCE** Various locations

During Giotto's stay in France – dated by Vasari somewhere between 1305 and 1315 (but see *Avignon*) – the chronicler states that he executed 'in various places in France a number of panels and frescoes'.

### GAETA

Vasari is the first of the early chroniclers to record Giotto's activity in this city, at the end of his stay in Naples, namely in 1333. However, there is no documentary proof.

**Annunziata** Vasari lists 'several scenes from the New Testament, now defaced by time, but not to the extent of making it impossible to identify a self-portrait of Giotto beside a large and very fine Crucifix'. There is no trace of this work.

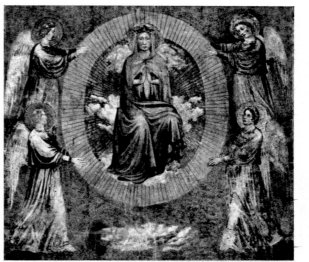

*Virgin assumed into Heaven by the 'Maestro di Figline' (?) – and only extant painting in the Tosinghi Spinelli Chapel in Sta Croce, Florence.*

## LUCCA

Vasari makes a rather confused reference to Giotto's having been at work in Lucca in 1322, in the service of Castruccio Castracani, lord of Lucca from 1316 to 1328.

**S. Martino** Vasari declares that the Master here painted a 'panel . . . depicting Christ uplifted and the four patron saints of the city, namely St Peter, St Regulus, St Martin and St Paulinus, who are shown interceding on behalf of a Pope and an Emperor'. These are identified as 'Federigo Bavaro and Nicholas the Fifth, antipope'. If the work was executed in 1322, it could not have featured either Ludovico (and not Federico) of Bavaria, who was crowned in 1327, or Nicholas V who was elected in 1328. The figures might have been Frederick of Austria and John XXII.

## MILAN

**Palazzo di Azzone Visconti** There is an early reference in Villani's *Chronicle* to Giotto's activities in Milan round about the year 1335 in the now destroyed palace of Azzone (on the site of the Royal Palace). Villani writes that 'our commune had sent him to serve the Lord of Milan'. In 1775, Giulini referred to the frescoes in one of the rooms as being by Giotto but added that they, together with the palace itself, had been destroyed quite some time previously. He added that the subject had been *Vainglory* 'surrounded by the most famous princes of olden times in the world – Aeneas, Hector, Hercules, Charlemagne, with Azzone Visconti himself to complete the group'.

## NAPLES

There is documentary evidence that Giotto worked in Naples in the service of Robert of Anjou between 1329 and 1333. Though they do not specify the location, the anonymous Dante commentators who wrote in 1333–4 (the so-called 'Ottimo' commentary) and around 1395–1400 also mention a number of works in Naples by Giotto.

**Chapel in Castelnuovo** Petrarch (*Itinerarium de Janua usque ad Jerusalem*, 1358) refers to this *capella regis* decorated by Giotto at the behest of Robert of Anjou. There is no further mention of it in any other early source and we think it unlikely to be the same 'Famous men' painting discussed below. The chapel was destroyed in 1470–2.

**Castelnuovo** Mentioned by Ghiberti ('Giotto decorated in fine style King Uberto's hall of famous men') and later by the 'Anonimo Magliabechiano' and Gelli. 'Billi', too, recalls an 'allegory' painted by Giotto for 'King Charles' (this does not

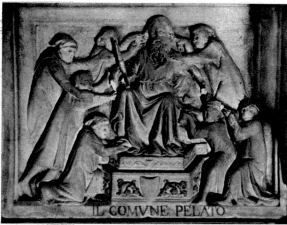

Comune pelato *(Commune despoiled)*: one of the marble slabs from the Tarlati tomb in Arezzo Cathedral. (see p. 126), which may have been used as a yardstick for the lost painting in the Palazzo del Podestà, Florence

accord with the documentary evidence of Giotto's stay in Naples) – but he may have been referring to the same work. Vasari records the destruction of the cycle for which he holds Alphonso I of Aragon responsible (1385–1458).

**Castel dell'Uovo** In addition to the work in the Castelnuovo, Ghiberti states that Giotto 'in Naples, painted in the "castel dell'uovo" '; the reference is such that Ghiberti cannot merely have got the two places mixed. In Gelli's manuscript the word 'nuovo' is crossed out and 'dell'uovo' has been written in instead, but the reference is to the 'Famous Men' cycle which, according to Ghiberti, was in fact executed in Castelnuovo. In any case, all that now remains in the Castel dell'Uovo are a few heads in the decoration of the window embrasure, probably the work of Giotto's pupils, including Maso di Banco (Morisani, 1947).

**Church of Sta Chiara** 'Billi', the 'Anonimo Magliabechiano', Gelli and Vasari all state that Giotto worked in a number of chapels in this church, which Robert of Anjou is known to have built between 1310 and 1328, but the frescoes in question were apparently stuccoed over by Barrionuevo, the Spanish Regent, during the first half of the eighteenth century.

**Church of the Incoronata** 'Billi' mentions Giotto's activities here without giving any further details, and the same is true of the 'Anonimo Magliabechiano' and Vasari. When Summonte was writing to Michiel at the beginning of the sixteenth century, he attributed to 'pupils of Giotto' the fourteenth-century frescoes here extant, which are today believed to be the work of a Neapolitan artist of the Giotto school (identified by Berenson as Roberto d'Oderisio).

## PADUA

The early sources, in particular Vasari, speak of two visits by

Giotto to Padua, during the first of which he executed the fresco cycle in the Scrovegni Chapel (cf. p. 98). The second visit occurred later : probably 1317 or possibly 1335.

**Basilica del Santo** Riccobaldo Ferrarese (writing before 1319) and, of course, Ghiberti, the 'Anonimo Magliabechiano' and Gelli, refer to works by Giotto. The context does not, however, make it clear whether the reference is to paintings on the walls of the Chapter House, which are also mentioned by Michele Savonarola round about 1440, but were later partially removed and finally (1687) whitewashed over. Steps were taken in 1851 to restore the walls with the result that the following works, though much damaged, are now visible : on the south wall (from left to right) : the figures of Isaiah, Daniel, St Anthony and Death ; on the north wall : St Clare, St Francis, St John the Baptist and David ; in the lunettes on the east wall : *St Francis receives the Stigmata* ; *Death of the Protomartyrs of Morocco*, below ; on the wall itself : a fragment of a *Crucifixion*. All of these were attributed by Pichon and Mather to Giotto, though leading modern commentators favour relatively late imitators of his style. In the basilica itself, to the left of the sanctuary and on the intrados of an arch formed by the choir loft, there are traces of a very much reworked fresco depicting St Anthony between two kneeling figures. The work has traditionally been attributed to Giotto, but it is impossible to express a definite opinion as it is in such a poor condition.

**Palazzo della Ragione** The attribution to Giotto of some works here dates back not only to Giovanni da Nono (*Visio Egidii*, 1320ca) but also to Riccobaldo Ferrarese. In the latter instance, however, the reference is not in the original manuscript but appears in a later interpolation dating, apparently, from about the year 1313, by which time, therefore, it would seem legitimate to

assume that the works in question had been completed. This and other references would seem to indicate that the ceiling had been decorated with the twelve signs of the zodiac and the seven planets with their attributes, while other stars and similar representations were depicted on the walls. Tradition has it that the iconography for this cycle was the work of Pietro d'Abano or at least that it owed its inspiration to his *Astrolabium Planum* – though there is no positive proof of this.

**Whereabouts unknown** Ghiberti attributes to Giotto in the Palazzo della Parte (sic) an *Allegory of Christianity* and a number of other unspecified paintings. Since the writer was in Padua in 1424, he may merely have confused the cycle with that in the Palazzo della Ragione (see above), which had been destroyed only a short time earlier. In addition, there is a reference in Ghiberti's manuscript to 'four panels (which Giotto) painted very excellently in Padua' but this is almost certainly a slip of the pen and the writer was in fact referring to those at Sta Croce in Florence.

## PISA

In the second edition of his *Lives*, Vasari attributes to Giotto 'at the beginning of one side of the Camposanto, six large frescoes portraying the patient Job'. In his first edition, Vasari had already attributed these frescoes to Taddeo Gaddi (as had 'Billi', the 'Anonimo Magliabechiano' and Gelli before him). Toesca (1951) maintained that they were by one of his pupils. Writing in *Paragone* in 1959, Longhi reinstated Gaddi.

## RAVENNA

**S. Francesco** According to Vasari, Dante persuaded Giotto to work for the Polentas, lords of Ravenna, who commissioned a 'number of frescoes around the church which are quite good'. The extant portions of these frescoes are in fact attributed to fourteenth-century Rimini artists.

## RIMINI

If we are to credit the chronology of Riccobaldo Ferrarese (prior to 1319), Giotto worked in Rimini between his activity in Assisi and that in Padua, i.e. some time before 1302. Vasari's contention that his time in Rimini followed his stay in Naples (and therefore occurred in 1333 at the earliest) would seem less reliable.

**Church of the Friars Minor** Riccobaldo Ferrarese mentions a number of works by Giotto in this church. Even Vasari only goes so far as to record 'a great number of paintings' executed for Pandolfo Malatesta, and then to express his regret that these

were destroyed by Pandolfo's son, Sigismondo, in order to make way for the existing Tempio Malatestiano. Vasari devotes a great deal of space to a description of a series of episodes from the lives of the Blessed Michelina of Pesaro and of St Francis situated in the cloister attached to this church, declaring that, in his view, they are among the finest works executed by Giotto. The fact that Michelina of Pesaro died in 1356 would seem to rule out the probability of the frescoes having been the work of Giotto.

**Church of S. Cataldo** (later dedicated to St Dominic) Vasari speaks of a fresco with 'St Thomas Aquinas reading to his brethren' over the main doorway. The work was still visible at the beginning of the last century, but there is now no trace of it.

## ROME

**Old Basilica of St Peter** In addition to the 'five episodes from the life of Christ' (no. 152), Vasari mentions 'scenes from the Old and New Testaments' and 'many other paintings, some of which have been touched up by artists of our own day while, to make room for the foundations of the new walls, others have been destroyed or moved out of old St Peter's as far as the organ, as for instance a wall painting of the Madona'. This was apparently rescued by a Florentine, Niccolò Acciaiuoli, but in the long run it must have suffered the fate of the others.

**Sta Maria sopra Minerva** Ghiberti, the 'Anonimo Magliabechiano', Gelli and Vasari all attribute to Giotto a 'large Crucifix done in tempera' (Vasari) in this church. Nibby claims to have seen this work in 1824 and expressed reservations as to the probability of its having been executed by Giotto.

## URBINO

According to Vasari, after his stay in Ravenna (q.v.), Giotto moved on to Urbino, where he executed 'a number of works', of which the writer gives no further details and of which, if they ever existed, there is now no trace.

## VENICE

The 'Ottimo' Commentary on the *Divine Comedy* (1333–4 ca) mentions works by Giotto in Venice, but there are no known works which suggest any connection with the artist.

## VERONA

Vasari is the first to record any activity by Giotto in Verona. He suggests a date shortly after 1316 ; thus : for 'Messer Cane (della Scala) he executed a number of paintings in his palace, and in particular a portrait of the said lord ; as well as a panel for the Franciscan friars'. Of any such works there is now no trace.

# Appendix
## Giotto — Sculptor and Architect

In the Foreword to his *Life of Giotto*, Vasari describes the artist as a 'sculptor and architect', as well as a 'painter' (cf. page 84), and amplifies this remark by referring to a number of projects with which he was concerned in one or other of these capacities, including the design for the Agosta Fortress in Lucca (which Vasari dates in 1322 on the basis of a tradition current at the time, and the foundations of which were, in fact, laid in 1322). Furthermore, the early fourteenth-century chroniclers attributed the design of a number of major undertakings to Giotto. In spite of all this, it was only in 1963 that an attempt was made, by Gioseffi, to produce the first systematic critical appreciation of his activities as an architect and sculptor. Gioseffi based his survey on three separate themes: Giotto as a painter of architectural settings suitable for adaptation to real buildings (a theme for which much material is available from the fresco cycles in Assisi, Padua and Florence); Giotto as the designer of works of sculpture; Giotto as an architect in the true sense, not only of the famous campanile which bears his name, but also of the Scrovegni Chapel and the Carraia Bridge in Florence. No other prominent scholars have, as yet, either accepted or rejected Gioseffi's theses. While it is, of course, impossible to corroborate much of the material which has been used in its formulation, there can be no doubt as to the validity of the method. Specially worthy of attention are the affinities detected by the writer between a number of the buildings featured by Giotto in his paintings and the actual buildings which he is believed to have designed. Thus, for example, a very interesting parallel has been drawn between the inclusion by Giotto of a number of features of Arnolfo di Cambio's style in the buildings and other architectural settings featured in his frescoes and the re-appearance of these same features in the cathedral bell tower in Florence.

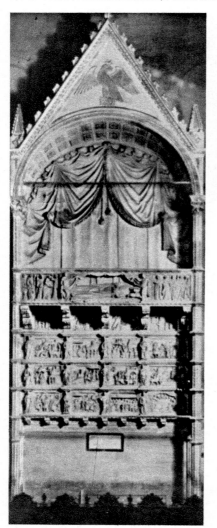

*Above: Scrovegni Chapel in Padua (see also pp. 98–109). Reverting to the theory propounded by Selvatico (1859) to the effect that Giotto was responsible for the design of this chapel, Gioseffi endeavours to confirm this view by pointing to the interrelation between structures and space which has been conceived as a function of the proposed decoration. The building was erected between 1303 and 1305 and has been altered several times. It bears some resemblance to the apse of Sta Croce in Florence and the façade of S. Vitale in Ravenna.*

*Left: Tomb of Bishop Tarlati in the Cathedral of Arezzo. Vasari attributed the design to Giotto; it was in fact executed by two Sienese artists, Giovanni and Agnolo di Ventura, who signed it in 1330. The presence of classical features so common in Giotto's work and the quality of the relief panels explain the alteration of the design to Giotto; in addition, the graciousness of the supporting structure recalls the bell tower in Florence which bears his name.*

*Below: The Carraia Bridge in Florence. The foundations were laid in 1334 and the bridge was completed in 1337; it was repaired in 1559, extended in 1867, destroyed by the Germans in 1944 and later rebuilt. Villani (Cronica) declares that it was 'made and finished' while Giotto was architectural supervisor in Florence, a position which entailed responsibility for work on the cathedral and on the town's fortifications.*

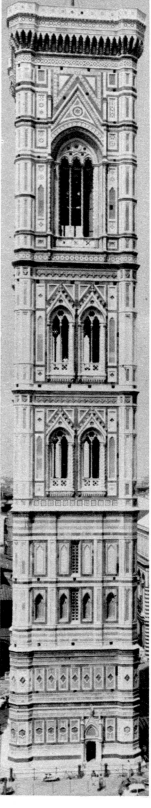

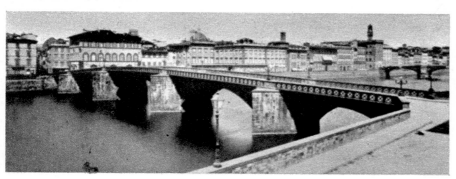

*Above, right: The bell tower of Florence cathedral. Its design was first attributed to Giotto by the anonymous Florentine author of the commentary on the Divine Comedy (1395–1400ca). Ghiberti certainly maintains that he was responsible for its design and also for supervising the work of construction up to the lower order of bas-reliefs. Gioseffi inclines to the view that Giotto's original design is preserved (in the form of a direct copy from the original) in a parchment owned by the 'Opera del duomo di Siena' (above left). However, many critics have questioned the authenticity of this document. Gioseffi further argues that the lower portion of the campanile corresponds, as regards 'measurement and proportions, design and colour' to that actually built, adding that the architects, Andrea Pisano and Francesco Talenti, thereafter radically altered Giotto's own ideas.*

# Index

# Topographical Index